The Glossary of Digital Photography

John G. Blair

The Glossary of Digital Photography

rockynook

John G. Blair hello@johngblair.com

Editor: Gerhard Rossbach
Copyeditor: Wes Palmer, Santa Barbara, USA
Layout and Type: John G. Blair
Cover Design: Helmut Kraus, www.exclam.de
Cover Photos: John G. Blair
Printer: Friesens Corporation, Altona, Canada
Printed in Canada

ISBN 13: 978-1-933952-04-8

1st Edition
© 2008 by Rocky Nook Inc.
26 West Mission Street Ste 3
Santa Barbara, CA 93101

www.rockynook.com

Library of Congress catalog application submitted

Distributed by O'Reilly Media
1005 Gravenstein Highway North
Sebastapool, CA 95472

This book is printed on acid-free paper.

Introduction

Compared to the 180 plus years of photography, digital photography is relatively new. The first personal computers came out in the mid-1970's. Photoshop 1.0 was released in 1990. The first affordable digital cameras (under $1,000) appeared about ten years ago. As the popularity of digital photography has grown, so has the creation of new words and new meanings for existing words. Strangely there are only a few printed glossaries for general film-based photography and they are between 35 and 70 years old. There have been no comprehensive, printed glossaries for digital photography. There are numerous online digital photography glossaries, but they are generally incomplete. With the growing popularity of digital photography among non-technical people, it is time for a comprehensive glossary of the terms that are used everyday.

This glossary is the product of 20 months of work by the author and the publisher, Rocky Nook. There are always a number of people behind the scenes that get little credit for the hard work that they do. Gerhard Rossbach, one of the founders of Rocky Nook, acted as publisher and acquisitions editor and conceived the idea and contacted the author's agent, Carole Jelen McClendon, about the project. The copyeditor, Wes Palmer, put a cohesive style to all of the writing that was done over many months. Jimi DeRouen served as development and production editor at Rocky Nook, and Joan Dixon assisted

him in pulling the entire production together and answering the myriad of detailed production and project questions that the author continually directed to them. Finally, Helmut Kraus, of Exclam in Dusseldorf Germany, designed the great cover.

New words were continually added as the project progressed. Some of the terms, such as "chimping", are brand new, having been invented only months ago to explain some new portion of the digital photography world. Others, such as "camera", predate film-based photography by 800 years. The use of computers is often required in digital photography, so there are many computer-related terms defined here. Digital photography is still growing rapidly. It is the intent of the author to add to this glossary, and, over time, release updated editions of this glossary. Indeed, a list of words to be added has already been created, and new words unable to be included in this edition because of production deadlines will be added to the next edition. If you find any errors or wish to suggest words to be added to future editions, please contact the author through his website: www.johngblair.com. Happy exploring!

1

16.7 million colors
> The number of colors used in *24-bit color space*. See also ***24-bit color.***

16:9 chip
> A chip is the image sensor in a digital still or video camera. A *16:9 chip* is a chip with an aspect ratio of 16 to 9, that is, 16 units wide by 9 units high. The other common size is the *4:3 chip*. See also ***4/3 Chip***

16 Base
> One of the six sizes used by the Kodak Photo CD system when scanning or digitizing photographs. It has a resolution of 2048 by 3072 pixels. The other sizes are 64 Base, 4 Base, Base/16, Base/4, and Base. See also ***64 Base; 4 Base; Base/16; Base/4; Base; Photo CD.***

16-bit color
> A color system in which each pixel is represented by 16 bits. These bits are broken down into 3 bytes; each byte represents one of the three primary colors: red, green, and blue (RGB). There are 5 bits, 6 bits, and 5 bits assigned to the 3 bytes. On PC computers this is called *high color*, on Macintosh computers it is called *thousands of colors*. The actual number of colors available with 16 bits is calculated by looking at each color, which is represented by 1 byte, which has 5 or 6 bits; this translates to 2^5, or 32, colors for each of 2 bytes or colors, and 2^6, or 64, for the third byte or color. Since there are three colors, there are 65,536 (i.e., 32 x 64 x 32 = 65,536) colors available for each pixel. The reason that the color green is typically chosen for the extra bit is that the human eye is most sensitive to the various shades of green. *24-bit,* or *millions of colors,* is more common today. See also ***24-bit color.***

1

18 percent gray – This is the color of an 18 percent gray card used for white balancing and exposure checking with digital images. Due to variations in the printing process, this image is only an approximation of a true 18 percent gray.

18% gray

Refers to the amount of light reflected by a *gray card*. Also used as the name of the card: *18% gray card*. 18% gray is referred to as the standard by which light meters are calibrated, but light meters are actually calibrated by reference to the ANSI standard, which some argue is more closely represented by a reflectance of 12%. If properly done, a light meter pointed at an 18% gray card will properly give a reflected light reading, representing the average light value in a scene. This is useful when photographing a scene that has a lot of white, such as sand or snow, or a scene that has a lot of black. By using a gray card in those cases, the exposure will be much more correct than trying to use a reflected light-meter reading of the scene. A 12% reflectance can be adjusted by opening up a stop. This can be tested by photographing an 18% gray card and looking at the camera histogram to see if the curve or line is centered. If it

is off to one side, the card is either over- or under-exposed and the exposure can be adjusted accordingly. *(see figure on page 2)*

1-bit color

A color system in which each pixel consists of only 1 bit. This bit can be either 0 or 1, off or on, or black or white. Even though there are two possible colors, 1-bit color is also known as *monochrome.*

24-bit color

A color system in which each pixel is represented by 24 bits. These bits are broken down into 3 bytes, where each byte has 8 bits and represents one of the three primary colors: red, green, and blue. On PC computers, this is called *true color* and on Macintosh computers it is called *millions of colors.* The actual number of colors available with 24 bits is calculated by looking at each color, which is represented by 1 byte, which has 8 bits, thus there are 2^8, or 256, colors for each byte or color. Since there are three colors, there are 16,777,216 (256 x 256 x 256 = 16,777,216) colors available for each pixel. It is more common in usage today than 16-bit color. See also ***16-bit color.***

3200 K

Refers to a color temperature with *K* referring to *kelvin.* Note that, unlike other temperature scales, when stated properly, only *kelvin* is used to refer to the unit, not *degrees kelvin*, or *°K.* 3200 K is used as the approximate temperature of incandescent room light, although it is typically a bit lower. There are professional tungsten bulbs available that will produce a color temperature of 3200 K. See also ***Kelvin.***

32-bit color

Similar to *24-bit color*, except that an extra channel of 8 bits, called the *alpha channel*, is added. As in 24-bit color, these other bits are broken down into 3 bytes; each byte has 8 bits and represents one of the three primary colors: red, green, and blue. On PC computers this is still called *true color* and on Macintosh computers it is called *millions of colors*, as in 24-bit color. The actual number of colors available with 32 bits is calculated by looking at each color, which is represented by 1 byte; each byte has 8 bits, which means 2^8, or 256, colors for each byte or color. Since there are three colors, there are 16,777,216 (256 x 256 x 256 = 16,777,216) colors available for each pixel, the same as 24-bit color. The extra byte of 8 bits is represented by the alpha channel, which can be used for masking information, effects, or when compositing several images. Sometimes the alpha channel is left empty and used for padding a 24-bit color image up to a 32-bit color image, since modern computers often use 32 bits for their processing. See also ***Alpha channel.***

3:2 chip

A digital sensor or chip with an aspect ratio of 3 units wide by 2 units

high. This is the same aspect ratio used by 35mm film cameras. See also *16:9 chip; 4:3 chip.*

3400 K

Refers to a color temperature, with *K* referring to *kelvin*. Note that, unlike other temperature scales, when stated properly, only *kelvin* is used to refer to the unit, and not *degrees kelvin* or *°K*. 3400 is used as the approximate temperature of incandescent photoflood bulbs. See also *Kelvin.*

35mm camera equivalent

Refers to a viewing angle on a digital camera that is the same as the angle one would see using a certain focal-length lens on a 35mm camera. Different digital cameras use different sized digital sensors, which affect the viewing angle using the same lens. For example, some digital cameras have a 1.5 factor, which means that using a 50 mm lens on such a camera would have the same viewing angle as a 75 mm lens on a 35mm film camera. Using that same lens on a digital camera with a full-size sensor would make the viewing angle equal to a 50 mm lens on a 35mm film camera.

36-bit color

A color system in which each pixel is represented by 36 bits. These bits are broken down into 3 bytes, where each byte has 12 bits and represents one of the three primary colors: red, green, and blue. The actual number of colors available with 36 bits is calculated by recognizing that each color, which is represented by 1 byte, which has 12 bits, which equates to 2^{12} (or 4096) colors for each byte or color. There are three colors, so by multiplying 4096 x 4096 x 4096, a total of 68,719,476,736 (over 68 billion) colors are available for each pixel. 36-bit color is often used in better-quality scanners and digital cameras that have *raw* format. The 12 bits for each pixel are usually represented by 16 bits, with the additional bits not used.

3-bit color

A color system in which each pixel is represented by 3 bits, which means that each pixel can be eight (2^3) possible colors. There is 1 bit for each of the three colors: red, green, and blue; therefore each color can be 0 (off) or 1 (on). This approach leads to the colors: black (0,0,0), blue (0,0,1), green (0,1,0), cyan (0,1,1), red (1,0,0), purple (1,0,1), yellow (1,1,0), and white (1,1,1). The system that was used by the early Radio Shack TRS-80 computer, it is not commonly used today.

3D color matrix meter

A metering system, developed by Nikon to evaluate brightness, contrast, selected focus, distance information, and the color characteristics in a scene, that is fed to a camera-based microprocessor to provide very

precise exposure control. It uses a CCD that has more than 1,000 pixels with RGB information from each and a microprocessor with more than 300,000 exposure possibilities stored in its database.

4/3 Chip

A chip is the image sensor in a digital still or video camera. A *4/3 chip* is a chip with an aspect ratio of 4 to 3, which means 4 units wide by 3 units high. Some of the earliest digital cameras available to the public were 640 pixels by 480 pixels, and were called simply 640 x 480. This figure is equivalent to a 4 to 3 ratio, written *4:3*, hence a 4/3 chip. The same 4:3 ratio is used in NTSC American television, and is therefore used in many consumer digital video cameras. The 4/3 chip is used in many consumer, or compact, digital still cameras as well. Digital SLRs tend to use a 3:2 ratio chip to fit better in the common ratio of 35mm film. Other common sizes of chips include 16:9 and 3:2. See also **chip; NTSC; 16:9 chip.**

4 Base

One of the six sizes used by the Kodak Photo CD system when scanning or digitizing photographs. It has a resolution of 1024 by 1536 pixels. The other sizes are 16 Base, 64 Base, Base/16, Base/4, and Base. See also **16 Base; 64 Base; Base/16; Base/4; Base; Photo CD.**

4-bit color

Also called *16 colors*. A color system in which each pixel is represented by 4 bits. This means that each pixel can be 16 (2^4) possible colors. This is similar to a 3-bit color system, in which there is one bit for each of the three colors: red, green, and blue. In addition, there is a 4th bit for intensity. The following colors are possible in 4-bit color: black, blue, green, cyan, red, magenta, brown, light gray, dark gray, bright blue, bright green, bright cyan, bright red, bright magenta, yellow, bright white. This color system has some use on IBM PC-compatible computers and in the Windows operating system. Most common systems use more bits today so more colors can be represented.

5500 K

The approximate temperature, in kelvins, of daylight. This is the photographic standard color temperature of daylight used in creating digital images. Note that, unlike other temperature scales, when stated properly, only *kelvin* is used to refer to the units, and not *degrees kelvin* or *°K*. See also **Kelvin.**

64 Base

One of the six sizes used by the Kodak Photo CD system when scanning or digitizing photographs. It has a resolution of 4096 by 6144 pixels. The others are 16 Base, 4 Base, Base/16, Base/4, and Base. See also **16 Base; 4 Base; Base/16; Base/4; Base; Photo CD.**

1

8-bit color

Also called *256 colors*, a color system in which each pixel is represented by 8 bits. This means that each pixel can be 256 (2^8) possible colors. For color images, this is a common bit depth using the GIF format in websites. This format is used mainly for graphic images in order to save storage space and to download more quickly. See also **GIF.**

8-bit grayscale – This is an 8-bit grayscale image, often called black and white.

8-bit grayscale

Similar to 8-bit color, except the 8 bits represent 256 shades of gray rather than different colors for each pixel. *(see figure on page 6)*

8 x 8 block

A block of 64 pixels, 8 to a side. Images are broken down into 8 x 8 blocks by software for processing into JPEGs. This size was chosen for simplicity of computation.

A°

See **angstrom**

A0

A paper size of 841 mm by 1189 mm, or 33.1 inches by 46.8 inches. It is defined by the international standard, ISO 216. There are a number of sizes of paper that are defined for convenience in the digital and printing industries. These sizes that are more commonly used outside of the United States, which has its own standards in English rather than metric units.

A1

A paper size of 594 mm by 841 mm, or 23.4 inches by 33.1 inches. It is defined by the international standard, ISO 216. There are a number of sizes of paper that are defined for convenience in the digital and printing industries. These sizes are more commonly used outside of the United States, which has its own standards in English rather than metric units.

A2

A paper size of 420 mm by 594 mm, or 16.5 inches by 23.4 inches. It is defined by the international standard, ISO 216. There are a number of sizes of paper that are defined for convenience in the digital and printing industries. These sizes are more commonly used outside of the United States, which has its own standards in English rather than metric units.

A3

A paper size of 297 mm by 420 mm, or 11.7 inches by 16.5 inches. It is defined by the international standard, ISO 216. There are a number of sizes of paper that are defined for convenience in the digital and printing industries. These sizes are more commonly used outside of the United States, which has its own standards in English rather than metric units.

A4

A paper size of 210 mm by 297 mm, or 8.3 inches by 11.7 inches. It is defined by the international standard, ISO 216. There are a number of sizes of paper that are defined for convenience in the digital and printing industries. These sizes are more commonly used outside of the United States, which has its own standards in English rather than metric units.

A5

A paper size of 148 mm by 210 mm, or 5.8 inches by 8.3 inches. It is defined by the international standard, ISO 216. There are a number of sizes of paper that are defined for convenience in the digital and printing industries. These sizes are more commonly used outside of the United States, which has its own standards in English rather than metric units.

A6

A paper size of 105 mm by 148 mm, or 4.3 inches by 5.8 inches. It is defined by the international standard, ISO 216. There are a number of sizes of paper that are defined for convenience in the digital and printing industries. These sizes are more commonly used outside of the United States, which has its own standards in English rather than metric units.

A7

A paper size of 74 mm by 105 mm, or 2.9 inches by 4.3 inches. It is defined by the international standard, ISO 216. There are a number of sizes of paper that are defined for convenience in the digital and printing industries. These sizes are more commonly used outside of the United States, which has its own standards in English rather than metric units.

A8

A paper size of 52 mm by 74 mm, or 2.0 inches by 2.9 inches. It is defined by the international standard, ISO 216. There are a number of sizes of paper that are defined for convenience in the digital and printing industries. These sizes are more commonly used outside of the United States, which has its own standards in English rather than metric units.

A9

A paper size of 37 mm by 52 mm, or 1.5 inches by 2.0 inches. It is defined by the international standard, ISO 216. There are a number of sizes of paper that are defined for convenience in the digital and printing industries. These sizes are more commonly used outside of the United States, which has its own standards in English rather than metric units.

A10

A paper size of 26 mm by 37 mm, or 1.0 inches by 1.5 inches. It is defined by the international standard, ISO 216. There are a number of sizes of paper that are defined for convenience in the digital and printing industries. These sizes are more commonly used outside of the United States, which has its own standards in English rather than metric units.

AA cell

A standard size of battery often used by cameras and flashes. The rechargeable version supplies about 1.25 volts; the alkaline battery version supplies about 1.5 volts. It is a popular battery because of its small size and widespread availability. *(see figure below)*

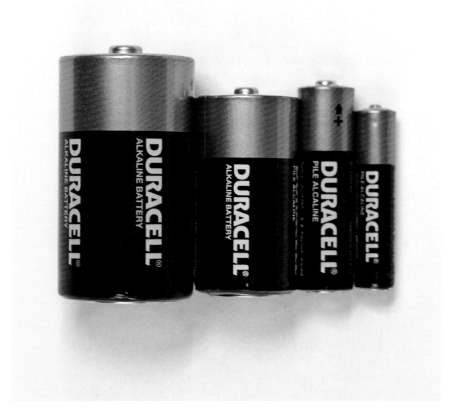

AA cell – The AA cell is the second from the right. The batteries, or cells, are (left to right) D cell, C cell, AA cell, and AAA cell.

Abbe number

A number used to classify the glass used in making lenses and other items. It represents the dispersion of a glass and therefore of a lens. The Abbe number is represented by the symbol V. A high Abbe number represents low dispersion of the glass. The Abbe number measures the difference in refraction of different wavelengths or colors of light. Abbe numbers are used only for dispersion of visible light. Other methods are used for other wavelengths of light. Typical values of V are in the range of 20 to 80. These numbers are important to photography because they are used to minimize chromatic aberration in the calculation of focal lengths in multiple-element lenses. The Abbe number was defined in about 1873 by Ernest Abbe (1840–1905), a young physicist, when he worked with Carl Zeiss in the design of microscopes. The Abbe number is also known as the constringuence of a transparent material.

aberration

A blurring or distortion of light rays through a lens. Abberation is created by imperfections that cause the rays to focus improperly. The different types of aberrations include *monochromatic* and *chromatic aberrations*, which can be further broken down into other types of aberration. Aberrations can show up in images and are to be generally avoided. See also **monochromatic aberration; chromatic aberration.** *(see figure on page 11)*

abort

The process of stopping the operation of a computer program or data-processing activity before it would normally complete on its own. Aborting will often cause the program to freeze or crash, and may cause the loss of data in some situations.

absolute colorimetric

One of four different *rendering intents* used to convert colors from one color space to another. The others are *relative colorimetric rendering*, *perceptual rendering*, and *saturation rendering*. With absolute colorimetric rendering, color values are converted exactly to the same value in the new space. Colors that are out of range, or gamut, of the new color space are mapped to the closest value in the new color space. If the new color space is smaller, the new color value will be cut off or clipped from the original, often resulting in a reduced saturation. Absolute colorimetric is commonly used only when moving from a smaller to a larger color space where exact colors are desired, such as when producing a proof print. See

aberration – This figure is a detail of a digital image that shows a color shift aberration of light green and purple in the edges of the branches.

also ***relative colorimetric rendering; perceptual rendering; saturation rendering.***

absolute white

The hottest, or brightest, pixels in an image. In a *histogram*, the pixels at the far right of the graph. In an *8-bit image*, the maximum value would be (255, 255, 255).

accelerated graphics port (AGP)

A port for connecting graphics cards to the motherboard. Not all computers have AGP and fewer new models include it. PCI Express ports are replacing it.

accelerator

Has a number of meanings in photography. (1) In the past, a chemical added to a developer in analog photography. (2) In digital photography, a hardware device added to a computer to enable faster processing. (3) The use of keyboard shortcuts to speed up the processing of images in a computer program.

acceptable circle of confusion

Refers to a *circle of confusion* that is small enough not to be noticeable in a photograph. For common types of photography, acceptable circle of confusion is set as the largest size of circle that will still be seen as a point when the image is displayed as an image with a 30-cm diagonal when viewed at a distance of 50 cm. If human vision acuity can distinguish five lines per millimeter at 25 cm, an accepted standard, then the largest acceptable circle of confusion would be .2 mm. These numbers would then have to be converted to the size of the digital sensor if the measurement were to be made at the sensor rather than at the final print size. See also ***circle of confusion.***

acceptance angle

More commonly called the *angle of view*. The view of a scene that is seen by a lens. See also ***angle of view.***

access

(1) The request for information from a digital device such as a *disk* or *CF card*. (2) The ability to obtain or *access* that information. In the case of digital photography, images are the information that is requested or desired.

access time

The amount of time taken from the point information is requested to when a device is able to find that information and deliver it. In digital photography this is important because it will help to determine how quickly an image can be found and provided on a disk.

accuracy

The degree to which a photograph comes to reproducing the desired image. This tends to be a subjective judgment. Other areas of digital photography, such as the accuracy of a shutter or a diaphragm, are easier to measure. In those cases, accuracy would refer to how close the measure of the shutter speed or diaphragm is to the stated value. This is sometimes confused with precision, which is a measure of the repeatability of the values.

ACE

A file format similar to the *zip file format*. ACE is used to compress and archive data. It offers more compression than zip, but it runs more slowly.

It is a proprietary file format, although there are some free decompression programs available. See also **zip.**

achromatic

(1) Without color. An achromatic lens will refract all colors equally, which means the lens has no *chromatic aberration* or is corrected for chromatic aberration by the use of multiple lenses to focus all colors to a single point. (2) Refers to the *colors* of black, white, and some grays, which are really *noncolors* since they have no hue. See also **chromatic aberration.**

acid free

Refers to paper or matting that is neutral (pH=7) or basic (pH>7) and has no acid. This is important because of the damaging effects of acid to paper, causing it to yellow and become brittle over time. Paper made from wood pulp has base material added to neutralize the natural acids found in wood. Buffering may be added to deal with any future acidity; this can be added during later processing. Acid free paper is more expensive and is generally used for higher-end products, such as fine art papers for photographs and in books, where greater longevity is desired.

acid migration

The movement of acid from one medium to another. In photography, it can refer to the acid in matting or backing of a print or in a frame. If acid touches the photograph, it travels, or migrates, to the print and causes damage. It is important to consider all materials in the photographic process, not simply the final print material.

acquire

The process of inputting an image into a computer from a device such as a scanner. See also **acquisition; scanner.**

acquire module

A plug-in to an image-processing program, such as Photoshop, which allows communication with a scanner to acquire an image. See also **acquisition.**

acquisition

The input of data into a computer system. In digital photography, acquisition refers to obtaining a scanned image from a scanner for image processing. The image is acquired through the use of an *acquire module*, such as a TWAIN module, which connects the software of the scanner

with that of the computer and allows the digitized photograph to be transferred. See also **acquire module; TWAIN.**

Acrobat

A software program or application created by Adobe Systems to create electronic files or documents in a format known as *PDF*, which stands for *portable document format*. The creation of this format allows documents to be transferred electronically between computers so the viewer sees the document in the way intended by the creator. Unlike e-mail, whose appearance is affected by the reading software, PDF documents always look the same. This format is widely used for creating simple documents up to complete books. It is ideal for transmitting formatted information quickly and accurately. New versions of the program allow indexing and linking to outside websites as well. Adobe's free reader, known as Acrobat Reader, can read these PDF files. The files can be locked, that is, they cannot be copied or printed, or they can be left unlocked. See also **Acrobat Reader; PDF.**

Acrobat Reader

A free software program or application created by Adobe Systems to read the electronic files or documents produced by their software program, *Acrobat*. These electronic files are equivalent to electronic paper in that they are relatively small in storage size, yet will remain formatted correctly on any computer. The file is called a *PDF* file, which stands for *portable document format* file. More recent versions of Acrobat Reader will allow forms in PDF format to be filled out. The Acrobat Reader program is available for nearly any computer free of charge at *adobe.com*. See also **acrobat; PDF.**

action

A function in Adobe Photoshop and similar software programs that allows a series of different tasks to be stored as a single command. This greatly speeds up the processing of digital images. For example, a photographer can create an *action* that resizes an image, converts to a different color space, adds contact information in the metadata, applies a visible water-mark, and then saves it as a JPEG in a different folder. This could be useful, for instance, in producing a series of thumbnails or proofs to send to a client for viewing. Adobe Photoshop comes with a few generic actions already available for use. An action can be set up so that it is easily triggered by the use of a droplet. See also **droplet.** *(see figure on page 15)*

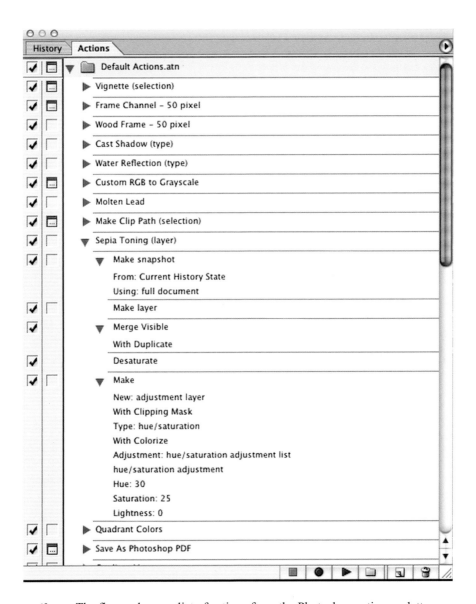

action – The figure shows a list of actions from the Photoshop actions palette. The Sepia Toning action has been opened up in the figure by clicking on the sideways arrow to turn it downward, which then shows the details of each step in the action.

actions palette

The palette in Adobe Photoshop on which all of the *actions* are stored and available to be called for use. *(see figure below)*

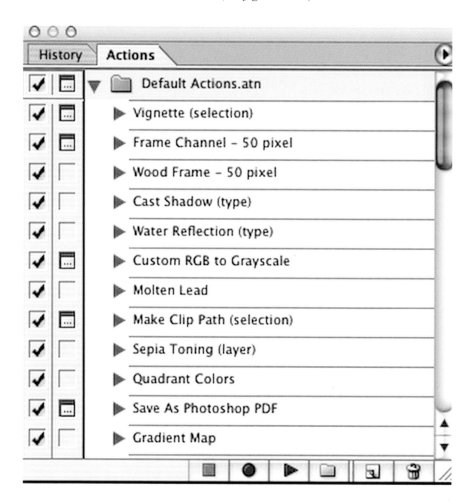

actions palette – The Photoshop actions palette shows a list of all of the available actions, as shown in this figure.

active-matrix display

Also called *thin-film transistor* (*TFT*) *display active matrix liquid crystal display (AMLCD),* or, more commonly, *liquid crystal display* (*LCD*). A

A

type of a display used in digital cameras and computers. These are the primary types of displays used in digital cameras and laptop computers. LCD displays have nearly replaced CRT types of displays or monitors for desktop computers as well. Active-matrix-displays use less energy than an equivalent CRT and take up less desk space. They are sometimes more difficult to calibrate.

active matrix liquid crystal display (AMLCD)
See *active-matrix display*.

active pixel sensor (APS)
A variant of *CMOS-based sensors* in digital cameras. APS is less expensive than a CCD, uses much less power, and provides less image lag. It does suffer from higher fixed-pattern noise. It is steadily improving with regard to not only noise but also dynamic range and responsivity as well. Currently, camera cell phones are a primary user. See also *CMOS.*

actual size
(1) Creating an image of an object in which the object in the photograph has the same dimensions of the actual object. Thus a two-inch long rock measures two inches in the photograph as well. This is also called *life-size*. (2) The creation of a photograph, either a print or a digital image, in which the dimensions of the photograph or image are the same as the size at which it will be reproduced, for example in a magazine or in a book. If an image will be three inches by four inches in the book, then the print or digital image is also three inches by four inches.

acutance
The apparent sharpness caused by the amount of edge contrast between two adjoining elements in an image. The higher the edge contrast, the more apparent sharpness. This is due to the way that human vision operates. The higher apparent sharpness appears to increase resolution, but there is no change in the actual resolution of an image. This is the principle used by Photoshop in the unsharp masking process. See also *unsharp masking.*

adaptive compression
A data compression technique in which the compression is automatically adjusted for different types of data. Although it is more often used in reducing storage requirements for backup of nonphotographic data, adaptive compression is part of the LZW compression technique used in the TIFF LZW image format. This is a non-lossy compressed image format. The LZW compression is most effective in compressing simple images, such as 8-bit monochrome images or images without a lot of detail. More complex images are not handled as well, and, in some cases, the compressed image can take up even more space than the uncompressed image. See also *TIFF LZW.*

ADC

See *analog-to-digital converter.*

A/D conversion

See *analog-digital conversion.*

A/D converter

See *analog-to-digital converter.*

additive color model

Another name for additive color system. See *additive color system.*

additive color system

A color system made up of the three primary colors: red, green, and blue (RGB). Adding two adjacent primary colors to each primary color produces the secondary colors: cyan, magenta, and yellow. Cyan is created by adding green and blue. Red and blue combine to create magenta. Finally, red plus green creates yellow. Adding together equal amounts of 100% intensity of all three primary colors produces white. Varying the amounts of each primary color added can produce a wide range, or gamut, of colors. The additive color system is used by devices that transmit light, such as monitors and televisions, and is based on how human vision operates. The other color system in use is the *subtractive color system.* The difference between additive and subtractive color is that additive color uses light and subtractive color uses dyes or pigments. See also *subtractive color system; RGB.*

additive palette

A palette of colors made up from the three primary colors of red, green, and blue (RGB). The total number of colors in the palette is determined by the bit-depth (number of bits per color) of each color. Most modern monitors use 24-bit color (8 bits per color) for a total of over 16 million possible colors in the color palette. See also *24-bit color.*

additive primary colors

Red, green, and blue light. See also *additive color system.*

addressable resolution

The largest resolution that a device can receive, capture, process, or manipulate. This resolution can be different from that which the device can display. Often a monitor may not be able to display the full resolution that a digital camera can capture, yet the computer can still process the full files.

ADI

See *advanced distance integration.*

adjacency effect

The effect of colors appearing different depending on the color that they are adjacent to.

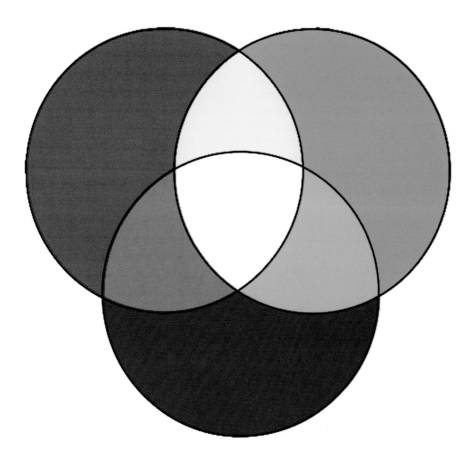

additive color system – These three overlapping color circles of red, green, and blue (RGB) show how the colors will combine in an additive color system.

Adobe Color Engine (ACE)

A color conversion tool created by Adobe that is used to convert images from one color space to another. At one time, ACE was only found in Adobe-created products such as Photoshop. Now it is available as a standalone module and can be used by other applications.

Adobe Gamma

A utility program that comes with Adobe Photoshop. This program is used to help adjust and create a rough calibration of the monitor. Al-

A

though not as good as a hardware calibration device, using Adobe Gamma is better than not doing any calibration.

Adobe RGB (1998)

An ICC color space that is becoming the standard for many commercial and stock photography applications. Larger than the *sRGB color space,* the Adobe RGB (1998) color space was developed by Adobe Systems in 1998, hence its name. Although created by Adobe, the color space is available for use in many other applications because of licensing agreements made by the other applications' developers with Adobe. It is one of the main color spaces used by digital photographers. Many stock agencies have set Adobe RGB (1998) as their standard color space. See also **sRGB**.

Adobe's electronic document format

Known as *PDF* or *postscript document format*. The electronic documents can be created by a number of programs, including Adobe's Acrobat software, and read by the free Adobe Acrobat reader. See also **Acrobat; Acrobat Reader; PDF.**

ADV

(1) An abbreviation referring to advertising photographers. Some databases will list abbreviations next to photographers' names to describe their specialties. (2) An abbreviation for *advanced photography* in a photography education program.

advanced distance integration (ADI)

A metering system developed by Minolta to measure light from a flash. ADI utilizes the distance from the flash to the subject in the calculation of exposure. It uses a short preflash as part of the process.

AEB

See **auto exposure bracketing.**

aerial perspective

The perception of depth in a photograph of an outdoor scene. It is influenced by the natural haze in the distance which causes distant objects to be lighter, more blue, and softer in focus. The haze could be caused by smoke, rain, snow, humidity, smog, or cloudiness. If the haze were removed, then the photograph would tend to look flat. Not the same as *aerial view*. See also **aerial view.** *(see figure on page 21)*

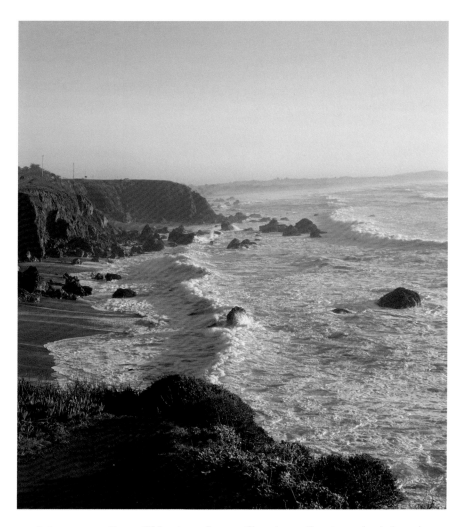

aerial perspective – This view of a coastline shows the atmospheric haze in the distance that is a characteristic of an aerial perspective.

aerial view
A view of a scene from a high altitude. Sometimes the term *birds-eye view* is used. A slight difference is that birds-eye view refers to a specific view looking straight down, while aerial view is a more general term referring to any view from an altitude. Not the same as *aerial perspective*. See also **aerial perspective.**

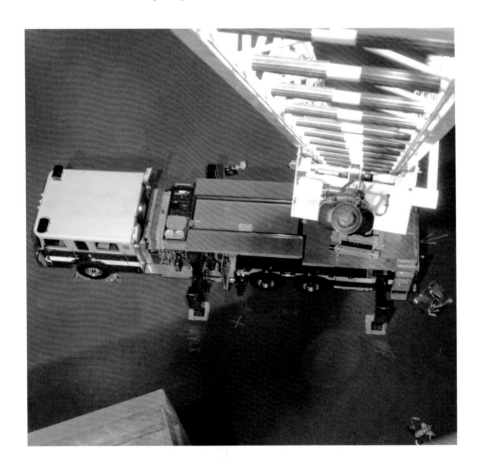

aerial view – An aerial view is represented by looking down from the top of a ladder to the ladder truck five stories below.

AF
See **automatic focus.**

AF assist

The illumination lamp used to assist the *automatic focus* process. (1) A visible light that flashes on for a moment in particularly dark situations. (2) An infrared lamp used instead of a visible lamp. The AF assist lamp is usually only effective over a relatively short distance. See also ***automatic focus.***

AFD

An abbreviation for *automatic focus distance.* A type of automatic focus lens that has a built-in distance calculator to provide both more accurate focusing and information for use by TTL flashes. See also ***TTL flash.***

AF illumination lamp

A light used to assist a camera's automatic focus feature; it illuminates a scene that is darker than desired. See also ***AF assist; automatic focus.***

AGP

See ***accelerated graphics port.***

airbrush tool

A digital tool, such as the Photoshop airbrush tool, designed to simulate an airbrush tool digitally and allow a photographer to "spray paint" on an image. It can be used for retouching, creative manipulations, and graphic design.

Airy disk

A circular pattern of light surrounded by concentric circles of light caused by the diffraction of light passing through an aperture. The size of the circular pattern is dependent on the size of the aperture. Larger apertures (smaller f-numbers) have smaller circular patterns. As the size of the airy disk increases, the image becomes softer. It is important to realize that as the f-stop is increased, to increase the depth of field, some or all of the increased sharpness in the image may be eliminated by additional softness caused by the larger Airy disk.

Airy's disk

See ***Airy disk.***

algorithm

A procedure or set of instructions used to perform a specific action. An algorithm does not have to be run in a software program, but it usually is.

A

Various algorithms are combined in software programs used to work on digital images.

aliasing

Has two meanings that are important in digital photography. (1) Sampling errors can cause unwanted effects in images, such as the jaggies or stair-stepping, of straight, usually diagonal, lines, and moiré patterns. There is a technique known as anti-aliasing, which helps deal with some of these situations by applying a slight blurring effect. (2) An "alias" of a program or file can be placed on the desktop of a computer even though the actual file resides on a different disk. This is done by placing an icon on the computer that links to the location where the file or folder is stored. This can help speed up workflow for the photographer who does not have to search to find his favorite tools. Merely clicking or double-clicking on the "alias" opens the desired file or folder. See also *anti-aliasing.* *(see figure on page 25)*

alpha

See *alpha channel.*

alpha blending

The use of the alpha channel to create transparency effects over parts of or an entire image. See also *alpha channel.*

alpha channel

A fourth channel added to the three channels in an RGB image. Along with the 8 bits of the image, the 8 bits of the alpha channel increases the total bits to 32. This alpha-channel data is used to represent masking information, effects, or multiple image composites. See also *RGB; 32-bit color.*

alpha channel transparency

The use of alpha-channel blending and an alpha channel to create an image that is partially or fully transparent. Only a few image formats, such as PNG, BMP, and PSD, will support alpha channel transparency. See also *alpha blending; alpha channel; A to D converter.* See *analog-to-digital converter.*

American National Standards Institute (ANSI)

A privately owned, nonprofit standards organization that has been in existence for nearly one hundred years. It sets voluntary standards, such as the old ASA film speed standards, which are used in the United States and other countries. As part of that function, they work with other organizations developing standards as well as government agencies, companies, and consumer groups. They also work with standards associations internationally to coordinate the development of international standards. Through their work, for example, the film speed standards

A

aliasing – The jagged edges of diagonal lines around these windows show aliasing.

developed by ASA were later incorporated into the ISO standards we have today. See ***ASA and ISO.***

American Standard Code for Information Interchange (ASCII)

A method created about forty years ago to convert or encode alphanumeric characters into numbers so that computers can use the characters.

The American National Standards Institute (ANSI), maintains the standard, so it is known as the ANSI binary-coding scheme. See also ***American National Standards Institute.***

American Standards Association

See ***ASA.***

AMLCD

See ***active matrix liquid crystal display.***

analog-digital conversion

Also called *A/D conversion*. A conversion of an analog image, such as a negative, print, or transparency, into its digital equivalent. See also ***analog-to-digital converter.***

analog-to-digital converter (A/D converter)

A device used to convert an analog subject into a digital one. A photographic example of an analog signal would be a photographic print or an analog video. The analog subject is converted to digital because a digital subject can be processed on a computer. A scanner or a digital camera could be considered an analog-to-digital converter.

anamorphic lens

A lens designed to squeeze a very wide image, thus distorting it, to fill a frame of film. This provides a higher-quality image when using an existing film size because the entire film area is used. When the image is shown at a theater, it is shown back through an anamorphic lens to unsqueeze the image and remove the distortion before the projected image hits the screen. The same is done digitally with images and movies stored on DVDs. This technique increases the apparent resolution of the images and movies played back on a widescreen without using the black bars or *letterbox format*.

anastigmat

A lens that has been corrected for astigmatism in one axis. See also ***astigmatism.***

angle of deviation

The deviation of a light ray after it has been refracted or reflected. See also ***refraction.***

angle of flash coverage

As the name implies, a number that expresses the width of the light generated by a flash. This number is often described as a focal length, as with a lens. This similarity makes it easy to see if the angle of flash coverage of a flash is large enough to cover the view of a particular lens. As long as the angle of flash coverage is larger than the focal length of the lens being used, there will be a minimal amount of light fall off on the edges of the image. Some flashes have a variable angle of flash coverage

that uses a lens to widen or narrow the angle. Other flashes have a flip-down lens that converts the flash to a wider angle for use with wide-angle lenses.

angle of incidence

The angle of a ray of light as it enters a lens. Unless the ray of light strikes the lens perpendicular to the surface at the point of entry, the light ray will refract and the angle of incidence, as well as the density of the lens material, will determine this angle of refraction. See also **angle of refraction; refraction.**

angle of refraction

The angle at which light rays bend when the light is refracted as it travels through one medium into another. This occurs when light rays enter the front surface of a lens and again when it exits. Because modern lenses are often made up of a series of lens elements, the light will be refracted as it enters and exits each lens element. See also *refraction.*

angle of view

The size of the area that can be seen by a lens. It is measured as a diagonal, angular field. The size is determined by the focal length of the lens used. A short focal-length lens is described as a wide-angle lens because it has a larger angle of view. A long focal-length lens is called a telephoto lens and has a narrower or smaller angle of view.

angstrom (A°)

A unit used to measure very small lengths, such as the diameter of atoms and the spectra of visible light. One Angstrom = 10^{-10} meters. It was named after Anders Jonas Angstrom (1814–1874), a Swedish physicist who worked with units on the order of 10^{-10} meters when he developed a chart of the solar radiation spectrum.

angular field

The field of view of a lens. See also *angle of view.*

anisotropic filtering

A computational technique used in 3D graphics to sharpen images as they recede in the distance.

anonymous FTP

FTP, or *file transfer protocol*, is a technique used to move images or other data from one computer to another. Anonymous FTP means that one computer does not need an account to connect to the other computer if the latter supports anonymous FTP. This technique is commonly used to download various types of information. In most digital photography applications, the user has an account on the other computer to upload images to a stock agency, client, or lab, for example. See also *FTP.*

ANSI

Acronym for the American National Standards Institute. See **American National Standards Institute.**

ANSI binary-coding scheme

A description of ASCII, a method by which alphanumeric characters are represented by numbers for ease in computations. See also **ASCII; American Standard Code for Information Interchange.**

anti-aliasing

A technique for reducing the effects of aliasing in images. Aliasing produces jagged edges. Softening the sharp edges of the artifacts with the use of a signal-processing filtering system can reduce these jagged edges. This makes the jagged edges much less prominent, but produces a slight blurring of the area. See also **aliasing.** *(see figure on page 29)*

anti-aliasing filter

(1) An optical filter installed directly in front of the digital sensor. It slightly lowers the high contrast areas of the image so that the digital sensor will still be able to sample the image. Since it softens the resulting image, the anti-aliasing filter is sometimes also known as a *blur filter*. (2) A software plug-in used in other software, such as Photoshop. It accomplishes the same thing by slightly blurring the edges.

anti-blooming gates

Devices placed on a CCD in between pixels to drain off additional photons once the pixel has reached its maximum value. These photons would otherwise overflow and cause surrounding pixels to reach their maximum value. If the photons overflow into the surrounding pixels, the detail in the image is reduced, causing a phenomenon known as *blooming*, as the other pixels also glow white. See also **blooming; CCD.**

anti-Newton glass

Glass used in scanning to reduce Newton rings. When negatives are scanned between pieces of glass, small air gaps form, which generate rings known as Newton rings. Anti-Newton glass prevents this phenomenon. Anti-Newton glass has been slightly roughened to keep air gaps from occurring. See also **Newton rings.**

aperture priority

A setting on an automatic camera that enables the photographer to select the aperture; the camera then selects the shutter speed. This method is used when the photographer wants to control depth of field for creative effect, either by having a large depth of field, so that most things are in focus, or a shallow one, where only one or a few things are in focus. When using this setting, watch the shutter speed and make sure to use a tripod or other support when necessary. Some cameras, if hand-held, will

Glo
Glo

anti-aliasing – The upper three letters show the jagged edges that are called aliasing. The lower three letters have been smoothed by blurring the edges in a technique known as anti-aliasing.

not warn the photographer when the shutter speed is so slow that the image is likely to be blurred.

aplanat lens

A lens that has been corrected for *spherical aberration* and for *coma*. The correction is accomplished by using two lens elements, where the second element corrects for the first element. The aplanat lens was created by Dr. H. A. Stenheil in 1866 in Germany. About the same time, J. H. Dallmeyer

invented a similar lens in England. This second lens was also called a *rapid rectilinear lens*. The *rapid* reflected the relative high-speed nature of the lens, for the time, at $f/6$ to $f/8$.

APO

An abbreviation for *aporchromatic lens*. See **apochromatic.**

apochromatic

Also called an *APO lens*. A lens that has been color corrected so that all three primary colors come to focus at the same point. This correction reduces or eliminates chromatic aberration. The lens is also corrected for spherical aberration at two wavelengths instead of the normal correction at one.

application

A software computer program used to perform a function. Photoshop is an example of an application. Digital photographers use various applications to process their images, to organize them, to back them up, and to deliver images to their clients. It is not unusual to have hundreds of applications available for use on a computer. Nearly all computers come with a variety of general-purpose applications. Digital cameras typically include several computer programs in their accessory pack.

application-specific integrated circuit (ASIC)

An integrated circuit or microchip designed for a specific application, such as a digital camera or a cell phone, rather than for a general-purpose application. Thus, a number of functions can be integrated into a single chip, which will lower manufacturing and design costs.

APS

(1) An abbreviation for *active pixel sensor.* A variant of CMOS-based sensors in digital cameras. (2) An abbreviation for Advanced Photographic System, a film format developed by Kodak that is smaller than 35mm film with a magnetic film backing to record exposure and other information to be used by the photo processors. In digital cameras, the term *APS-sized* is often used to describe an image-sensor size that is smaller than a 35mm full-frame sensor. See also **active pixel sensor.**

archival

A term applied to photographic products, usually prints or storage media such as CDs or DVDs, to indicate that they are expected to last a fairly long period of time. It is often used a marketing term without any set scientific meaning. One archival paper for producing prints might last fifteen years and another thirty, and yet they are both referred to as *archival* by their manufacturers. Accelerated testing is usually conducted to ensure the longevity of photographic and computer materials.

archival dye inks

One of four types of inks that are generally used in ink jet printers. The four types are *dye inks* (also called *dye-based inks*), *archival dye inks, pigmented inks*, and *pigment inks*. Dye inks usually have brighter, more vibrant colors than other types of ink, but are not as long lasting. Archival dye inks are those designed with special formulations to produce inks that are more fade-resistant than are regular dye inks. A British firm, Lyson, was the first to offer these inks. Their first formulations were much longer lasting, but color saturation and gamut were poor. Later formulations had better color gamut, but longevity was not much improved over regular dye inks. The term *archival* is a bit of a misnomer with regard to the ink alone. To maintain any increase in longevity, paper choice is important. Glossy and coated papers provide more gamut and much shorter longevity. Accelerated testing is usually done to test for the longevity of various ink and paper combinations.

archival image

The name given to the digital master image kept in the digital archive so that different sizes and versions can be made from it in the future. Ideally, archival images are backed up in several locations on different types of media (hard drives and DVDs, for example) to ensure their safety.

archival medium

Material designed to hold a digital image without deterioration, permanently. The material must be stored and handled under archival conditions, with special regard for light, temperature, humidity, and air quality. In reality, there is no material that meets this strict standard. Therefore *archival medium* is not a strict technical term. Instead, it is used in a casual sense to reflect a material's relatively long life compared with other types of materials. Accelerated testing is usually conducted to ensure the longevity of photographic and computer materials.

archival scans

The scan of a negative or transparency designed to act as a digital master of the analog image and replace it for future copies. This scan is done at the scanner's native resolution, which is the highest resolution possible without interpolation. See ***native resolution.***

archival techniques

The techniques used to produce archival images or prints. These include careful selection of materials used to produce and display photographs, including inks, papers, and framing materials; the choice of lighting conditions and location in which they are displayed; the determination of how they are stored when not on display; and the strategy of how the

A

originals are protected. While no technique will guarantee permanent survival without deterioration, careful planning can significantly increase the lifespan of photographic materials, including digital ones.

archive

A group of records stored together. Here it is taken to mean a group of images in digital form that is usually the complete historical collection of a photographer or organization. Ideally, this is done in a protected environment such as in a media fire-safe or off-site in a safety deposit box. Generally the word *archive* implies that it is a duplicate copy stored for safekeeping and long-term preservation, but it could also mean a single copy of all of the images stored on the photographer's hard drive.

area-array

Also called *area CCD*. The grid of picture elements, or pixels, of a CCD image sensor arranged in the form of rows and columns to form a matrix. See also **CCD; array; pixel.**

area CCD

See **area-array.**

array

The grouping of picture elements, or pixels, of a CCD. When the elements are formed in a single row, as a column or row, they are called a linear array. When there are a number of rows or columns, the grouping forms an area-array or matrix. See also **area-array; CCD; pixel.**

array camera

A digital camera designed to capture an image with a single pass or exposure that captures all three primary colors (red, green, and blue). Some cameras do not have an array of pixels designed to capture three colors, so they require three passes, one for each color, in order to complete the image capture. This is usually found only in larger-format digital cameras, such as *digital backs* for medium-format and view cameras, or in special-purpose digital cameras.

artifact

A visible defect in a digital image. When there are a number of artifacts, they are called *noise, aliasing*, or *color fringing. A*n artifact can also be a hot or cold pixel. See also **noise; aliasing; color fringing; hot pixel.** *(see figure on page 33)*

ASA

(1) An abbreviation for the American Standards Association. (2) A numerical rating of the sensitivity of a film or a digital sensor to light. The higher the number, the more sensitive the film or sensor. Typical ranges of ASA are from 25 to about 1600, although both higher and lower values are found occasionally. ASA is equivalent to *exposure index* (*EI*) and has

artifact – The single red pixel, also called a hot pixel, between the hands and the bottom of the photograph is known as an artifact.

been replaced by *ISO*. The numbers are the same in either case. See also **EI; ISO.**

A.S.A.

See **ASA.**

ASCII

See **American Standard Code for Information Interchange.**

ASIC

See **application-specific integrated circuit.**

aspect ratio

The ratio between the width (long dimension) and height (short dimension) of a photographic sensor or image. In digital cameras, typical aspect ratios are 3:2 (the same as 35mm film), 4:3, or 16:9. Common print sizes of 3 1/2 inches by 5 inches and 4 inches by 6 inches are in a ratio of 3:2 because they are often made from digital camera images. Larger and more traditional print sizes, such as 8 inches by 10 inches, are a different aspect ratio and require cropping when made from digital images. *(see figures on page 35)*

aspherical lens

A lens designed to incorporate an *aspheric lens element*, that is, one that is not spherical, in order to reduce spherical aberrations. These lenses are characterized by relatively high speed and detail sharpness because most light rays are focused at a single point no matter what angle they strike the front of the lens element. Using aspheric lens elements reduces the need for additional lens elements. See also **aspheric lens.**

aspherical surface

A surface that is not spherical. An aspherical lens is an example of an aspherical surface. See also **aspheric lens; aspherical lens.**

aspheric lens

A lens element that is not circular or spherical in shape. When a lens has an aspheric element, it is often called an *aspherical lens*. The use of the complex shape in an aspheric lens element allows for the correction of various aberrations, especially spherical aberrations reducing the use of multi-lens designs. See also **aspherical lens.**

aspect ratio – 8x10 – This image has been cropped from the original image below to create an aspect ratio of 8 x 10, a common print size used in the United States.

aspect ratio – This is the original image with its original aspect ratio of about 4 x 6 (or 8 x 12). Compare that to the figure above that is in a ratio of 8 x 10 to see the differences in cropping.

astigmatism

A type of lens aberration in which horizontal and vertical lines are not in focus at the same point. The human eye often contains an astigmatism. As many as one-third of the population suffers from astigmatism, and it tends to increase with age. Just as the proper glasses can adjust for astigmatism in the eye, lens systems can be designed to eliminate it in photographic applications. See also ***aberration.***

astrophotography

The photography of stars, planets, comets, galaxies, and other astronomical objects, usually with a camera mounted on a telescope. Most professional astrophotography has converted from film to digital capture techniques because of the greater sensitivity possible. In the past, extremely long exposures were required with film. With long exposure came the need for special tracking equipment so that the telescope could slowly rotate and follow the object being photographed. This is often not the case with digital. Digital imaging does require special post-processing techniques to reach its full potential. Some of these techniques include processing to remove light pollution and using a dark frame capture to remove noise caused by thermal issues. In some cases, the CCD is cooled to reduce thermal noise.

A to D converter

See ***analog-to-digital converter.***

auto balance

(1) A tool used in image manipulation software such as Photoshop. This function adjusts contrast and brightness to give a more pleasing result. In some cases, it adjusts the color balance and levels as well. (2) The auto white balance function found either in the camera or, later, in image manipulation software. The software in the camera or computer attempts to create a more pleasing photograph by adjusting all of the colors in the image so that the whitest color is converted to pure white and the other colors are adjusted to match.

auto batch rename

A function built into Photoshop beginning with the Browser in Photoshop 7 and continuing into later versions. Images can be selected and then renamed by various criteria. A prefix can be used, followed by incremental numbers of a variable quantity of digits, followed by a suffix. This is applied to the grouping of images, with each new image numbered and the counter incremented before moving to the next image. It is a very powerful feature to keep digital images organized. It is important when renaming images to make sure that each image has a unique name so that there will be no confusion when working on them later.

A

auto bracketing

A feature of some digital cameras that allows the photographer to set the initial exposure. The camera then automatically takes an additional series of images with greater and lesser exposure in increments chosen by the user or the camera, depending on the camera. An example would be an exposure of $1/125^{th}$ of a second at $f/8$. The camera then takes two exposures 1/2 stop and 1 stop greater than the original $f/8$ exposure, and then two exposures 1/2 stop and 1 stop under the original $f/8$ exposure. So the final exposures are $f/5.6$, $f/6.7$, $f/8$, $f/9.5$, and $f/11$. All of these images are taken in quick succession.

auto exposure bracketing (AEB)

A series of additional exposures taken around the initial chosen exposure value. See also *auto bracketing.*

auto levels

A function in Photoshop used to improve the look of an image. It works by adjusting the *black point* and *white point* of an image and then readjusting all of the pixels in between by using a function to move them proportionally in the new image. This tends to increase contrast and improve flat and washed-out images. Since it actually works on each color (red, green, and blue) individually, auto levels can be fooled by images with a predominance of a single color. In those cases it is best to turn off auto levels, adjust the image manually using the levels function, and drag each end and the middle gray sliders separately until a more pleasing image results. See also *levels.*

automatic diaphragm

Also called *automatic iris*. A diaphragm or iris that stays open while viewing through the lens and then closes down to the desired aperture before the exposure occurs. Cameras without an automatic diaphragm must have the diaphragm manually closed down after focusing and viewing wide open. There is generally a ring on the lens for this function. When the diaphragm is open, the viewfinder is brighter, making composition and focusing easier. The camera will automatically close the diaphragm when the shutter is tripped if the lens and camera are both automatic.

automatic focus

A function that enables most modern digital cameras to automatically determine the focus by moving lens elements. Many cameras allow the photographer to choose where in the image the focus point should be. The viewfinder may show four, nine, or even more focus points that can be selected by the photographer. Other cameras have many focus sensors and actually can determine where the photographer is looking and use

that point to set the focus point. This feature is called *eye control focus*.
See also ***eye control focus.***

automatic gain control (AGC)

A function in a digital camera often used to automatically prevent
overexposure by reducing the exposure. It is also used in digital video
cameras to increase or decrease exposure automatically to keep the
exposure within recordable boundaries. While it works in average
conditions, it does not work well in special lighting situations such as
back-lighting.

automatic iris

See ***automatic diaphragm.***

automatic lens

A lens that has an automatic diaphragm. The opposite of an automatic
lens is a manual lens, which requires the diaphragm to be stopped down
from viewing wide open to the proper size for exposure. In the case of a
manual lens, there usually is a ring on the lens to twist to close the
diaphragm before making the exposure. Manual lenses are usually less
expensive and are found most frequently in inexpensive telephoto lenses
and in specialty lenses. See also ***automatic diaphragm.***

automatic meter

A meter built in to the camera that has control over the aperture and/or the
shutter speed when setting exposure. The meter reads the light reflected
from the subject and sets it approximately to an 18% gray level to create a
proper exposure. This automatic meter function can be set so that it
creates an automatic exposure by adjusting both the aperture and shutter
speed, locks in a shutter speed at one value and adjusts the aperture, or
locks in the aperture at one value and then adjusts the shutter speed. The
automatic function is usually user selectable. Often, the automatic
function can be turned off or adjusted in increments for situations in
which the subject is not an 18% gray level, such as a portrait of a bride in
a white wedding dress. In that case, the exposure can be adjusted by
increments of 1/2 or 1/3 stop so the automatic feature will still operate.
See also ***18% gray; exposure compensation.***

AWB

See ***auto white balance.***

axial chromatic aberration

Also called *longitudinal chromatic aberration*. Appears in a digital image
as purple fringing. If the fringing is on all sides of an object, it is *axial
chromatic aberration*. If the chromatic aberration is purple on one side of
an object and green on the other, it is *lateral chromatic aberration*.

Another aspect of axial chromatic aberration is that it is more affected by the f-number of the lens in use. The purple fringing tends to increase as the lens is stopped down. See also ***fringing; lateral chromatic aberration.***

background processing

A function on a computer that allows the operator to continue working on one task in the foreground while the computer works on something different in the background. The computer could be printing in the background, downloading images, or backing up a disk while the operator retouches a photograph. This allows a more efficient workflow and helps to maximize productivity. The more functions the computer is carrying out, the more powerful the computer needs to be.

backing up

The process of making additional copies of images, or other data, in case one is accidentally destroyed or lost. Having one backup copy off-site helps to protect against a loss caused by a burglary, fire, or natural disaster. It is very important for photographers to back up all of their images. Digital images are actually very fragile and can be lost in a second. It is not a matter of if, but when, you will lose images. The files can be backed up on CDs, DVDs, another hard drive, or some combination of these media types. The backing-up process can be done manually or automatically. Having several backups is usually a good idea for peace of mind.

backscatter

The reflection of light from a flash off of dust particles, snowflakes, rain, or similar elements in an image. Backscatter shows up as flecks of light. The flecks can be cloned out in Photoshop or can be reduced by lighting the scene carefully so the light from the flash is not reflected back into the lens of the camera.

banding

A digital artifact or specific type of noise that often appears as noisy stripes in generally smooth areas of an image or print. Banding is usually most visible in the shadows and at high ISO settings. If the banding occurs in the original digital image, software options exist that can help eliminate or reduce the problem. Working in raw format will often help, since the photographer will have between 12 and 16 bits, instead of 8, leading to more values for each pixel. Sometimes the banding takes the form of posterization. A clogged jet or running out of a color of ink can cause banding in an inkjet print. The printer's ink levels should be checked and a nozzle check run to find the problem. See also *noise.* *(see figure on page 41)*

bandwidth

Indicates the data-carrying capacity of a network or a connection. It is usually measured as a function of time, such as bits per second (bps), megabits per second (Mbps), or gigabits per second (Gbps). This is important to digital photographers when they need to transfer a quantity of large images. They will want as large a bandwidth as possible between their source and their destination. Larger bandwidths are available over cable, DSL, and satellite than are usually available over dial-up Internet service.

banner

Commonly a rectangular headline or ad on a website. It is usually wider than it is tall and it often covers the width of the screen.

barrel distortion

A lens aberration in which straight lines in the image bend outward, creating a barrel-like look. This is most common in very-wide-angle lenses and at the widest settings of zoom lenses. It is most noticeable with straight lines within the image and especially with straight lines near the edge of the image. A fish-eye lens is an extreme example of barrel distortion. Some software tools, such as Photoshop, will help correct barrel distortion. See also *aberration.*

Base

The shortened name for base resolution. See *base resolution.*

Base/16

One of the six sizes used by the Kodak Photo CD system when scanning or digitizing photographs. It has a resolution of 1024 x 1536 pixels. The other sizes are 16 Base, 64 Base, Base/4, 4 Base, and Base. See also *16 Base; 64 Base; 4 Base; Base/4; Base; Photo CD.*

Base/4

One of the six sizes used by the Kodak Photo CD system when scanning or digitizing photographs. It has a resolution of 1024 x 1536 pixels. The

B

banding – The vertical bands of noise in this image are known as banding.

other sizes are 16 Base, 64 Base, Base/16, 4 Base, and Base. See also ***16 Base; 64 Base; 4 Base; Base/16; Base; Photo CD.***

baseline

A term used in typography to indicate the base upon which letters set. Letters that descend below the line, such as *j, p,* and *y,* will have a portion below the baseline.

base resolution

One of the six sizes used by the Kodak Photo CD system when scanning or digitizing photographs. It has a resolution of 512 x 768 pixels. The other sizes are 16 Base, 64 Base, Base/16, Base/4, and 4 Base. See also ***16 Base; 64 Base; Base/16; Base/4; 4 Base; Photo CD.***

base-stored image sensor (BASIS)

An image sensor chip used for auto focus by Canon.

basic input / output system (BIOS)

The software first run as a computer is booted up. Other software then takes over to accomplish the tasks desired. In the beginning, BIOS was stored in read-only memory. Later, BIOS was changed to firmware and stored in flash memory so it could be altered and updated as needed.

BASIS

See ***base-stored image sensor.***

batch-auto-rename

See ***auto batch rename.***

batch processing

A series of programs lined up to run through a computer system one after another. Although batch processing originally began to utilize the resources of large, expensive mainframe computers, it has moved especially into situations involving printing a number of jobs. The order and timing of the printing can be controlled with software and done as batch processing.

batch scanning

The process of scanning a series of slides automatically by the use of an automatic slide-feeder attachment for a slide scanner. The slide feeder feeds each slide into the scanner that scans the image, saves it, and then loads the next slide. Some slide mounts are slightly thicker and have a tendency to jam. It is difficult to get the best possible scan when done in a batch process because the scan is done automatically on an average basis rather than adjusting the scan for each image. If the images are sorted into similar exposures before batch scanning, this process can work well.

batteries

The electrical components used to provide the energy to power digital cameras. They produce or store energy through chemical reactions. The name of each type of battery is related to its chemistry. There are a

number of choices of batteries today, depending on the size the camera takes. Many digital cameras will take AA batteries, which provide the option of using rechargeable batteries normally, and substituting regular disposable alkaline (actually alkaline/manganese) batteries when traveling and there is no time for recharging. Among the rechargeable batteries are nickel-cadmium (NiCad) and nickel metal hydride (NiMH). The NiMH batteries generally provide better service over the long run. Some cameras will use only custom batteries made by their manufacturer. If that is the case, be sure to have backup batteries when traveling. Because the different types of batteries actually provide different voltages to the camera, cameras may require the photographer to tell it what kind of battery is being used so it can adjust for the different voltage internally. The capacity of the small batteries used in digital cameras is usually related in terms of milliampere-hours, abbreviated as mAh. The rechargeable batteries lose their charge fairly quickly compared to an alkaline type of battery. While an alkaline AA battery can be good for years, rechargeable batteries can lose their charge at rates up to 3% per day. Typical rechargeable batteries can be recharged hundreds of times. *(see figure below)*

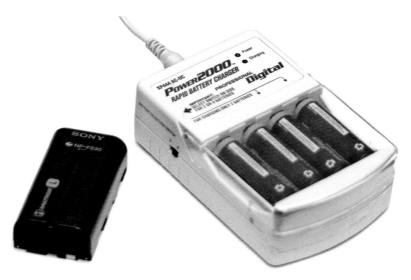

batteries – These are samples of two types of batteries. The battery on the left is a lithium-ion rechargeable battery that is commonly used in digital cameras. The battery charger on the right is holding four AA nickel-cadmium rechargeable batteries.

battery memory

The tendency for the performance of a rechargeable battery to deteriorate over time with use. This is believed by many to be caused by a failure to discharge a battery completely before recharging, which disables the battery from holding the same amount of charge. Although this was true with older types of batteries, modern batteries suffer from a phenomenon known as *voltage depression*, which is often incorrectly called *battery memory*. Improper charging, rather than improper discharging, usually causes this phenomenon. Voltage depression is also usually confined to NiCad batteries, not Li-Ion or NiMH.

baud

One symbol transmitted per second where a symbol can be an ASCII character, for example. A symbol is sometimes called a signaling event. A symbol is often more than one bit so a baud is often more than one bit per second. See ***baud rate.***

baud rate

The speed at which symbols (or characters) can be sent. By convention, a baud is one symbol or one signaling event per second. Since baud rate does not tell how much information each symbol holds, it does not make clear how much data is being sent. As an example, if each symbol can represent only 1 bit, then a rate of 1,000 baud is equal to 1,000 bits per second. If, on the other hand, each symbol can represent 4 bits, then a rate of 1,000 baud is equal to 4,000 bits per second. At one time, computer modems were rated in *baud*, but now *bits per second* is used because it more accurately depicts the amount of data or information that is being translated.

Bayer array

Refers to a color filter array arranged in a Bayer pattern. See ***Bayer pattern.***

Bayer pattern

The pattern of red, green, and blue (RGB) filters arranged on a digital sensor. It is necessary to have a way to distinguish the various colors when a single sensor or chip is used. Eastman Kodak scientist Dr. Bryce E. Bayer invented the particular arrangement of filters that takes his name. The Bayer pattern was patented in 1976 and is the basis for nearly all digital camera sensors. The unique part of the Bayer pattern is the way in which the colors are split. 25% of the elements are red, 50% are green, and 25% are blue. This proportion is used to reflect the way in which the human eye works, as it is more sensitive to green. Each of the elements is a pixel and represents only one color. Software in the camera, or later in the computer in the case of raw files, interpolates the single-color-per-pixel data to calculate three colors for each pixel. This software is known

as *demosaicing software*. The Foveon sensor is one of the few sensors that does not use a Bayer pattern. See **demosaicing; raw; RGB; pixel; Foveon sensor; digital sensor.**

BCPS

See **beam candlepower seconds.**

beam candlepower seconds (BCPS)

A numerical rating of the light output of an electronic flash when its light is focused into a beam. See also **effective candlepower seconds.**

beam splitter

Splits the incoming light into several equal portions in some digital cameras. Each portion of light is then sent to a different set of image sensors, usually one for each primary color (red, green, and blue). The three separate images are then combined to make a full-color image. This technique is usually found only in expensive cameras. The beam splitter often consists of prisms or half-silvered mirrors.

beta version

When software is being developed, the first version of the software, which often has bugs, is given to small, select, and knowledgeable groups of users. This is known as the *alpha version* of the software, and during this phase new features are still being added. Later, when the product is working well, most known bugs have been fixed, and the feature set is somewhat fixed, a second release of the software is made available to a wider group to look for more bugs and operational difficulties. This is known as the beta version. Most users will never be exposed to alpha versions of software. Since beta versions of software are released in a more public way, digital photographers will have a chance to use beta versions from time to time. It is important to remember that the software is not fully functioning and tested, and may have more problems than final-release versions. Appropriate safeguards and backups should be in place whenever beta software is being used. Photographers should never use beta software on their original images, only on copies of original images. If you assume that the beta software will destroy your images and take appropriate precautions, you will be safe. See also **backing up.**

Bézier curve

Mathematical function used to create smooth curves between points. The curves are known as vectors and the points are called nodes. An image created with these curves or vectors is called a *vector graphic* or *vector image*. In contrast to a vector graphic is a *raster image*, assembled from discrete elements called pixels. Vector images have the unique ability to be scaled upward without any loss of quality. The Bézier curve is always smooth. Raster images will pixelate if enlarged too much. For simple

images, vector images will have much smaller file sizes as well. See also *vector image.*

bicubic interpolation

A method of averaging adjacent pixels to create new pixels in between. Bicubic interpolation uses the values of surrounding pixels in its calculations in a weighted average where the closest pixels are given more weight than those farther away. This is one of the most popular methods of producing additional pixels when an image is enlarged in size. Compared to other interpolation methods, this bicubic takes longer to compute, but is generally a better representation of the original. There are now several versions of bicubic interpolation available in Photoshop: *bicubic smoother*, which is designed to make more-pleasing enlargements of images; *bicubic sharper*, which is designed to make more-pleasing reductions of images; and the original bicubic interpolation.

big data

A Photoshop term referring to any image information that exists in a layer but falls outside the dimensions of the document so that it is not visible. Certain image formats, such as TIFF, PSD, and PDF, will save the data even though it is not visible. By expanding the canvas, the photographer will be able to view the big data. See also *canvas size.*

bilevel

Refers to a black-and-white image in a bitmap format. *Bilevel* refers to whether a given pixel should be black or white. It is often used in scanners.

bilinear filtering

A filtering or interpolation technique used when enlarging or reducing the size of an image. Two other techniques are *nearest neighbor* and *bicubic*. Bilinear techniques work satisfactorily only when a dimension of an image is halved or doubled. Outside of that range, bilinear filtering interpolation breaks down and other techniques work better. See also *bicubic interpolation.*

bilinear interpolation

A method of creating additional pixels by interpolating from four other pixels. It is not as widely used as *bicubic interpolation* when enlarging an image. See also *bicubic filtering.*

binary

Also known as *base 2*. Computers, and therefore computer images, are based at some point on the use of a binary numbering system. In a binary numbering system there are only two numbers: *zero* and *one*. This can translate to an image of being black or white. All digital imaging is based on a binary system.

binary digit

Also called a *bit*. A number that is either *zero* or *one*. A binary digit is made up of a number of bits. See also **binary.**

binary number system

Also called *base 2*. A numbering system composed of only *zeroes* and *ones*. It is widely used in computers, but the numbers are usually converted to our normal numbering system—base 10—before being displayed.

binning

Combining the charges of several adjacent pixels. This is done to increase the sensitivity in low light situations. These combined pixels are represented by a single, larger pixel known as a super pixel. *1 x 1 binning* uses the value from a single pixel. *2 x 2 binning* combines the charges of four pixels located next to each other in a 2 x 2 array as a single super pixel. The resulting combination is four times more sensitive than the single pixel, but resolution is also cut in half. See also **pixel; super pixel.**

bit

See **binary digit.**

bit depth

The number of bits used per pixel to represent the color of the pixel. In digital photography, the most common bit depth is 8 bits per channel per pixel. With the three RGB colors (3 x 8 = 24), there are 24 bits for the three channels. Bit depth is also known as *true color* or *millions of colors*. Higher-end cameras and scanners use 12 bits per channel, which are represented in 16 bits of data per channel. The extra 4 bits are ignored. See also **true color.**

bitmap

A raster graphic in which each bit is mapped to a rectangular grid of pixels. In digital photography, each pixel is represented by 3 bytes, one each for red, green, and blue (RGB). A bitmap is represented by the total number of pixels and the *bit depth*, or number of bits per pixel. The total number of pixels is calculated by multiplying the number of pixels in the height by the number of pixels in the width of the bitmap. The number of bits per pixel determines the number of possible color combinations.

bitmap images

See **bit-mapped image.**

bit-mapped

Graphics or images that have been processed and converted to a bitmap. See also **bitmap.**

bit-mapped image

An image that has been converted to a bitmap. See **bitmap.**

bitonal black / bitonal

An image with either black or white pixels. Bitonal black is such an image with black pixels. Bitonal scanning is used with documents where each pixel should be either black or white.

bits per inch (bpi)

A measurement used with scanners to indicate resolution. The term is used less frequently than the correct term: pixels per inch (ppi). This term is also used to indicate the resolution of a bitmap image in bits per inch.

bits per second

Also called *baud*. Data transfer rate. See also **baud rate.**

black limit

In printed documents, the percentage of black ink used from 0 to 100%. This limit is assigned in Photoshop when converting *RGB* images to *CMYK* images before printing with a four-color printing process. See also **RGB; CMYK.**

black noise

Noise that has a low power rating. That is, noise that is predominately black with a few white or other-colored dots mixed in randomly. Black noise can occur when scanning a pure black image. See also **noise.** *(see figure on page 49)*

black point

The darkest point in an image. Typically, this should be pure black, with the three colors—red, green, and blue—equaling 0 (RGB=0,0,0). The black point can be seen by opening an image in Photoshop and looking at the histogram in *Levels*. The farthest point on the left of the curve is the black point. The placement of this black point can be adjusted with the black point slider just underneath the curve.

black point compensation (BPC)

Used when converting an image from one color space to another. If black point compensation is enabled, then white is mapped to white in the new color space and luminance of black is mapped to luminance of black. During the conversion, software using BPC evaluates the source and destination of black points and adjusts them such that the blacks will not be blocked in or washed-out in the final converted image.

bleed

(1) A photographic print that has no borders. The image goes to the edge of the paper. (2) Refers to colors that spread or bleed into each other due to an exposure error, the malfunction of a printer, or the texture of the paper being printed mixing with ink.

blend

The process of gradually changing one color or brightness level into another. For example, when retouching on a person's face, the

black noise – The random colored dots in this figure are colored pixels that have turned on without light falling on them, resulting in a type of noise is known as black noise.

photographer's brushes should be set so they blend or gradually change the effect of the brush from 100% in the middle to 0% at the edge. This method will make retouching look smooth and well blended.

blend mode

A Photoshop term used to describe how a tool operates on the current layer. There are a number of different ways that the tool can work on the

data. Some of the blend models include: *normal, dissolve, behind, clear, darken, multiply, color burn, linear burn, lighten, screen, color dodge, linear dodge, overlay, soft light, hard light, vivid light, linear light, pin light, difference, exclusion, hue, saturation, color,* and *luminosity.* Each blend mode will blend the data in a different way.

blocked up

A lack of detail in the shadows of a photograph. Because of a lack of dynamic range of the digital sensor or scanner, it is difficult to obtain detail in both shadow and highlight areas simultaneously with a single exposure in a scene that has a wide range of light values . Sometimes multiple exposures can be taken and combined to extend the dynamic range and gather more detail in both the shadows and highlights. See also **dynamic range.**

blockiness

A softness, or pixilation, of an image that loses detail. Compressing an image too much or repeatedly when creating a JPEG image can cause blockiness.

blooming

A type of image distortion caused when charges from one pixel leak to an adjacent pixel in a CCD. Blooming occurs when the amount of charge that one pixel receives is more than it can store. Anti-blooming gates are used on some CCDs to counteract this distortion. The anti-blooming gate drains the excess charges away from each pixel to keep it from overflow-ing. This process has helped, but there are still situations in which a bright edge is next to a dark edge and the blooming, which looks like a white halo or streak in the dark areas, occurs. This effect may cause the purple halos or lines of chromatic aberration to become more visible as well. See also **chromatic aberration.**

blown out

The lack of detail in the highlights caused by overexposure. In a photo-graph, this condition shows up as areas of the image that are pure white. *(see figure on page 51)*

blue

One of the three primary colors used in digital photography. The other two colors are red and green. Together, the three make up the RGB image format. See also **RGB.**

Bluetooth

A wireless technology designed to transmit data. Some digital cameras now come equipped with Bluetooth technology to enable them to transmit images directly from the camera to a laptop or other Bluetooth-equipped device. Such a process could enable a client to sit at the photographer's

blown out – The highlights in this figure have no detail and are very large, and are called blown out.

laptop and see each image immediately after it was created, ensuring that the client's needs were being met, as well as avoiding costly reshoots and making for a smoother workflow.

blur

(1) Occurs when sharp lines in the subject matter of an image are not sharp in the resulting image. This can be caused by camera movement that creates motion blur or by incorrect focus. Blur can be purposeful, for creativity, or it can result from error. (2) The process of using the Photoshop blur tool. This tool is used for creative effect. See also *Bokeh; blur tool.*

blur tool

A tool in Photoshop designed to blur parts of an image in a localized manner. The photographer can control the amount and location of blur desired. The blur tool can be used to smooth out areas in an image; it can be used creatively, by blurring parts of an image to focus more attention on the sharper parts of an image; or it can be used to remove distracting elements.

BMP

A file format for images used internally by the *Microsoft Windows graphic subsystem* (GDI). BMP is a bitmapped graphics format that is uncompressed and generally used for simple graphics. A BMP image can use a variety of color depths—from 2 to 32. See also *color depth.*

Boke (pronounced bow-keh)

Boke is the English transliteration of an abbreviated form of the Japanese term *boke-aji*. The term is now usually known simply as *bokeh*. See *bokeh.*

boke-aji (pronounced bow-keh-ah-gee)

See *bokeh.*

bokeh (pronounced (bow-keh)

Sometimes spelled as *bookeh*. B*okeh* is the English spelling of a Japanese word that means *fuzzy* or *blurry*; in photography, it refers to the out-of-focus area of an image. Specifically, it refers to the beauty and aesthetic quality of this portion of an image. The original Japanese word is *boke-aji*, which was truncated to *boke*. In March 1997, Mike Johnson, editor of *Photo Techniques* magazine, added an *h* to *boke* to make *bokeh*, so that readers would pronounce it correctly, instead of rhyming it with *joke*. The spelling stuck and has been used by most photographers since then. A photograph is made of what is in focus, usually the subject, and the area that is out-of-focus, usually the background and foreground. When the out-of-focus area is attractive—not what is out of focus, but the way it is out of focus—it is said to have good *bokeh*. The lens and the style of the

bokeh – The background of this figure shows out of focus highlights known as bokeh.

photographer determine the actual *bokeh*. Photographs created with a wide-angle lens, for example, usually have very little out-of-focus areas, and thus little *bokeh*. Telephoto lenses tend to isolate the subject; the background and foreground are more likely to be out-of-focus. Mirror telephoto lenses are generally thought to have unattractive or bad *bokeh* because of the shape of their circles of confusion, which look like donuts. These blur circles are the out-of-focus areas in the image created by all lenses. They are usually dark with light edges (bad *bokeh*) or light circles with dark, diffuse edges (good *bokeh*). Both the coloring of these circles as well as the sharpness of their edges affect the *goodness* of *bokeh*. These circles are different due to the construction of lenses and their spherical aberration. Generally, due to the way that circles of confusion are rendered in the image, a lens will have either good *bokeh* in the background and bad *bokeh* in the foreground, or the other way around, but not both. Since most people prefer out-of-focus backgrounds to out-of-focus foregrounds, a lens with good *bokeh* is one that produces good *bokeh* in the background. Some photographers are skilled at using good *bokeh* to enhance their images. See also **circle of confusion; spherical aberration.** (see figure above)

Bookeh

See *bokeh.*

boot

The process of starting a computer. When a computer is first started, it has to go through a series of internal operations before it is ready to be used. While in this state, which can last from a few seconds to a few minutes, the computer is said to be booting up.

boot time

The amount of time taken for a computer to become operational once it has been turned on. That is, the period of time that the computer remains in the boot stage.

bounce flash

The process of aiming the flash at a nearby surface such as a ceiling or wall instead of the subject. This tends to make the light wrap around the subject and reduce the harshness of the shadows. When using bounce flash, more power is required than when using a direct flash, but the former produces a very soft light. Some flash units have *flash heads* that can rotate to make this easier. The flash sensor still points at the subject, but the flash points up or to the side to bounce it. Since the flash sensor still points at the subject, any automatic feature of the flash should still work. The flash-to-subject distance on a bounced flash must be measured from the flash to the bounce surface, and then from the bounce surface to the subject. See also *flash.* (see figure on page 55)

BPC

See *black point compensation.*

bpi

See *bits per inch.*

bps

See *bits per second.*

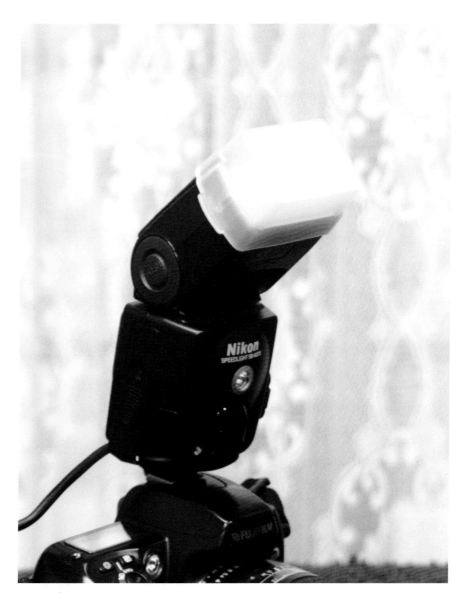

bounce flash – The flash head on this electronic flash is pointed upward at an angle. When the flash is fired, the light will bounce off of a surface before striking the subject, a technique known as bounce flash. The white cover on the head is a diffuser to soften the light.

bracketing

Taking multiple images of the same subject by varying the exposure in various increments above and below the determined exposure. This is done to make sure the "correct" exposure is found, especially under difficult photographic conditions. It is also used to provide additional exposures that can be combined to increase the dynamic range and to provide detail in both the shadow and the highlight areas of an image. Some cameras have the capacity to bracket automatically and in quick succession. See also *HDR.* (see figure at right)

bracketing – This is a series of photographs of the moon all combined into one figure. Each exposure is one half f-stop darker (less exposure), starting at the top and working down, illustrating a process is called bracketing.

B

Brewster's angle

Also known as *polarization angle*. Represents the angle of incidence of light that produces the most polarization of the light. When light strikes a surface, a portion of the light is reflected. This reflected light is polarized by the reflection process. The Brewster's angle is dependent upon the refractive index of the material. See also *refraction.*

brightness

The intensity or strength of light in an image. In digital photography, brightness is the numerical value of a pixel. Typically these values range from black (0) to white (255) in an 8-bit pixel where 0 is the smallest brightness and 255 is the highest.

brightness range

The range in values in a scene to be photographed from the brightest highlights to the darkest shadows.

British Standards Institution (BSI)

Part of the BSI Group, which is responsible for determining a number of standards for the United Kingdom. The standards set are similar to those of the American Standards Association, for the United States, and those of the ISO, for worldwide standards. See also *American Standards Association; ISO.*

browser

A piece of software used to visit and search websites. A browser can also be used to view digital images on a CD, such as when images are sent to clients. Some common and popular browsers include Internet Explorer, Safari, and Firefox. Many others are also currently in use.

BSI

See *British Standards Institution.*

buffer

In a digital camera, memory where images are stored temporarily after they are taken and until they can be written to the memory card. Having a large in-camera buffer allows the photographer to continue photographing faster than the memory card can write the images. The larger the size of the image, the larger the buffer needed. Printers also have hardware buffers to store images, or they use buffer space on a computer in a

software program called a *print spooler.* CD and DVD burners also use a buffer to keep the burning process smooth. See also ***buffer ram.***

buffer ram

Hardware buffer, such as a memory chip in a digital camera. See also ***buffer.***

bug

An error in a computer software program. The term came into being on September 9, 1945, at 3:45 p.m. at the Harvard Computation Laboratory when Lieutenant, Junior Grade Grace M. Hopper, later a rear admiral, traced a problem the laboratory was having with the Mark II computer to a moth that had gotten caught between two relays. Laboratory technicians removed the moth and taped it into their log book (which is why we can date the expression so precisely). The computer began operating properly once again. Ever since then, a computer or a piece of software that is not operating properly is said to have a bug in it.

burning

The term used for the process of creating a CD or DVD. It is so called because a laser is used to burn holes in a dye base that is sandwiched between the pieces of plastic that make up a CD or DVD. See also ***CD; CD-R; DVD.***

burning in

Refers to a process of giving a portion of an image more exposure to bring out more detail. When working with negative materials, burning in will give more detail in the highlights; when working with positive materials, it will give more detail in the shadow areas. Photoshop has a burn-and-dodge tool that allows this effect to be applied to digital images. In the days of film, the photographer's hands were used to burn and dodge an image in an enlarger. This is why the digital burn-and-dodge tool in Photoshop has icons that look like hands. See also ***dodging.***

burst mode

Also known as *continuous mode.* A digital camera mode that fires a series of images quickly when the shutter is pressed. This feature is useful for studying events that happen quickly and in such areas as sports photography. The camera will continue taking photographs, as long as the shutter release is pressed, until the camera's buffer is filled. This is why the specifications on digital cameras indicate the speed in frames per second for a set number of frames. See also ***buffer.***

bus

(1) A signal path between multiple devices within a computer or on an integrated circuit. (2) A wire bundle or cable. (3) A pathway on a circuit board.

byte

A measure of storage in a computer or memory chip. A byte could also be described is a group of bits. By convention, a byte is now recognized as being made up of 8 bits. Since a bit can have two values (0 or 1), a byte that is made of 8 bits can have 2^8 values. That is, a byte can have values from 0 to 255, or a total of 256 different values, which is also 2^8. When prefixes are added, such as *kilo, mega,* and *giga*, the term is widely used in digital photography to measure the storage capability of hard drives and memory cards. See also **kilobyte; megabyte; gigabyte.**

cache

Data that is temporarily stored in a special area in a computer to make access to it faster. Sometimes this data is the result of calculations, and storing it saves the computer the time necessary to recalculate it. Caches are often used with image files. For example, information about images such as rotations or ratings maybe cached, which speeds up subsequent viewing of those images.

cadmium sulfide cell

See **CdS cell.**

calibration

The process of adjusting imaging equipment, such as cameras, scanners, monitors, and printers, to a standard that enables the image to look the same on all calibrated monitors and printers. Calibration needs to be done on a regular schedule, since equipment changes over time. When calibrating a monitor a calibration device called a *puck* is attached to the monitor screen and a software program is run to generate colors that are read by the puck. The software generates a profile that is applied to the monitor so that it will display in a standard way. A scanner can scan a standard color chart to accomplish the same thing. Calibration of other devices works in a similar manner.

calibration bars

Standardized bars printed on images or color separations to assist in confirming that the process is properly calibrated. These calibration bars are often a standard 11-step grayscale that prints from 0 percent to 100 percent in 10 percent increments. On color separations, a color calibration bar is printed. These calibration bars can be checked with a *densitometer* for accuracy. See also ***calibration.*** (see figure on page 61)

camera

A device designed to capture images. In its most basic form, the camera has an aperture to allow light to enter a chamber, a shutter to control the period of time that the light enters, and some kind of mechanism to fix the image in a more permanent form. This mechanism can be film or a digital sensor. The aperture can be a simple pinhole or an adjustable diaphragm that can be changed in size to allow more or less light in. In front of the aperture there is usually also a lens, to provide more adjustment over image size and angle of view. The shutter can be a simple flap, a focal plane curtain, or a series of overlapping leaves. In each case, the shutter is designed to control the amount of time that light can enter the camera. In addition to these basic requirements, some sort of viewfinder is included so that the image can be composed. In the case of a digital camera, this viewfinder can be an optical viewfinder that either looks through the main camera lens, as in the case of an SLR, or through a smaller separate lens. Digital cameras often also have an electronic LCD screen. This LCD screen can be active and used to compose the image, or it can be used after the image is captured to view the resulting digital image. See also ***LCD; aperture; diaphragm; viewfinder; image sensor; lens; shutter.***

camera profile

An adjustment applied to images with software after they are captured in order to provide more accurate or more pleasing color. Each camera sensor sees light just a little differently, which why camera profiles are useful. Various companies offer camera-profiling software. A standard target, such as a Macbeth color chart, is photographed with even lighting under controlled conditions, and the camera-profiling software uses the image of the color-chart target to create a profile that will work for that specific camera. Some photographers like to create a different profile for each kind of lighting, such as daylight, room light, theater light, and so on. Other photographers are satisfied with a single profile. See also ***camera; Macbeth color chart.***

camera raw

Another way of saying a raw, unprocessed file from a camera. It is usually called a raw file. See also ***raw.***

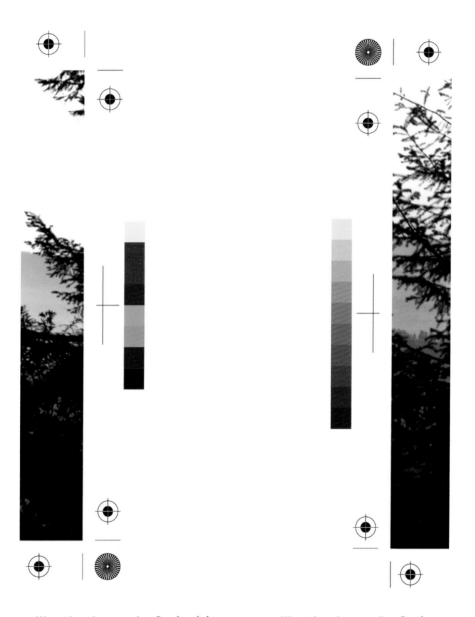

calibration bars – 1 – On the right side of this figure is a series of color bars that are used for calibration when printing.

calibration bars – 2 – On the left side of this figure is a series of grayscale bars that are used for calibration when printing.

candela (cd)

The base unit of luminous intensity in the SI measurement system. It has been defined by the 16th General Conference of Weights and Measurements since 1979 as: "The luminous intensity, in a given direction, of a source that emits monochromatic radiation of frequency 540 x 10^{12} hertz and that has a radiant intensity in that direction of 1/683 watt per steradian." The frequency chosen is a green that the human eye is most sensitive to. A common candle produces about 1 cd, while a 100-watt light bulb produces about 120 cd. See also ***candle-meter; lux.***

candle

Natural light producing object that creates light by burning various materials such as paraffin, beeswax, and plant waxes. A candle that produces a luminous intensity of about one candela is known as a standard candle. At one time the intensity of light was stated in terms of candlepower. This term has been replaced by candela. *See also **candela.***

candle-meter

Also called a *lux* or *meter-candle*. A unit of measure for illumination equal to one lumen per square meter, which is the amount of light measured one meter away from a single, standard candle. A single, standard candle produces one candela. See also ***candela; lux.***

candle meter second

Also known as *lux-second*. A unit of measure for the amount of illumination during an exposure, equivalent to one candle-meter per second, . See also ***candle-meter; candela; lux.***

canvas size

(1) The size of the *work area* when working on an image in a software program. The work area often has the same dimensions as the image, but that is not necessary. The canvas size can be enlarged without changing the size of the image. (2) A command in Photoshop to change the canvas size. The canvas is often enlarged so that the borders can be stretched with *cloning* or by adding graphics around the borders of the image.

capacity

Short for *storage capacity*. The amount of space that exists on a hard drive or memory card. Capacity is usually measured in MB or GB, although it could also be stated as the number of photographs that could be added to a memory card in a camera.

caption

(1) A short description of the contents of a photograph. (2) The name of a field in the metadata of a digital photograph, where the caption is stored so that it can travel with the image. See also ***metadata.***

capture

Also called a *digital capture*. To take or create a photograph.

card

A shortened name for *memory card*. See ***memory card.***

card reader

A small device that attaches to a computer enabling the camera to download images. The card reader usually attaches to the USB or FireWire port on a computer. Besides reducing wear on a camera, using a card reader allows the photographer to continue photographing while the images are being transferred. This is especially useful when taking photographs on location. *(see figure below)*

card reader – Two card readers are shown here. The reader on the left can read many different kinds and sizes of memory cards including the xD-card shown with it. The reader on the right reads only CF cards and microdrives, and is shown with a CF card.

cascading style sheets (CSS)

A language used to describe a document's font, color, layout, and other features. This language is used primarily when using the HTML language layout of web pages. CSS is known as a stylesheet language. Not all browsers, including some of the most popular ones, support some of the features of the latest version of cascading style sheets: *CSS2*. This limits the ability of all web visitors to see what the authors intended. This limitation should be kept in mind when designing a web page.

catadioptric lens

More commonly known as a *mirror lens*. *Catadioptric* refers to optical systems that are made up of both mirrors and lenses. Mirror lenses actually include both, even though the name doesn't suggest it. Catadioptric lenses are much lighter and shorter than the equivalent, traditional telephoto lens, but they usually lack the speed and adjustable diaphragm of the latter.

cataloging

The process of logging and organizing a collection of images. Cataloging usually involves naming in a unique way, assigning keywords to the metadata, and storing in an organized manner. All of these features make it much easier to find a specific image later. Specialized software exists to help with cataloging.

cathode ray tube

See *CRT.*

CCD

An abbreviation for *charge coupled device*. An image sensor, made up of an array of pixels, in a digital camera. The pixels send electrical signals to the camera's processor, thereby creating an image. See also *active pixel sensor; array.*

CCD raw format

Also called *raw format* and *CCD raw image format*. The recording of the unprocessed data from an image sensor. CCD raw format needs to be converted into a more common format using special software. See also *raw format.*

CD

An abbreviation for *compact disc*. Also called *optical storage disc*. A thin, plastic disc with a metal coating, about 4.75 inches in diameter, used for digital storage of music, images, or data. The CD was originally designed as a method to store and distribute music. CDs can hold up to either 650 MB or 700 MB of digital data. *(see figure on page 65)*

CD burning

The process of creating a CD. See also *burning.*

CD – A gold, archival CD is shown in the image. It has no printing on the surface to help protect its longevity.

CD-R

An abbreviation for *compact disc – recordable*. A variation of the CD audio disc designed to hold music, images, or data. CD-R is often referred to simply as a *CD*, but *CD-R* is the correct term. The lifespan of a CD-R can vary from a few years to hundreds of years, depending on the quality of the disc and storage conditions. The cheapest discs use cyanine dyes and are not stable, so they have a short lifespan. Longer-life discs are made from azo dyes and can last several decades. Phthalocyanine dyes are used in CD-Rs with the longest lifespans. Although the discs

with the longest life are usually gold in color, color cannot be used as a guide, since manufacturers will dye their cheaper discs to make them look more like the long-life discs. See also **CD.**

CD-rewritable (CD-RW)

A CD-type of optical disc that can be rewritten usually up to one thousand times. It usually takes longer to create a CD-RW than a CD-R. Since CD-Rs are so inexpensive, and DVD-Rs, which hold more data, are also relatively inexpensive, CD-RWs are not used as often. Also, a primary purpose of CD-Rs is to store data permanently; having a format that can be changed is not as useful. See also **CD; CD-R.**

CD-ROM

An abbreviation for compact disc – read only memory. Also called *CD* and *CD-R*. See **CD; CD-R.**

CD-RW

See **CD-rewritable.**

CdS cell

An abbreviation for *cadmium sulfide cell*. A light-sensitive cell, or photo resistor, used to measure light in cameras and light meters. The more light that falls on the cell, the lower the resistance of the cell and the more energy it can pass from an external source, such as a battery, to the meter.

Celsius (C)

The unit of temperature used in the SI measurement system. In the Celsius temperature scale, the freezing point of water was defined as $0°$ C and the boiling point of water at $100°$ C until 1954, when the definition was shifted slightly to make the reference points more uniform. Anders Celsius first proposed the scale in 1742, hence its name. Until 1948 Celsius was referred to as *centigrade*. Even after nearly sixty years, the term *centigrade* is still used in many places. The full name of the term is *degree Celsius*. In the United States, the temperature scale more commonly used is Fahrenheit. See also **Fahrenheit.**

centigrade

See **Celsius.**

central processing unit (CPU)

Also called *processor*. The brains of a computer. The CPU is the component of a computer that processes instructions given to it by a computer program. Some CPUs are manufactured on a single chip. These are called *microprocessors*. Digital cameras usually contain microprocessors to convert the signals from the image sensors into an image.

Centre Internationale D'Éclairage (CIE)

As the name implies, an international organization located in Vienna, Austria. The CIE develops methods and specifications for color measure-

ment. It was the organization that developed the *LAB color space*. See **L*a*b*; Lab color.**

Centronics port

Also known as a *Centronics printer port*. Centronics developed the original standard parallel printer port or interface. Over the years this interface has evolved into the printer interfaces currently in use, but it still often referred to as a Centronics port.

CF

See **CompactFlash card.**

CF 3.0

The current standard for CompactFlash cards using flash memory. Cards manufactured to this standard can offer internal speeds of up to 66 MB/second and storage capacities up to 137 GB.

CFA

See **CompactFlash Association; color filter array.**

CF card

See **CompactFlash card.**

CF I

Is a type of CompactFlash card that is 43 mm by 36 mm by 3.3 mm thick. They can be read in a CF II slot by means of an adapter. See **CompactFlash card.**

CF+ II

A standard for microdrive image storage. CF=II specifies a size of 43 mm by 36 mm by 5 mm. The + in the standard indicates that it is for a microdrive. Microdrives will fit into the same slots that take *CF II cards*, the most common memory card in use in digital SLR cameras.

C.Fn.

See **Custom Function.**

channel

(1) One of the three colors (red, green, or blue) that make up a color image. (2) A grayscale image made up of the information from only one of the color channels. In Photoshop, with an image open, by opening the *channel mixer* (Window>Channels) and clicking on each channel individually, the photographer can see the three grayscale images with each one based on a different color channel. Opening each grayscale image, the photographer can see the differences in the information stored in each channel. If working with just a grayscale image, there will be only one channel. An RGB image will have three channels, a CMYK image will have four. See also **RGB; CMYK; grayscale.**

channel mixer

A function in Photoshop that allows the photographer to display and process or adjust each channel or color individually. Techniques are

available in the channel mixer to create black-and-white images from color images with a great deal of control. See also **channel.**

charge-coupled device

See **CCD.**

chiaroscuro

A lighting feature in both painting and photography that emphasizes a strong contrast between light and dark. It is often created by using Rembrandt-style lighting. It is a desirable feature because of the dramatic effect and the impact it creates.

chimping

A new term that describes photographers using, for the first time, the LCD display screen on the back of their digital cameras to view all of the images they have just created. They are so excited that they exclaim "ooooh, ooooh, ooooh," making a sound like a chimp. The term is now generally used for reviewing the images during a photography session.

chip

A common term for an integrated circuit or I/C. See **integrated circuit.**

chipset

A group of chips, or integrated circuits, that work together to perform an action. See also **integrated circuit.**

chroma

(1) An abbreviation for *chromatics.* Chromatics is the science of color. (2) An abbreviation for chrominance. (3) The color information (*hue* and *saturation*) in a video signal. The other information is the black and white that is called *luma.* (4) The degree of brilliance of a color or intensity.

chromatic aberration

Also called *color fringing.* A type of aberration in a lens in which different wavelengths of light are refracted, or bent, to different degrees as the light passes through the lens. This phenomenon causes color fringing or shadowing in color images and a general fuzziness in black-and-white photographs. There are two forms of chromatic aberration: longitudinal, also called *axial*; and lateral, also called *traverse.* Achromatic and apochromatic lenses correct for chromatic aberration. See also **achromatic; apochromatic; longitudinal chromatic aberration; lateral chromatic aberration.** (see figure on page 69)

chromaticity

The quality of a color based on its *saturation*, or purity, and its *hue*, or dominant wavelength.

chromaticity diagram

A diagram of chromaticity derived from the CIE 1931 XYZ color space developed by the CIE in 1931. This color space is the standard reference

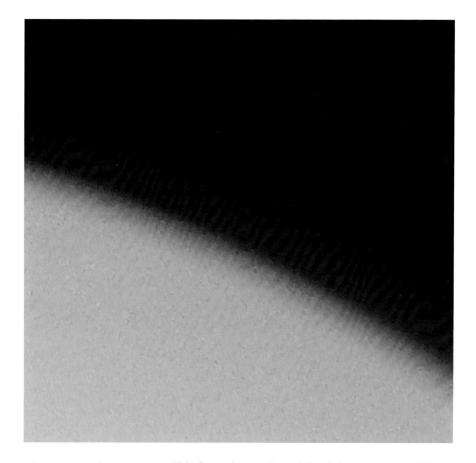

chromatic aberration – This figure is an enlarged detail from an image. The purple band is a color shift known as chromatic aberration.

for defining colors. The diagram is based on measurements of human metameric color matching. Taking into account the way that human vision works, it causes the graphing of the color space to be a three-dimensional figure. The chromaticity diagram consists of the plot of hue and saturation at a constant and maximum intensity. It is a veritable slice through the three-dimensional color space. See also *chromaticity; color space.*

chrominance
 See *chroma.*

CIE

See ***Commission Internationale de l'Eclairage.***

CIE LAB

A color space developed by the Centre Internationale D'Éclairage (CIE). The actual name is *CIE 1976 L*a*b**. CIE LAB was designed to be a perceptibly linear space so that a change in color value would make a similar change in visual importance. It is also designed to mimic human color vision. The "L*" stands for *luminosity*. One color axis is represented by *a** and the other by *b**. See ***CIE, L*a*b*.***

CIFF

An abbreviation for *camera image file format. A*lso known as *digital still camera image file format*. Also refers to *exchangeable image file format for digital still cameras*, or *EXIF*. CIFF was first published in 1996 as the standard for EXIF. See ***EXIF.***

circle of confusion

When a lens is operating properly, subjects that are perfectly in focus should come to a point at the plane of the sensor. This is known as the *focal point* of the lens. Subjects closer or farther away will not be in as good of focus as the main subject. Instead of coming to a point at the sensor, the subjects create a small circle or other shape depending on the lens and aperture configuration. If the circle is sufficiently small, the subject is considered to be in focus. As the circle grows larger, due to subject distance from the lens, it becomes more noticeable. This circle is known as a circle of confusion. The range of distances of the subject from the lens when the circle is small enough not to be noticeable is known as the *depth of field*. The largest circle of confusion still considered acceptably small, such that the subject is in focus, is known as the *maximum permissible circle of confusion.*

circular polarizing filter

One of two types of polarizing filters. The other is known as a *linear polarizer*. Circular polarizers are needed for cameras with automatic focus or through-the-lens metering. Even though circular polarizers are more expensive and not generally as effective as linear polarizers, they are required for most cameras. Linearly polarized light will not work well with automatic focus or through-the-lens metering.

CIR-PL

See ***circular polarizing filter.***

CIS

See ***contact image sensor.***

CLA

An abbreviation for *clean, lubricate, and adjust*. The maintenance done

regularly on cameras. CLA is more applicable to film cameras rather than digital cameras, since film cameras have more moving parts.

clipping

The loss of highlight or shadow detail in an image. The highlights are lost when the image is too bright and suffers from over-saturation, causing increasingly more tones to move into the pure white and leaving no separation between light-colored tones that are near each other in value. The same phenomenon occurs at the lower end of the scale. When there is too little light, all of the darker tones are pushed together, leaving no detail. This can readily be seen in a histogram, either on the camera or in Photoshop. See also ***blown out.*** *(see figures below)*

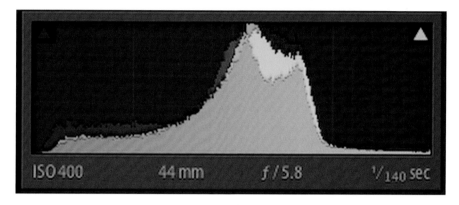

clipping – no – This image shows a histogram curve of the image values with a nice smooth decline on each side.

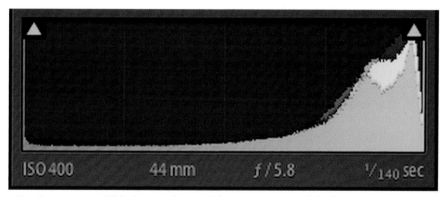

clipping – yes – This image shows a histogram curve of the image values with the curve skewed to the right. The right piles up against the right edge and the values drop off suddenly.

clipping path

A line or series of vectors that are drawn around an object in a program such as Photoshop to enable an object to be cut out of the background. A clipping path is similar to a *mask*. The object and the clipping path can be saved in an EPS file so that the subject can easily be removed from the existing background by a user to be placed on either a white or a new background. In this way, the image can be used with the existing background or a new one. The process is also known as creating a *knock-out*, since the photographer is generally knocking out the background.

clock speed

The speed in cycles per second, or hertz, at which a computer operates. Different sections of a computer will have different clock rates. By convention, clock speed usually refers to CPU clock speed, although the clock speed of the internal bus is very important to the overall speed of a computer. The earliest personal computers had a clock speed of 2 MHz, or two million cycles each second. Modern computers have clock speeds of 2 GHz (two billion cycles per second) and higher. Clock speed is commonly used in comparing computers that have similar chips and architecture, but it is not very useful for comparing computer families. Other factors, including bus speed, will have a great impact on the overall speed of the computer. For example, clock speed is useful for comparing different Macintosh computers, but not as useful for comparing Macintosh computers to PCs.

clone stamp tool

A tool in Photoshop and other photo-manipulation software that allows the photographer to copy one section of an image and then *stamp* it over the image in various locations. It works very much like a custom rubber stamp. In Photoshop, it is known as the *clone tool*, while in other programs it may be called the *rubber stamp tool*.

cloning

The process of using the *clone tool* in Photoshop or the *rubber stamp tool* in other image-editing programs. See also **clone stamp tool.**

close range correction system

See **correction of aberrations at close distance focusing.**

CLUT

See **color lookup table.**

CMM

See **color management module.**

CMOS

See **complementary metal oxide semiconductor.**

CMOS APS

See **active pixel sensor.**

CMOS image sensor

See ***complementary metal oxide semiconductor.***

CMS

See ***color management system; content management system.***

CMY

An abbreviation for *cyan* (*C*), *magenta* (*M*), and *yellow* (*Y*), the three primary colors in a subtractive color system. They are most commonly seen in conjunction with *black* (K), in CMYK systems. See also ***CMYK.***

CMYK

An abbreviation for *cyan* (*C*), *magenta* (*M*), *yellow* (*Y*), and *black* (*K*), the four colors used in four-color printing. CMYK is a subtractive color system. It is basically the CMY color system with black ink added. Theoretically, the mixture of CMY should produce black, but when using inks, the black is not pure, so black ink, represented by the letter K, is added.. Using black ink instead of mixing the three colors to make black is less expensive. See also ***four-color process printing.***

CMYK image

An image made up of the four CMYK colors instead of the common three RGB colors. CMYK images are commonly used for printing processes that require four different inks. See also ***CMYK; RGB; four-color process printing.***

cockle

The wrinkling of paper caused by too much water. The thinner the paper, the more likely the wrinkling will occur. Inkjet printers often use water-based ink, so this can be a problem when using some paper in inkjet printers.

codec

A software program designed to encode and decode digital data, especially digital video. At one time, a codec was a hardwired encoder/decoder, but now it refers to specialized software. Digital data is processed through a codec to compress it before transmission; it is then uncompressed by another codec at the other end. Codec is sometimes said to be a contraction of *compression* and *decompression.*

cold mirror

A mirror designed to reflect visible light and transmit infrared light. A cold mirror acts as a dichromatic interference filter and is constructed with coatings of dielectric materials to simulate that filter's characteristics. See also ***dichroic mirror; hot mirror.***

cold pixel

A pixel that does not respond or has a low response when light falls on its surface. It is the opposite of a hot pixel that indicates light falling on it

even when no light is present. A cold pixel is a type of correlated noise. See *correlated noise; hot pixel; pixel.*

color balance

The type of light a digital sensor is designed to reproduce such that it looks natural. Typically, the image sensor is set up for one particular color temperature, such as daylight (5500°K) or tungsten (3200°K), but there are other options that can be selected from the menu of a digital camera. The ultimate goal is to be able to reproduce a neutral gray color under a variety of lighting situations. This is usually done before photographing by adjusting the white balance, or after photographing by adjusting the color balance in post-processing. See also *white balance.*

color banding

When bands of color are seen instead of smooth changes within an image. This especially appears in portions of images that have areas of smooth color, such as skies. Color banding tends to be less obvious with 16-bit images than with 8-bit images. D*ithering* is used in digital printing to reduce the appearance of color banding. See also *16-bit; 8-bit; dithering.* (see figure on page 75)

color bars

Bars of color designed to calibrate monitors and other computer and camera equipment. See also *calibration bars; color control bars.*

color calibration

A type of calibration. The process of adjusting imaging equipment, such as cameras, scanners, monitors, and printers, to a standard that enables the color in the image to look the same on all calibrated monitors and printers. See *calibration.*

color cast

An unwanted overall coloration of an image. A color cast can occur when a single ink runs out or an inkjet is clogged on a printer. An improper white balance setting on a digital camera can also cause it. For example, if a daylight setting is used and the photograph is taken indoors under room light, the image will have an overall reddish cast to it. Another instance is when a black-and-white (grayscale) image is printed on a color printer and it may have an overall color to it.

color channel

The color portion of an image consisting of a single color. An RGB image is made of three colors: red, green, and blue. Each of those colors is a single channel of tonal and color information, shown in Photoshop as a single black-and-white image when the color image is split into the three channels. When those black-and-white images are combined with a color filter for each, the complete color image is displayed. See also *RGB.*

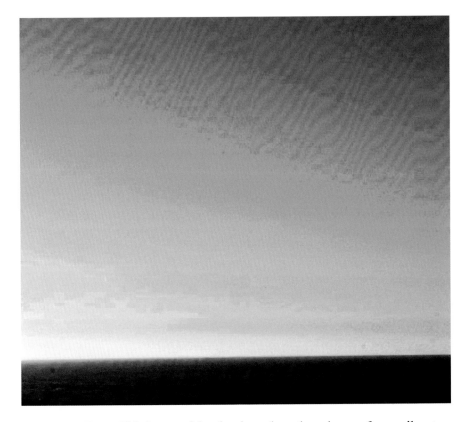

color banding – This image of the sky shows how the colors go from yellow to blue, but it is not a smooth gradation. Instead, the colors form bands known as color banding.

color control bar

A printed calibration chart of different color bars that can be scanned or photographed along with the image to provide a reference value for getting the correct color in the final scan or image. See also *calibration; calibration bars.*

color balance

The conversion of an image from one color space to another. Specifically, it can mean the conversion of an RGB image to a CMYK image to prepare it for printing. See also *RGB; CMYK.*

color correction

(1) The correction of the color of an image to bring it up to the expecta-tions of the photographer. (2) Adjusting the lighting with color gels or adjusting the camera with color filters so that the white balance of the camera is the same as that of the lighting. The main use of the term today in digital photography is in the post-processing of images in a software program such as Photoshop. Color correction can also mean the adjusting of the white balance in a raw file processor or the enhancement of the colors in an image for artistic effect. See also *white balance.*

color coupler

A type of color print where color dyes are coupled to light-sensitive silver compounds. Color coupler is one of the most popular types of color prints because of the realistic colors. Kodak "C" prints are one brand of color coupler prints.

color curves

Also known as *histograms*. In Photoshop, selecting the curves function gives the photographer a choice of four or five different curves: the combination curve and one curve for each of the three colors in the case of RGB, or four colors in the case of CMYK. This choice allows the curves to make adjustments to any color or combination of colors. For example, if an RGB image is too red, selecting the red curve and pulling it down slightly will improve the image. See also *RGB; CMYK. (see figure on page 77)*

color depth

Similar to bit depth. The number of bits used to represent the color of a pixel. See also *bit depth; pixel.*

color engine

Also known as *color management module*. The software that converts the color of the image in its existing color profile to the colors of a new destination profile. Many different color engines are available. The Adobe Color Engine, or ACE, is a well-known one. See also *Adobe Color Engine; color management module.*

colorfast

A property of a color, for example in a print or fabric, that makes it resistant to change, especially to change caused by light, temperature, or air quality.

color filter array (CFA)

A device positioned over the top of an image sensor so that pixels, which only measure the amount of monochrome light, can be converted to colored light. Each pixel has a different color filter (red, green, or blue) than the array over it. The Bayer pattern is the most common color filter array. The ratio of the Bayer pattern is one red, two green, and one blue

color curves – This figure shows the Curves palette in Photoshop. The channel shown is RGB, so this curve is a combination of all colors. The channel can be changed to the individual channels of red, green, or blue.

pixel. There are twice as many green pixels to more closely align the digital capture with human vision, corresponding to the sensitivity of the human eye to the color green. The color filter array is a mosaic pattern. To convert the resulting single red, green, and blue pixels into RGB pixels, software called *demosaicing* software is used to calculate the values of the missing colors for each pixel.

color fringing

See ***chromatic aberration.***

color gamut

The range of colors that are possible in a given color space or that can be

represented by a given device. Colors that cannot be represented in a color space or reproduced by a given device are considered *out-of-gamut.*

colorimeter

An instrument for measuring color. A colorimeter is used to measure color values of physical samples of colors in relation to a known standard set of color values. It can measure color values more precisely than is possible by eye. It can be used by photographers to calibrate colors in a photographic print and to calibrate other devices in their workflow.

colorimetry

(1) The use of a colorimeter to determine the color value of a physical color sample. (2) The science of converting colors to numerical color values. See also ***colorimeter.***

color intensity

The luminance of each individual color. As intensity increases, the color lightens; as intensity decreases, the color darkens. Intensity is measured by energy-per-unit area. The unit for measuring luminance is *candela per square meter* or *cd/m²*. See also ***luminance.***

color key

A color proof used in printing. Each color of the four-color process is printed on separate sheets of clear acetate that are then overlaid to make up the final image. This process verifies that the color separation films are correct and will combine to give you the proper colors in an image. See also ***four-color process printing.***

color look-up table (CLUT)

A table of RGB color values used to translate intensity information from an image into the colors to be used to display the image on a color monitor. Keeping this information available in RAM is better than having to go back to look it up on a hard drive each time it is needed. Typically this table has 256 entries, corresponding to the possible colors of an eight-bit pixel ($2^8 = 256$). Each color is then chosen from the 16.7 million possibilities (256 each from red, green, and blue; 256 x 256 x 256 = 16.7 million). See also ***RGB; RAM; 8-bit.***

color management

Also known as *color matching*. The process of assuring that colors are correctly described, displayed, and printed throughout an imaging workflow. This is done by calibrating each device to a standard and maintaining the standards throughout the workflow. Color management involves the use of both software and hardware and produces profiles that are applied to each device so that each device can correct its values to calibrated values. See also ***calibration.***

color management module (CMM)

Software that enables colors to be translated or converted between

devices. CMM uses profiles, such as ICC profiles, to do the translation. See also *ICC profile.*

color management system (CMS)

The combination of procedures, software, and hardware to produce and maintain a color-calibrated system. See also *color management; calibration.*

color matching

See *color management.*

ColorMatch RGB

A color space that is larger than *sRGB*, but smaller than *Adobe RGB (1998)*. ColorMatch RGB is designed to match the color and tonal range of an offset press. See also *color space.*

color palette

A grouping of different colors selected from all of the available colors. The number of bits determines the size of the palette, that is, the number of colors in it and in the available system. For example, in a 1-bit system, such as a black–and-white cell phone, each pixel is either black or white, so the palette is two. In an 8-bit system, 256 (2^8) colors are possible. If the system uses 8-bit RGB, then there are 8-bits for each of the three colors and a total palette of about 16.7 million (256 x 256 x 256) colors. See also *color space.*

color picker

A tool in many software programs that allows the photographer to choose a color. The color picker can be a circle with the hue around the edge and the saturation, or lightness, varying as the selection tool approaches the center of the circle. The color picker is used, for example, to select the color of a font or paint brush in Photoshop. The eyedropper tool in Photoshop can also be used as a color picker. See also *eyedropper.*

color profile

Also known as *ICC Profile.* (*ICC* is an abbreviation for the *International Color Consortium.*) A description of the color characteristics of a device or image. It is necessary to have a color profile in order to be able to convert or transform an image from one color space to another, or to display an image on different monitors, for example. Color profiles can be obtained from the manufacturer of the device or by using a colorimeter to measure a standard target. Color profiles are often contained within image or data files, such as EPS, JPEG, PDF, PNG, SVG, and TIFF.

color proof

A simulation printed on a digital proofing machine that approximates the look of the final piece to be printed on a color printing press. It is less expensive to create proofs in this way, rather than setting up the printing

press, running a proof, and then waiting for approval. Press proofing is not only more expensive, but ties up valuable press time. Digital proofing provides a final check of the elements in the piece as well as the colors before committing to the press. It also gives the press operator a color guide to adjust the press as the piece is printed. In the days of analog photography, a color proof print was also a first-run color print done photographically without retouching or detailed color adjustments. Color proof prints were often used in the wedding and portrait photography business to show to clients for selection. See also *four-color process printing.*

color quantization

Also known as *color image quantization*. A conversion process that displays images on devices that have fewer colors available than the image itself. The goal is to create an image in the new, smaller color space that looks as close as possible to the original image. An example is converting an image to the GIF format. Since the GIF format will only support up to 256 colors, an image must undergo color quantization to be converted to a GIF. See also *color space.*

color sampler tool

A software tool built in to Photoshop that allows the photographer to determine the numerical values of discreet color points in an image. It can be set to read color values from a single pixel or from an average of several larger areas. The reading is displayed in 8-bit RGB (red, green, blue), with 0 to 255 for each of the three colors, or in CMYK with the values in percentage. If the image is in 16-bit mode, it still gives a reading of 0 to 255 for each color. The color sampler tool allows the photographer to take four separate readings and display them all as a continuous reading by moving the cursor over the image. The color sampler tool is available in Photoshop by clicking on the eyedropper tool, then selecting *color sampler tool* from the drop-down menu that appears. The color that is sampled can then be used by the other tools in Photoshop, such as the painting tool or fill tool.

color saturation

Generally refers to the intensity of color being increased, either by slightly underexposing or by post-processing efforts. See also *color intensity.*

color space

A color mapping function within a color model. Color models include RGB and CMYK, with RGB being the more common model in digital photography. The color mapping function describes how the color space is represented. A common representation is by a three-dimensional graph with the x, y, and z axes representing *hue*, *saturation*, and *brightness*. This

is known as the *HSB color space*. In the case of an RGB color space, the x, y, and z axes would represent red, green, and blue, the RGB colors. Some examples of common color spaces include sRGB, Adobe RGB (1998), and ProPhoto RGB. There are software functions in programs such as Photoshop that allow one to convert images from one color space to another. See also **HSB.**

ColorSync

A color management system developed by Apple to provide color matching between different devices. Initially, ColorSync was developed for the Macintosh computer, but later versions were developed to be cross-platform, enabling them to work on PCs as well. The International Color Consortium was co-founded by Apple to develop the cross-platform version of ColorSync. ColorSync utilizes device-specific profiles to produce the color matches as images travel between devices. These profiles are what synchronize the colors so the appearance of the image stays as constant as possible given the constraints of the hardware device itself. See also **profile.**

color system

There are two types of color systems: additive and subtractive. In an additive color system, used in monitors, for example, the addition of all three primary colors (red, green, and blue) creates white. In a subtractive color system, used in color inkjet printers, for example, the addition of the three primary colors (cyan, magenta, and yellow) produces black. See also **additive color system; subtractive color system.**

color temperature

Describes the color of a light source by measuring the temperature in kelvins. Note that this is not *degrees kelvin*. Although there are many references to degrees kelvin, or °K, the proper terminology is simply *K*. Daylight has a color temperature of 5500 K, and tungsten bulbs can produce light with a temperature of either 3200 K or 3400 K, depending on the type of bulb. Temperatures above 5500 K have a bluish tint, those below have more of a reddish look. By adjusting the white balance of the camera to a temperature close to that of the light source, the colors in the scene remain natural looking. There are special meters available that can measure the color temperature of a scene or light source. See also **Kelvin.**

color theory

The rules for mixing color, either pigments or light, to achieve the desired color. Mixing pigments is part of the subtractive color system, while mixing light is part of the additive color system. Color theory is used in digital photography to understand the processes that are required to produce images in the colors desired by the photographer. See also **additive color system; subtractive color system.**

color value

> A value is the relative lightness or darkness of a color or an area in an image. Color value is similar to *brightness*. An RGB color value is made up of three numbers that specify the intensity of each of the three primary colors (red, green, and blue) that make up any given color.

color weight

> The visual characteristic of colors that are completely saturated. Some colors will appear darker and have more color weight than others. A color that is *heavy* has a visual dominance over colors that are *light*.

color wheel

> A geometric arrangement of colors that make their relationships easier to understand or visualize. For example, a color wheel can have 12 colors. First there are red, green, and blue (RGB) on the wheel, dividing it into thirds. Opposite them are their opposites, or complementary colors: cyan, magenta, and yellow (CMY). In between these colors are the colors that are mixtures of the ones on each side. For example, the color in between red and yellow is orange. *(see figure on page 83)*

coma

> A type of lens aberration. The defect produces a bright spot with a glowing, diffuse, comet-like tail. Coma is caused when the light rays passing through the lens do not focus at the same point. Coma aberration increases in size as the angle of the light striking the lens increases. See also *aberration.*

comma separated list

> Also called *comma delimited list*. A list of terms, such as keywords, in which each term or group of terms is separated by a comma to tell the operating system how to break them up.

comma-separated values

> A file format for data. Values, or words, are separated by commas, and each field is separated by a return. Some programs use comma-separated values for keywording digital images.

Commission Internationale de L'Éclairage (CIE, or, in English, International Commission on Illumination)

> The international authority on illumination, light, color, and color spaces, based in Vienna. The CIE was formed over ninety years ago and currently consists of 38 member countries. According to the CIE, it is "an organization devoted to international cooperation and exchange of information among its member countries on all matters relating to the science and art of lighting." The CIE is a technical, scientific, and cultural, nonprofit autonomous organization. It has grown out of the interests of individuals working in illumination.

color wheel – This color wheel allows the user to select a color on the wheel by dragging the cursor through the colors.

C

compact disc

> See *CD.*

compact disc – read only memory

> See *CD-ROM.*

compact disc – recordable

> See *CD-R.*

Compact Flash Association (CFA)

> A nonprofit corporation set up in October 1995 to establish and maintain standards for use of CompactFlash technology in data storage. An example is the well-known CompactFlash card. See also *CompactFlash card.*

CompactFlash card

> Also called *CF card* and *CF*. A type of memory card used mainly in digital cameras to store images. The CF card can also be used for other types of data. The CompactFlash differs from a similar product, the Microdrive, in that it is solid state with no moving parts; the Microdrive is a miniature hard drive with a high-speed disk inside. The CompactFlash is also more robust, faster, and can handle movement better than the microdrive. Both memory devices will generally fit the same camera. The CF standard specifies that the cards are 43 mm by 36 mm by 5 mm. There are currently three different types of CF cards, denoted by adding I, II, or III. CF I memory cards are only 3.3 mm thick and can use an adapter to be read in a CF II slot. There are now CF III cards that are the same size as CF II cards but offer higher internal speeds. See also *Microdrive; memory card.* *(see figure on page 85)*

complementary metal oxide semiconductor (CMOS)

> Also known as *CMOS sensor*. An *integrated circuit*, or *IC chip*, that is a type of *microprocessor*. CMOS is used in digital photography as a type of image sensor chip. Its advantages include using less power, which produces less heat, and making less noise than other types of microprocessors and image sensors.

COM port

> An abbreviation for *Communications port*. The 8-bit serial communications port used on PC computers on a DOS computer. It is also used for a serial RS232 data port under the Windows operating system.

compositing

> The combining of two or more images to create a new one. This can be done with layering in Photoshop. Some final images are made up of combinations of many images that are composited in the final image.

compressed

> What is done to data when storing images so that they take up less storage space. Certain image formats, such as JPEGs, are compressed formats;

CompactFlash card – This figure shows a 1 GB CompactFlash card.

other formats, such as TIFFs, are not compressed. Besides taking up less storage space, compressed files take less time to transfer between computers or to download from the Web. There are two types of compressed image file formats: *lossy* and *lossless*. Lossy compressed images achieve their compression by throwing away data, while lossless do not. See **compression.**

compressed video network
See **CVN.**

compression
The reduction in size of a file or image. Compression helps to conserve file space and makes data transfer faster. It is generally classified either as *lossless* or *lossy*. Lossless means that no data is lost and the reconstructed image is identical to the original. TIFF-LZW is an example of a lossless compression technique. With lossy compression, similar data is thrown

away when the image is saved. When the image is reopened, it is similar, but not exactly the same as the original. JPEG is the most popular format for lossy compression. The more compression is used and the more times the image is resaved, the more data is lost. At some point, the image will degrade sufficiently to be noticed. The best advice is to keep the original in either a lossless compression file or a non-compressed file. Any compression should be the final process before delivery or final use.

compression, lossless

See *Compression; lossless; lossless compression; TIFF-LZW; LZW; and PNG.*

compression, lossy

See *compression; lossy; lossy compression; and JPEG.*

compression ratio

Indicates how much a file is reduced from the original. A compression ratio of 10 to 1 means that the compressed file is one-tenth the size of the original. Some compression techniques, such as JPEG, have a variable compression ratio that can be selected by the user at the time of the compression. Generally, the less compression, the better the quality of the resulting image.

computer-to-plate

See *CTP.*

constringuence of a transparent material

Refers to the Abbe number. See *Abbe Number.*

contact image sensor (CIS)

A sensor used in scanners to replace CCDs. Contact image sensors are placed very close—nearly touching—to the object being scanned. This sensor is made up of a linear array of detectors with LEDs as the light source. It has a lower power requirement than do CCDs, such that scanners can be smaller and lighter, as well as less expensive. In some cases it can even run off of the power available on a USB port, thus needing no external power. Recently the quality of these sensors has improved to the level of CCD-based scanners. See also *scanner.*

contact sheet

A number of images, usually small, on one sheet or page. The term came from the analog (film) photography era, when the negatives from one roll of film were laid onto a sheet of enlarging paper so that many images could be seen at the same time. When digital came about, the concept was still useful, so sheets of thumbnail-sized images are still often called contact sheets. With software such as Photoshop, the size and number of images on a sheet can easily be changed, unlike the film days, when the size of the images was usually the same as the negatives. Sometimes the

contact sheets are bound into a book for presentation, such as for a wedding client. *(see figure below)*

contact sheet – This is an 8-1/2" x 11" sheet with thumbnail versions of images printed on it.

content management system (CMS)

Software that allows the management of data on a website. CMS allows for dynamic creation of website content; users prefer it to being hardwired into HTML. Allowing dynamic content can be much more flexible and useful from a visitor standpoint.

continuous tone device

See *CT device.*

contrast

The tonal differences between the lightest and darkest areas in a photograph. A high-contrast image has fewer tones between the highlights and shadows than does a low-contrast image. There are a number of ways to adjust the contrast in the final image by using image manipulation tools such as Photoshop.

contrast gradient

The measurement of the contrast in a photograph. Calculating the contrast gradient is done by measuring the separation of tones in the photograph. A high-contrast gradient is found in a high-contrast image, and a low-contrast gradient is found in a low-contrast image. See also *dynamic range.*

contrast range

The range of values from the brightest to the darkest areas of an image. See also *dynamic range.*

contrast ratio

The ratio of the brightest and darkest areas of an image. See also *contrast.*

contrasty

When applied to images, refers to not having very many tones between the whitest and blackest parts of an image. An image that has a lot of contrast is said to be *contrasty*. *Contrasty* is the opposite of a *flat image*. See also *flat.*

controlled vocabulary

An organized way to assign keywords to images such that the same words are used. Setting up lists of words or using specialized software are the easiest ways to do this efficiently. Call something a *car* one time, an *auto* the next time, and an *automobile* the third time would make finding similar images difficult. Ideally, images would have all three words as keywords, making it easy and fast to locate the images. In a controlled vocabulary, one word, *automobile* in this case, would be the main word to be used, and the others, *auto* and *car*, would be synonyms.

cookie

See *cukaloris.*

C

cooling filter

A filter placed on a camera or applied in software after photographing, to make the resulting image *cooler*, or bluer. The filter is blue and it lowers the cooler temperature of the scene as photographed. Filters of Wratten number 82, such as 82A, 82B, and 82C, are examples of cooling filters. These filters are usually used to correct the color of a scene to balance with the type of film used in analog photography; they are often used for creative effect in digital photography. A cooling filter is the opposite of a warming filter. See also *warming filter.*

copyright

The exclusive right to make copies of intellectual property granted by the government to the creator of intellectual property and protected by laws and treaties. Ideas cannot be copyrighted, only the tangible expression of ideas. In digital photography, the right to copy images is fixed at the time of creation to the creator of the work (the image). In the United States, the creator of the work is the owner of the copyright unless the work was created by an employee during the course of his or her employment. In some circumstances, the copyright belongs to the commissioning party if the creation of the work is done under a written work-for-hire contract. In the United States, in order to enforce the copyright of images in federal court, copyrights must be registered with the US Copyright Office of the Library of Congress. Also, to be able to collect statutory damages and attorney fees, they must be registered before the infringement occurs. Luckily, this is not difficult or expensive to do, as an unlimited number of images can be registered at one time for the same fee. In other countries, the rules for copyright generally do not require registration, but they also do not offer statutory damages. It is important for all photographers to understand the workings of copyright law.

copywrite

A frequent misspelling of the term *copyright*. See *copyright.*

correction of aberrations at close distance focusing

Also called *close range correction system* (*CRC*). As lenses focus at close distances, aberrations that were not seen at infinity become visible. Some lenses have built-in corrections that move lens elements inside the lens as it focuses more closely so that it can correct for these aberrations as much as possible.

correlated noise

Image sensor noise that is repeated on each image in the same pattern. There are techniques available to subtract correlated noise by using a dark frame. Hot pixels and cold pixels are correlated noise. See also *hot pixel; cold pixel; dark frame.*

corrupted

Damaged. An image file that is corrupted is one that has been damaged in some way that it can no longer be read by software. In some cases, depending on the type of corruption, special software can be run to correct the image file. Corruption can occur when normal data processing operations are interrupted. This can occur when a memory card is pulled out while it is still writing or while it is still in use. It can also occur if there is a power failure during a data operation. It can be caused by random factors or malfunctioning hardware as well. Good backups and careful image processing are good preventive measures to take.

CPL

See *circular polarizing filter.*

CPU

See *central processing unit.*

CRC

(1) The correction of aberrations at close distance focusing. (2) An abbeviation for *close range correction system.* See *correction of aberrations at close distance focusing.*

creative suite

See *CS.*

creator

The author of a work of intellectual property. In the case of a digital photograph, the creator is the photographer under most circumstances. A creator transforms ideas into tangible forms of expression, which is what makes the intellectual work copyrightable, since ideas cannot be copyrighted. The creator is not necessarily the owner of the copyright if the work was created as an employee or under a work-for-hire agreement.

credit

(1) The listing of the creator of an image when it is printed. Credit is usually rendered as *photo by Joe Photographer.* (2) A field in Photoshop that indicates how the credit should be written when it is used. Generally, credit is only given in editorial use such as books, magazines, and newspapers, but not when used in advertising. Credit usually goes to the creator of the image. See also *creator.*

crossed polarization

Used in *polarized light microscopy.* Two polarizers are set up at right angles to each other. Light that passes through the first polarizer is blocked by the second. In polarized light microscopy, one polarizer is between the sample and the light and the other is between the sample and the viewing lens. Certain types of crystals can be revealed under this type of lighting.

cross-eyed bokeh

Bokeh in which single lines appear as double lines. Cross-eyed *bokeh* is often considered unattractive and described as harsh. It is often seen with the use of mirror lenses. See aslo **bokeh; mirror lenses.**

CRT

An abbreviation for *cathode ray tube*. A display device for computers, video monitors, televisions, oscilloscopes, and radar displays. Digital photographers are familiar with these from their experience with computer monitors in the past. Today CRTs are no longer manufactured for computer monitors, except for very expensive, high-end models. CRTs have been replaced by LCDs for use as computer monitors.

CS

An abbreviation for *Creative Suite*, a group of graphic design programs created by Adobe Systems designed to work well together for photographers, designers, and web designers. These programs include Photoshop, Illustrator, InDesign, Version Cue, Bridge, GoLive, and Acrobat Professional. Creative Suite was replaced by *Creative Suite 2 and Creative Suite 3* has recently been released, replacing *Creative Suite 2.*

CS2

See **CS.**

CSS

See **cascading style sheets.**

CSV

See **comma-separated values.**

CT device

An abbreviation for *continuous tone device*. Used to render images without creating half-tone dots. Instead, it creates tones with varying densities.

CTP

An abbreviation for *computer-to-plate. A* printing process. Normally, when printing photographs on an offset press, a negative is created, which is then used to create a plate that is used for printing. With CTP, the digital file is used to create the plate directly without making a negative.

cukaloris

Also called *cookie*. Used by photographers to generate patterns on the background. A cukaloris is a panel with holes cut into it that is placed in front of a light. Sometimes the pattern projected is of random shapes; at other times, it is a recognizable pattern, such as window panes or palm leaves. It is a quick and easy way to dress up an image.

cursor

The indicator on a computer monitor or display that is moved by the

C

mouse or track-pad device. The cursor indicates where the next entry or action will occur. The shape of the cursor depends on the software involved. In some cases, for example in Word, the cursor is a blinking straight line. In the Macintosh operating system, it is an arrow. In Photoshop, it has a variety of shapes, such as crop marks or an eyedropper, depending on the tool selected.

curvature of field

A lens aberration. The image formed by a lens with curvature of field aberration is in focus on a curved plane relative to the lens, rather than on a flat plane. Thus an image made with a lens with curvature field would be in focus in the center and would gradually go out of focus at the edges.

curves

A function in Photoshop used to adjust images by mapping pixels into different tonal values. The adjustments can be made for the entire image or for each channel individually. In the case of RGB images, there is a choice of the three channels (RGB) or the entire image. In the case of CMYK images, there is a choice of the four-color channels or the entire image. The actual function is an x-y coordinate system with the input (original) values across the x-axis and the output (changed) values across the y-axis. Curves allows for detailed adjustments that are more precise than using the *levels tool*. Since tonal values can be changed for each color, the photographer is able to make creative changes to the colors as well as changes designed to make the image more pleasing. See also **RGB; CMYK.** *(see figure on page 93)*

curvilinear distortion

A distortion in the image causing straight lines to appear curved. This is a common lens aberration in wide-angle lenses. Depending on the direction that the lines are curved, the lens aberration can be classified as *barrel distortion* or *pincushion distortion.* See also **barrel distortion; pincushion distortion.**

custom file info panels

See **custom panels.**

Custom Function (C.Fn)

A feature of Canon digital cameras. A two-digit number usually accompanies the Custom Function. Each C.Fn refers to a special feature on the camera that can be addressed and changed through the menus. For example, C.Fn 01 turns on long-exposure noise reduction. This allows each photographer to customize the camera's function in a way that suits his or her work.

custom panels

Also called *custom file info panels*. A feature of Canon digital cameras. Other brands of cameras may have a similar feature with a different name.

curves – The Curves palette from Photoshop allows the user to display a curve of the image value for all colors or each color channel (red, green, and blue) individually.

Custom panels allow the photographer to adjust the XMP metadata that will be stored in the image file with an automatic action to repeat placing the same information into the metadata in an image. This would allow, for example, the creation of custom metadata properties needed in an internal application for a company's database or for a stock agency.

cut out

(1) Similar to cut / paste, except that only the cut function is done. No pasting is done. (2) To photograph an item or a person on a white background to make it easy to cut them out and use them on another background. The item photographed is known as the *cut out*. The actual

cutting out is done after the photography by using a photo-editing program such as Photoshop, Elements, or Paint Shop Pro.

cut/paste

A common operation done on a computer to move data, such as moving keywords from one location to another by literally cutting them out electronically and pasting them into the new location. This function can also be done in Photoshop by selecting portions of images, cutting them out, and pasting them in a new location or a new image. Cutting is done by highlighting the portion of interest, then using the command *cut* (usually the keyboard shortcut is the *x* key pressed simultaneously with the *command* or *alt* key). Next, to do the pasting, move to the new location and, using the command *paste* (the keyboard shortcut often uses the *v* key, pressed with the *command* or *alt* key), the information previously cut out is now pasted into the new location.

CVN

An abbreviation for *compressed video network*. A method of compressing video signals to reduce the bandwidth requirements. CVN is used to set up a network, especially in educational settings, for distributing video signals over a distance. It can use basic-rate ISDN lines to transmit the video signal. See also **ISDN.**

cyan

A blue-green color that is one of the primary colors used in printing. The others are magenta and yellow. When black is added, the colors make up what is known as *four-color printing* or *CMYK*. See also **CMY; CMYK; four-color process printing.** (see figures on page 95)

D50

A common white point setting used with monitor calibration. D50 stands for 5000 K, one representation of the color of daylight. It is no longer commonly used; having been superceded by D65. See also **D65; white point.**

D65

The most common setting for white point in monitor setup and calibration. D65 has replaced the old standard of *D50*. D65 represents 6500 K, a warmer color of daylight. See also **D50; white point.**

cyan – CMYK – This is the color cyan in the CMYK color system. Notice how it varies as compared to the RGB version. The variations in the color printing process mean that this is only an approximation of the color.

cyan – RGB – This is the color cyan in the RGB color system. Notice how it varies as compared to the CMYK version. The variations in the color printing process mean that this is only an approximation of the color.

DAM

The common abbreviation used for *digital management system*. DAM actually stands for *digital asset management*. See **digital asset management system.**

dark current

Current from a sensor when the camera is on but no light is hitting the sensor. Dark current causes *dark noise*. The dark current is the rate that electrons flow from the image sensor. Hot pixels are the bright spots in a dark image. These hot pixels are caused by the dark current noise. The higher the ISO, the longer the exposure, and the hotter the CCD becomes, the worse the problem and the more noticeable the hot pixels. This can be reduced by cooling the image sensor. Using a technique called *dark noise subtraction* can eliminate it. See also **dark noise; dark noise subtraction.**

dark field

Also known as dark current or dark noise. Dark field refers specifically to the image created without any light. A dark field image can be created by leaving the lens cap on during the second exposure. This *dark field* is really a photograph of the noise present. It is taken at the same ISO and same exposure time. The resulting image is subtracted in Photoshop or a similar program from the actual photograph to subtract the noise. See also **dark current; dark noise; dark noise subtraction.**

dark noise

The noise caused by dark current. The dark current, which is caused by heat, builds up on a sensor and causes a random noise. Dark noise can be reduced by cooling the image sensor; it can be eliminated by using a technique called *dark noise subtraction*. See also **dark current; dark noise subtraction.**

dark noise subtraction

The process of taking an image without light, such as with the lens cap on, just before or just after taking a normal exposure, then using software to subtract the dark noise from the normal exposure. This can correct for heat-related dark noise such as hot pixels. See also **dark current; dark noise; hot pixel.**

data

Information of some kind, such as numbers, words, or even images. In

digital photography, data can include the image, keywords, camera information, and other metadata.

database

A collection of data that has not only been gathered but also organized in some manner. A number of software programs have been designed to organize and find data, particularly images. When organizing images in a database, it is important to gather the metadata as well as the images. There is also an assumption that each image has a unique file name. Some database software programs ensure that names are not duplicated by rejecting an image with a duplicate file name. See also *data.*

data compression

A way of reducing the amount of storage space that any data, such as an image, takes. There are two types of data compression: lossless and lossy. In the lossy format, some data is thrown away to approximate the original with a much smaller file size. In lossless data compression, the original file can be reconstructed exactly. In some cases, a different format utilizing data compression techniques can be used for an image. Two examples of compressed data formats are JPEG and TIFF-LZW. JPEG is a lossy format; TIFF-LZW is a lossless format. JPEG images can be compressed a great deal. Generally, the more compression used in the format, the poorer the quality of the image. With TIFF-LZW, the compression is more modest and, in some cases, nonexistent. There are other techniques, such as ZIP, that can be used on images or groups of images. Data compression techniques such as ZIP are not as useful for images, aside from special image formats, as they are for other types of data. Besides the smaller storage requirements, another advantage to data compression is faster transmission to another computer or storage location. See also *JPEG; TIFF-LZW; lossy; lossless.*

DCF

See *design rule for camera file system.*

DCS

(1) An abbreviation for Digital Camera System, a series of high-end, professional digital cameras manufactured by Eastman Kodak. (2) An abbreviation for *desktop color separation*. See *desktop color separation.*

DCT

An abbreviation for *discrete cosine transformation*. The algorithm used

to compress an image in the JPEG file format. DCT is also used in the MJPEG, MPEG, and DV video compression formats. See also **JPEG; MPEG.**

decamired

A filter measurement system designed to simplify making color temperature adjustments. The systems are available in both red and blue. The measurement is in *decamireds*. The term *mired*, an abbreviated version of *micro reciprocal degree*, which is equal to a value of one million divided by the color temperature in kelvins. A decamired is a mired divided by ten. If a shift of 30 mireds is needed, then a *3* filter is used. If a red shift is needed, then a red filter, *R3*, is used. If a blue shift is needed, then a blue filter, *B3*, is used. The filters can be added together. Thus, R3 = R1.5 + R1.5. If the red and blue filters of equal strength are added together, the result is a neutral gray color. The filters will produce the same visual difference in an image no matter what the color temperature of the image. See also **Kelvin.**

decompression

The process of reversing the compression to display the image. If the compression is lossless, then the original image is recreated. If the compression technique is lossy, then a close approximation of the original image is recreated. See also **data compression; lossy; lossless; compression.**

default

See **default setting.**

default setting

Also called *default*. The original setting of the parameters in a software program when it is first set up. These default settings can be modified to fit the user's personal working methods. If a program has to be reloaded for any reason, it will revert to its default setting. There is often a button or a switch in the software to reset all values to the defaults set at the time of manufacture, often called *factory defaults*.

definition

The sharpness of an image; more specifically, the rendering of detail. Aberrations in a lens degrade definition; stopping down the lens usually improves definition. See also **aberration; detail; sharpness.**

D

defocus

Also called *defocus aberration*. Areas in an image that are not in focus by choice. The smaller the f-number, the more defocus is likely to be seen as image blurring. For very high f-numbers, defocus is unlikely to display image blurring as frequently. See also ***bokeh.***

defocus image control

A feature built in to certain lenses that allows the photographer to add defocus to an image and control, at least partially, its placement. See also ***defocus.***

defringe

A Photoshop tool that removes fringing from photographs. The tool, built into Photoshop, is designed to remove the halos that sometimes occur in images with transparent backgrounds. There are also fringes in the form of purple bands around overexposed areas in digital images. The purple fringing in this case is caused by sensor overloading. Photoshop plug-in tools can correct for this kind of fringing. Careful use of the defringe tool can provide considerable improvement. Defringe can also be used for fringing caused by chromatic aberration. See also ***aberration; chromatic aberration; fringing.***

degauss

The process of removing or reducing a magnetic field. In digital photography, degaussing is found especially in operating magnetic storage media. Data or images are erased by using the degaussing process to randomize the magnetic fields used to store information on a hard drive or other magnetic storage device. Degaussing is also used to remove the effects of a magnetic field on a CRT monitor display. CRT displays will pick up discolorations on the screen over time. Many CRT displays will automatically degauss when they are first turned on. When this occurs, they will *pop* and the screen display will jiggle for a moment as the CRT is switched on. See also ***CRT.***

demosaicing

The kind of software algorithm used to calculate the missing two colors from each pixel in data from a *Bayer pattern sensor*. This software is used in the camera, or later in a computer if the images are captured in raw format. In a Bayer pattern sensor, filters convert the incoming image into red, green, and blue elements. Each pixel represents only one color and needs to be processed so that three colors can be associated with each

pixel. The demosaicing software accomplishes this pixel to colors association. See also *Bayer pattern; raw; RGB.*

depth

See *color depth; bit depth; depth of field; depth of focus.*

depth of field

The areas in front of and behind the main subject that remain acceptably sharp. A number of factors influence depth of field, including the focal length of the lens, the aperture, and the distance from the subject. A larger aperture (smaller f-stop number) will yield a smaller or shallower depth of field. A longer focal-length lens will also yield a smaller depth of field. The closer the photographer is to the subject, the narrower the depth of field will be. See also *depth of focus.* *(see figure on page 101)*

depth of field preview button

A button or lever on a camera that, when activated, causes the lens to stop down to the chosen aperture so that the photographer can see which subjects are in focus through the viewfinder. If the aperture chosen is not largest (smallest numerically), then the viewfinder will grow noticeably darker. By adjusting the aperture and holding the depth of field preview button or lever, the photographer can see how the depth of field will change. See also *depth of field.*

depth of field scale

The markings on the lens barrel that indicate at what distances subjects will be in focus for various f-stops. See also *depth of field.*

depth of focus

The distance the digital sensor can be shifted inside the camera so that the subject remains in focus. Depth of focus is often confused with or misused for *depth of field*. See also *depth of field.*

derivative image

Also called *derivatives* and *derived image*. An image created from another image. The usual method for creating a derivative image is from a master image that is archived, usually in a lossless format such as TIFF or PSD. Images for websites, images for clients, and thumbnails are created from the master image. These new images are derivatives. They are often smaller and stored in a lossy format such as JPEG. To create a derivative image, an image manipulation program such as Photoshop is commonly used. See also *lossless; master image; TIFF; PSD.*

depth of field – The depth of field of this image is quite shallow. The eyestalks on the banana slug are sharp and in focus, but the body quickly becomes out of focus as the distance increases from the head.

D

derivatives
> See *derivative image.*

derived image
> See *derivative image.*

desaturate
> Removing the color from an image, which leaves behind a grayscale (sometimes called a black–and-white) image. Although desaturating is one way of creating a grayscale image, there are other methods that give more creative choices and can produce an image with a more pleasing appearance. A desaturate function is available in Photoshop and other image-manipulation programs. See also *grayscale.*

descreening
> The process of removing the *moiré pattern* that occurs when images are scanned from images printed in publications such as magazines, books, and newspapers. Images printed in publications are created with a series of dots in a process called *halftone printing*. Photographing the original images through screens creates halftone dots, a process that is currently done with software. Still, the process of removing the moiré pattern is called descreening in reference to the historical use of screens in halftone printing. See also *halftone image; halftone screen.* *(see figures on pages 102 and 103)*

Design Rule for Camera File System (DCF)
> A definition of file formats, file names, and file folder names used with images developed by JEITA (Japan Electronics and Information Technology Industries Association) for use in digital cameras. This is the current standard for digital camera files and their filing systems.

descreen – before – This image was scanned from a book. Since it was printed with a screen as part of the printing process, a moiré pattern occurs during the screening process. See next figure for a corrected version of the image.

descreen – after – The same screened image shown in the previous figure is processed with the descreen function to minimize the moiré pattern that occurs during the screening process.

deskew

When an image is skewed, its horizon, or a vertical line, is not straight. Deskewing brings the image back to a straight format. An image may be skewed because it was not straight when the original was scanned, or it may be due to the camera being tilted when the image was created. , To deskew an image in Photoshop, use the ruler tool to draw a line—either horizontal or vertical— and then use the *rotate – arbitrary* command to rotate the image until it is straight. *(see figure below)*

deskew – The image in the figure has been rotated to make the horizon straight in a process known as deskewing.

desktop color separation (DCS)

(1) A file format in Photoshop designed to save CMYK files. (2) A way of saving files as five EPS files. One file is created for each color channel (CMYK) and another for a master file that contains instructions and perhaps a preview file. See also **CMYK; EPS.**

Deutsche Industrie Norm or Deutsches Institut für Normung (DIN)

The English translation is the *German Institute for Standardization*. DIN is the German national standards organization, similar to the American Standards Association (ASA). DIN is a member of ISO. See also **ASA; DIN; ISO.**

device-dependent

A device profile or color information that is specific to a particular device. See also **device profile.**

device driver

Also called *software driver*. A component of system-level software that allows a computer to control a hardware device such as a scanner or a printer. This software often needs to be updated when the computer's operating system changes. Device drivers are usually obtained from the manufacturer's website, where the most current one can be downloaded. Sometimes merely updating the device driver will solve unusual problems with a device. Each model of a device, such as a printer, will often require the use of a different device driver.

device-independent

Color information or a color space that does not depend on a particular device. See also **device profile.**

device profile

A file read by color-management software to convert color from one device to an independent color space. The file contains the characteristics of the device. There are three types of device profiles—input, display, and output— for the three different types of devices. *Input devices* include cameras and scanners. Monitors are *display devices*. *Output devices* are usually printers. Output device profiles take into consideration the printer, ink, and paper. Different combinations of printers, inks, and paper require different device profiles. Some profiles are built into the device driver. Monitors are often calibrated with special software and a hardware device to create a custom profile. See also **device driver.**

DIB

An abbreviation for device independent bitmap. See **bitmap.**

dichroic mirror

A mirror that also filters light. Some frequencies of light are reflected and others are transmitted, depending on the construction of the dichroic mirror. A common use for a dichroic mirror is to reflect infrared light and pass through visible light. This is known as a *hot mirror*, since it reflects infrared, which includes thermal, or *hot*, energy. These mirrors are often used in digital cameras to keep infrared light from affecting the digital image. A mirror that will pass infrared light and reflect visible light is known as a *cold mirror*. These are often used in slide projectors to keep the heat from the lamp from damaging the slide being projected. A dichroic mirror is also used as a beam splitter to split visible light into red, green, and blue (RGB) light, used in scanners. See also **hot mirror; cold mirror; RGB.**

didymium filter

Also called an intensifying filter because it intensifies reds, oranges, and browns without affecting other colors. This filter can be useful in landscape photography, for example. When the subject falls within the above-mentioned color groups, the image will be more saturated and have more contrast. A didymium filter contains two rare earth metals: neodymium (Nd) and praseodymium (Pr).

diffraction

The bending of light rays as they pass through a lens, possibly resulting in the reduction of sharpness . Different wavelengths of light will bend differently, which keeps light rays from the subject from coming together at a single focus point. Diffraction increases as the aperture is reduced (higher f-number) and can become noticeable in a print made at a small aperture.

diffraction filter

Also called a diffraction grating. A filter made up of fine lines etched into its surface. This filter is used for special effects in photography. When light passes through the filter, it diffracts into different wavelengths of light, causing a rainbow effect of the spectrum of colors of light in different areas of the image. Cross–screen, or *star*, filters use the diffraction of fine lines to create their effects. See also ***diffraction.***

diffractive optics

Also called *DO lenses*. Optical elements used to correct for color aberrations by the use of diffraction. DO lenses tend to be lighter than regular lenses, as well as more expensive. See also ***diffraction.***

diffusion dithering

Using randomly placed pixels, rather than a pattern of pixels, when dithering. This is done so that dithering can be better blended between two differing tones or colors. The pixels are generally two different colors trying to simulate a third color or black and white pixels trying to simulate grayscale images. See also ***dithering.***

digicam

A slang term for *digital camera*. See ***digital camera.***

Digimarc

Refers to the *Digimarc Corporation*. The most common usage of the term is to refer to the company's *digital watermarking security system*. The system uses an invisible watermark designed to protect digital images from unauthorized use. See also ***digital watermark.***

digital

Information broken up into discrete bits instead of being continuous. Essentially, digital is information collection and storage based on *base 2*, using only zeroes and ones. It is the very heart of digital photography,

enabling photographs to be processed and stored on machines and to be transmitted electronically. Digital images can be reproduced exactly.

digital asset management system (DAM)

Although a true DAM includes all types of digital assets, such as images, documents, music, and more, here we are concerned specifically with assets that are digital images. A complete DAM system for images includes ingesting the images, annotating them so they can be found, cataloging them, storing them digitally, backing them up by making several duplicate copies, producing them upon request, and distributing them for use. There are a number of DAM software applications available for purchase.

digital camera

A camera that uses a digital sensor instead of film to capture an image. The resulting image is digital rather than analog and is rendered in pixels. See also *camera; pixel.*

Digital Camera System

See *DCS.*

digital capture

(1) The process of creating an image in digital form, often using a digital camera. (2) Another way of referring to *digital photography.* See also *digital camera.*

digital darkroom

The new *darkroom* is actually a *lightroom.* It consists of a computer workstation with a computer, monitor, and appropriate image-processing software such as Photoshop. Although it no longer requires a completely dark room, a digital darkroom should have controlled lighting that is somewhat dimmer than usual so that consistency can be maintained on a calibrated monitor.

digital duplicates

Refers to copies of the digital originals that are exact copies or duplicates. Digital duplicates can also refer to digital copies of analog or film originals. In this case, to create the digital duplicate from an analog original, the film needs to be scanned. These are actually near-duplicates, since they are not as exacting and are second-, not first-generation copies.

digital envelope

A method of protecting a message or image by encrypting it. In this technique, two levels of encryption are used. The message or image is encrypted using a secret key. The secret key is then encrypted using a public key. Only the recipient has the private key to unlock the secret key. The advantage to this method is that the public/private key technique is much slower for opening larger messages or images. By using the faster secret key to encrypt the larger image and the slower public/private key

technique to encrypt only the small, secret key, the encryption operation is substantially faster overall.

digital file

A digital image or photograph stored on a memory card, CD, DVD, or hard drive.

digital film

(1) Digital memory storage cards in the term's most common usage. In digital photography, the digital memory cards take the place of film and are placed into a digital camera to record the image just as film did in analog photography. (2) Digital motion picture techniques. In the case of digital film, the motion picture or movie is represented by pixels instead of film. Digital film has higher resolution than digital video systems.

digital halftone

A halftone created by digital means. In regular halftone creation, film is placed in contact with a halftone screen and a process camera is used to create the halftone. When this process is done digitally, a scanner or video digitizer is used with an image setter to create the digital halftone. The pixels used to create the halftone dots must be fairly small, ranging from 600 ppi to 2,500 ppi.

digital ICE

Also called *ICE*. Stands for *digital image correction and enhancement*. A technology developed to improve the results from scanned film images by removing or reducing dust and scratches. Digital ICE is built in to the scanner and requires special scanner technology. It is not just software that can be run later on an image. It works by making two scans of the film. The first scan uses visible light, the second infrared light. The infrared light detects the dust and scratches and the ICE program in the scanner subtracts them from the image and fills in the missing data by making calculations based on the surrounding pixels. This makes *clean-up* post-scanning much easier. Early ICE systems did not work well on Kodak Kodachrome transparencies because of the different composition of the film. More recent scanners and ICE are able to deal with Kodachrome more effectively. Digital ICE, unlike purely software-based corrections, does not soften the image to do the removal.

digital image correction

Refers to a variety of software and hardware techniques for automatic corrections and cleaning of digital images. The best known is Digital ICE, which is built in to many scanners and is used to remove dust and scratches from film while it is being scanned. See also ***digital ICE.***

digital image filtering

A process of applying filtering techniques in software applications to change a digital image. Well-known applications of this are the filters

available in Photoshop. Originally, digital image filtering was used to correct an image by sharpening it, reducing dust or artifacts, or similar tasks. Now digital image filtering is done for creative purposes as well. Some of the filtering techniques include artistic ones such as *colored pencil, dry brush, film grain, fresco, neon glow, palette knife, plastic wrap, rough pastels, smudge stick, sponge*, and *watercolor*. Various kinds of brush strokes and distortions can be applied. There are sketching techniques and textures as well. All of these effects can easily be seen by using Photoshop's *filter gallery*.

digital image management system (DIMS)

A *digital asset management system* (*DAM*) designed specifically to handle images only. Although this is a more specific term, the current tendency is to use *DAM* instead of the more specific *DIMS*. See also **digital asset management system.**

digital imaging

The more general term for *digital photography*. Digital imaging includes the creation or acquisition of the image, processing it, storing it, backing it up, exporting it, and distributing it as a print or digital image. See also **digital camera.**

digital infrared

An infrared image created with a digital camera. Digital image sensors are sensitive to infrared light. Many cameras have a built-in cut off filter to remove the infrared so that only visible light passes through to the sensor. Since infrared light focuses at a different point than visible light does, the cut-off filter removes the infrared light to keep the image from becoming blurry. To create a digital infrared image, a camera sensitive to infrared light (without a cut-off filter) needs to be used. Using an infrared television remote control pointed at the camera will enable the photographer to tell if the camera is sensitive to infrared. A special filter that passes only infrared and blocks all or most visible light is used on the camera lens to create the digital infrared image. This means that long exposure times, high ISO ratings, and lenses with apertures fully opened are generally needed. A tripod may be required as well. If the camera is not sensitive to infrared light because it contains a cut-off filter, the camera can be modified by removing the cut-off filter. See also **digital camera.** *(see figure on page 111)*

digital internegatives

A digital master image made from the original negative used in creating a motion picture. Each film frame is scanned at a very high resolution so that, after retouching, modification, or manipulation, a new film negative can be created with very little or no loss of quality. Each frame is saved, usually in an uncompressed format such as TIFF or a specialized format

digital infrared – This is a digital infrared image created by putting an infrared filter on the front of a digital camera to allow only infrared energy to pass through to the sensor.

developed for the motion picture industry. Digital internegatives are also sometimes called digital film in the motion picture business. It is different from digital video, DVD, or even digital cinema, which are all lower-quality formats because they are compressed and related to the quality of the theatrical release print that is lower in quality than the original film negative.

digitally alter

Also known as *digital retouching, digital manipulation, digital modification,* and *digitally change.* To change a digital image using digital tools such as Photoshop. When the term *digitally alter* is used, it usually refers to more changes than a simple fix of a blemish. Often it means making major changes for artistic, aesthetic, or other reasons. It could mean replacing a background, adding someone to an image, or removing major features of the image. See also *digital retouching.*

digitally change

See *digitally alter.*

digitally enhance

Similar in meaning to digitally alter, but generally implies less drastic changes. Usually refers to changes made for aesthetic reasons, that is, "improving" the digital image rather than making other types of changes. Portrait photographers often refer to retouching as blemish removal or softening wrinkles; removing the bags under the eyes of a subject is called "digital enhancement." See also *digitally alter.*

digitally modify

See *digitally alter.*

digitally retouch

Similar to *digitally alter* and *digitally enhance.* Refers to changes made to improve a digital image in an image-manipulation program. See also *digitally alter; digitally enhance.*

digital negative

Another term for a raw file. The term digital negative is used because a raw file needs to be processed to create the final image. More adjustments are possible with a raw file than with a JPEG file, which has already been processed in the camera. It is important to archive the original raw file in case it is necessary to reprocess it at some future time. Advancements in raw file processing software enable photographers to go back and create more pleasing versions of images at a later date. See also *raw file.*

digital printer

A printing device that creates a hard, or physical, copy output from digital input. Here, a digital printer is a printer that creates a photographic print from a digital image input. The typical technologies to produce the digital print include inkjet, laser, and photographic processes. Home printers are

D

often of the inkjet variety, while professional labs use photographic processes to produce prints that look identical to those based on analog photographic techniques as long as the digital image file being used is of high enough quality.

digital print order format (DPOF)

A format that allows the photographer to specify if an image is to be printed, its size, the number of copies to be printed, and other information. The DPOF is accessed and filled out via menus on the camera. The information is stored in text files in a directory on the memory card. This allows the photographer to print directly from the memory card on his or her own printer or at a photo lab.

digital realm

(1) Also referred to as the *online world, cyberspace*, or even the *Internet*. Encompasses the entire digital world. By that definition, it can include Usenet, websites, portals, discussion groups, mailing lists, chat rooms, and message boards. (2) The digital imaging world, including all of the tools, equipment, and processes used to create digital images.

digital rights management (DRM)

Various technologies used to control access and distribution of various digital media. Technically, DRM refers to all digital media, but the term has evolved to the extent that it is also applied to artistic copyrightable items such as digital images, digital music, and digital art. DRM is the method by which copyright holders and publishers can control access, reproduction, and distribution of their artistic works. This has become important in the digital world because any digital artistic work can be duplicated exactly, unlike early analog works that would degrade with each copy. Each digital copy is an exact copy, just as good as the original.

digital scan

(1) A digital image created by scanning an analog paper or film original. (2) The process of creating a digital image from the analog original, as well as the result. See also ***scanning.***

digital signal processor (DSP)

A special-purpose microcomputer designed to process signals in real time. A DSP is often a dedicated microprocessor that operates at high speeds to handle a real-time task. It first converts the analog signal to a digital one before beginning its operations. DSPs are used to improve signal quality by reducing noise. They are found in modems, sound cards, and high-capacity hard drives, among other devices.

digital single lens reflex (DSLR)

A camera similar to a film single-lens reflex camera, except an image sensor takes the place of the film. The most noticeable feature is the viewfinder, which looks through the same lens through which the

photograph is taken. This is an advantage in that it enables the photographer to properly compose the photograph in the camera. Additionally, a DSLR camera usually has a wide variety of lenses and accessories available. See also ***camera.***

digital to analog converter (DAC)

A device for converting a digital signal into an analog signal. For example, a digital signal from a computer must be converted to an analog one to display on most monitors, with the notable exception of digital (DVI input) monitors. See also ***DVI.***

digital video disc (DVD)

Also called *digital virtual disc.* An optical disc that can store information such as images; its more common use is to store and distribute movies. The DVD is the same size as a CD but holds much more information. New technologies are developing such that a double-layer DVD can hold up to about 8.5 GB of information; a double-layer, double-sided DVD can hold up to 17.1 GB of information. With digital image sizes growing, the DVD has become a common storage method for images and is used frequently in digital photography. There are two competing formats called DVD+ (DVD plus) and DVD- (DVD minus). DVD+ is also known as DVD+R and DVD- is also known as DVD-R. DVD+ was developed by DVD+RW Alliance and is not supported by the DVD Forum as an "official" DVD format. DVD- is a DVD format supported by the DVD Forum. Most modern DVD players and recorders can deal with DVD-discs The most popular DVD readers are hybrid readers, which can read both a DVD- and a DVD+, since neither format has become the single standard format. Very few single-format readers are available. See also ***disc; disk.*** *(see figure on page 125)*

digital video interface (DVI)

An interface designed for digital displays such as LCD panel monitors and video projectors. Because DVI is designed for digital devices, it can control the brightness of individual pixels better than groups of pixels.

digital virtual disc

See ***DVD.***

digital watermark

A way of marking an image to indicate ownership or copyright information. This watermark can be visible or invisible. A visible watermark often comes in the form of a logo or copyright information, or website and

contact information. An invisible watermark is built into the data of the image so that it can't be seen but can be detected by special software. Creating invisible watermarks requires a technique called steganography. Invisible watermarking is useful for identifying the ownership of an image or for finding it. See also ***Digimarc; steganography.***

digital zoom

Enlarging an image in the camera to simulate a longer-range zoom. Digital zoom actually creates pixels by interpolation. Although the image may appear the same on the LCD screen, since it is actually just an enlargement, the quality is usually inferior to that of an equivalent optical zoom lens. If a greater enlargement is needed than the camera's lens can provide, wait until the image is downloaded into the computer to enlarge it. The software in the computer is more powerful and can do a better job of "zooming" than the software in the camera. See also ***interpolation; pixel.***

digitize

The process of taking analog data and converting it to digital. An example would be to scan, or digitize, a photographic negative, print, or transparency to convert the image into a digital format so that it can be processed on a computer.

digitizing tablet

More commonly called *graphics tablet*. A tablet and pen attached to a computer, allowing the user to draw on the tablet and have that data digitalized for use in the computer. It can be used it to do fine-level retouching on an image because the digitizing tablet allows for finer and smoother control than is usually possible with a mouse. The user can sign his or her name to have a digital version appear on the monitor.

diminution

To make something smaller. In photography, the subject looks smaller the farther it is from the camera. The human eye perceives a greater sense of depth in the image because it is used to specific size relationships between objects.

DIN

An abbreviation for *Deutsche Industrie Norm*. A European film-speed rating, similar to ASA in the United States, developed by Deutscher Normenausschusss, a German standards organization similar to ASA.

The DIN numbering system is based on a logarithmic function. Both ASA and DIN have been replaced by ISO. See also ***ISO; ASA.***

diopter

The measure of the optical strength, or power, of a lens. Diopter is measured by the reciprocal of the focal length in meters. Thus a 4-diopter lens is equal to a focal length of 1/4 meter. Lenses can have positive or negative diopters depending on whether they are convex (positive values) or concave (negative values).

diopter correction

An adjustment on or to the optical eyepiece of a camera designed to adjust the eyepiece so that the photographer can use the camera without glasses. If the camera viewfinder has a built-in adjustable viewfinder, the diopter correction is adjusted by the photographer to his or her own vision. If the camera does not have a built-in adjustable viewfinder, a separate diopter corrective lens is added to the viewfinder to accomplish the same purpose. This correction changes the focus, but not the magnification, of the viewfinder. See also ***diopter.***

dioptric adjustment

The result of a diopter correction in an optical viewfinder. See also ***diopter; diopter correction.***

direct memory access (DMA)

Allows devices direct access to system memory without having to go through the CPU. By doing this, the CPU is freed up to continue operating while other functions are occurring. Disk drives and peripheral device drivers—both important in digital photography applications—use DMA. See also ***CPU; device driver.***

directory folder

A way to group information, data, or images in a computer. The term *directory* is equivalent to folder. When images are stored on a hard drive, many photographers will set up a structure made up of folders divided into different levels. Each folder is broken out into additional subfolders, and so on, to make it easier to find a specific image. An example would be to set up a master file, called *Photographs*, then create files subsumed under *Photographs* for each year, called *2005, 2006, 2007*, and so on. Each of the year files would in turn contain files for each month, such as *January, February*, and *March*. Within the monthly files, individual jobs would each get a file. An example layout would be: Photographs > 2006 > December > Jones Wedding.

direct photo printing

The ability to print an image directly from a digital camera or a digital memory card without having to go through a computer. Color printers are now available that have an input slot for various memory cards. Once the card is inserted, images can be printed with a selection of sizes and specific images to be printed. These can be used as event printers to save time and effort in getting a group of standard prints done quickly.

direct to card (DTC)

A technology designed to print digital images directly on cards for use as identification (ID) badges. DTC greatly speeds up the creation of ID badges and is useful for larger companies and trade shows.

disc

An optical storage medium for computers. These media include CD, CD-R, CD-RW, and DVD. Data is stored by being *burned* into the disc itself. See also *disk; CD; CD-R; CD-RW; DVD.*

discontinuous spectrum

A spectrum of light that is not continuous, such as that produced by various types of lamps. Since various frequencies or wavelengths are missing, these kinds of sources tend to alter color when subjects are photographed. Vapor lights, such as sodium vapor lights, fluorescent lights, and arc lamps, have discontinuous spectrums. Using discontinuous spectrum lighting can make it difficult to get true color fidelity in images.

discrete cosine transformation (DCT)

The algorithm used to compress an image in a lossy image format such as the JPEG file format. DCT is also used in the MJPEG, MPEG, and DV video compression formats. See also *JPEG; MPEG.*

disk

A magnetic storage medium for computers. There are a wide variety of disks, such as hard drive, zip disk, floppy disk, and diskette. See also *disc; hard drive; zip disk; floppy disk; diskette.*

disk drive

A data storage device made up of spinning platters. Various techniques are used to store data such as optical drives that use CD's or DVD's and magnetic drives that are usually called hard drives. *See also CD; DVD; floppy disk, optical drive; and hard drive.*

diskette

A small, removable magnetic disk. The diskette was based on earlier larger disks, such as 8-inch and 5 1/4-inch disks, known as *floppies*. Diskettes are still called floppies even they are not flexible. See also *floppy disk.*

diskette – This is a 1.3 MB diskette.

dispersion

The spreading of colors, or wavelengths of light, as they travel between media of differing density. This refraction varies according to the wavelength. A prism is an example: the colors are dispersed because some bend more than others based on their wavelength. After traveling through a prism, a ray of white light makes a complete color spectrum of visible light.

display technology

Technology used to display images. Besides CRT monitors, display technology includes LCD monitors, plasma displays, and various types of video projectors. New technologies for displays are being developed regularly. See also *CRT; LCD.*

distortion

A type of monochromatic lens aberration. Distortion occurs when straight lines are bent after going through the lens. There are two types of distortion: *barrel distortion* and *pincushion distortion*, depending on which direction the lines bend. These types of distortion are usually easy to correct in lenses of normal focal lengths by using *multiple element lens designs*. See also *aberration; barrel distortion; pincushion distortion.*

dithering

The use of two colors of pixels to simulate a third color, or the use of black-and-white pixels to simulate grayscale in images. This is the computer technique used to display images on devices with different color palettes without having to convert the colors. Dithering is used to blend areas that would otherwise band in compressed images, to create halftones for printing, and to create shading and fills. It is also used as an anti-aliasing technique to smooth jagged lines. Regular dithering uses a pattern of two different colors. D*iffusion dithering* uses randomly placed pixels of two different colors to accomplish the same thing. See also *diffusion dithering; anti-aliasing; halftones.*

DMA

See *direct memory access.*

dodge

A technique by which light is held back from portions of an image to make part of the image lighter. Although the term was originally created to refer to a darkroom technique with film, the digital equivalent is the *dodge tool* in Photoshop. The actual process is called *dodging*. See also *burning in.*

DOF

See *depth of field.*

domain

(1) The virtual host for a website on the Internet. The term *domain name* refers to a custom website URL, such as joesphotography.com. Sometimes the term *domain* is used incorrectly to describe the URL, when it should be called *domain name*. (2) Photographs available for free use under certain conditions, as in *public-domain photographs*. (3) The whole digital world, as in *digital domain*. This last meaning is similar to *digital realm*. See also *digital realm.*

dot

> A drop of ink on paper used in printing. On inkjet printers, the photograph is made of small droplets of color and black ink that are sprayed on the paper. A dot matrix printer uses larger dots created from pins hitting a ribbon, much like a typewriter, to print letters. In newspapers and magazines, photographs are created from small drops of different colored inks. See also *dots per inch.*

dot gain

> The action of paper wicking the ink applied during printing into larger dots. These dots gain in size, such that allowances must be made during the printing process through proper ink and paper combination selection. See also *dot.*

dot matrix

> An older type of printer that created letters out of dots made from small pins hitting a ribbon, much like a typewriter, to print letters. These printers could only print rough approximations of images. See also *dot.*

dot pitch

> (1) A measurement used to compare computer monitors. The distance between phosphor dots is measured in millimeters. Usually, the smaller the dot pitch, the sharper the monitor. When comparing the dot pitch between two monitors, it is important to note if they are using the same measurement of either diagonal or horizontal dot pitch. Horizontal dot pitch will generally give smaller numbers than diagonal. Diagonal dot pitch is generally considered to be a better representation of monitor display quality. (2) The measure of the size of the *RGB triad*, plus the distance between them. See also *dot.*

dots, halftone

> The drops of ink that make up an image when images are printed with offset printers. See also *digital halftone.*

dots per inch (dpi)

> A printing term indicating the resolution of the printing process. Dpi refers to the number of printing dots, either halftone dots or inkjet dots, per inch. It is often used incorrectly to refer to image resolution, which is actually measured in *pixels* or *pixels per inch* (*ppi*). The higher the dots per inch, the greater the printing resolution, and the more detail that will show in the final printed image.

Double SuperTwisted Nematic (DSTN)

> Also called *Dual SuperTwisted Nematic*. An LCD display that has more contrast than other types of LCD displays. DSTNs have a lower-quality image display and a slower response time, but they are less expensive to manufacture. The *dual* refers to a dual scanning process in which the

screen is divided in half and each half is scanned at the same time. This gives the display a sharper appearance.

download

The process of moving data (images) from the camera or media card to a computer or other digital storage device.

downsampling

Using specialized software such as Photoshop to reduce the size of an image. The amount of data in an image is reduced to make the image smaller. This is done by combining data points using various mathematical formulas. The formulas attempt to represent the removed data in such a way that the image appears to be unchanged. Other techniques involve simply throwing away the extra data points.. Currently, using the Bicubic Sharper function in Photoshop seems to be the preferred method of image downsampling.

downsize

Also called *downsampling*. Reducing the size of an image. See also ***downsampling.***

dpi

See ***dots per inch.***

DPOF

See ***digital print order format.***

drag

Half of the computer technique of *drag and drop*. An image in a folder or on a desktop is clicked on and then moved to a new location while still holding the button on the mouse. The moving action is called *dragging*. See also ***drag and drop.***

drag and drop

A computer technique to move objects, specifically photographs in this case, from one location on a computer to another. The object is clicked on with the mouse, and then the mouse is moved (dragged) while still holding down the button. Once the object is at the new location, the mouse button is released (dropped) and the object stays at the new location. This is a quick and graphical technique to move things from one folder to another, from a folder to the desktop, from one disk drive to another, or from the desktop to a folder. Some software programs will accept input by dragging items and dropping them onto the program icon. The program will then launch and perform an action. A *droplet* works the same way in Photoshop. See also ***drag.***

DRAM

An abbreviation for dynamic random access memory. DRAM is a volatile memory that loses its stored information when it loses power. It is a

simple form of memory that can store a lot of information in a small space because it has the capability of high-density storage. DRAM memory is often used as a buffer in digital cameras. See also **buffer; DRAM buffer.**

DRAM buffer

A temporary storage location for images found in a number of digital cameras. Images are stored in the DRAM buffer until they can be processed by the camera and then written to the digital memory storage card. The higher the pixel count and the faster the shooting speed, the larger the DRAM buffer must be to store images. See also **buffer; DRAM.**

driver

Software that allows a computer to control or *drive* devices attached to it, such as printers and scanners. Manufacturers often regularly update these drivers. When a computer operating system is upgraded, it is often necessary to upgrade drivers by downloading new, more-current ones from the manufacturer's website. If a computer user begins having problems with a device that has operated well in the past, checking and upgrading the driver is a good idea.

drive speed

Refers to how fast a hard drive, CD drive, or a DVD drive operates, or spins. The faster it can spin, the faster it can access data. When reading or writing large image files to one of those drives, a faster drive usually means that the operation will finish sooner. When processing and saving, or burning large numbers of images, the increased speed and time saved can really add up.

DRM

See **Digital Rights Management.**

droplet

A Photoshop action that is saved external to Photoshop. The droplet is represented by an icon that is shown on the desktop or in a folder on the system. To initiate the droplet action, simply drop an image, a series of images, or a folder of images onto the icon. Photoshop is launched and the action begins to work on the images. Using droplet is simply a faster and more efficient way to initiate actions in Photoshop. See also **action.**

drop shadow

A thin shadow placed behind an object or photograph to make it appear that the object or photograph is floating above the paper or monitor. This drop shadow is created and made part of the image by software such as Photoshop. This technique is often used effectively to dress up web page photo galleries. *(see figures on page 123)*

drop shadow – none – This is the original image without a drop shadow.

drop shadow – The same image has a drop shadow attached to make it seem to float on the page.

D

drum scan

A scan or digital file produced by scanning a film or print image on a drum scanner. Drum scanners usually produce the highest-quality file because the photo multiplier tubes they use are more sensitive to light than the CCDs used by most desktop or flatbed scanners. They can scan at resolutions higher than film can record. See also *drum scanner; scanner.*

drum scanner

A scanner used to create a digital file by scanning a film or print image on a drum scanner. Drum scanners usually produce the highest-quality file because the photo multiplier tubes they use are more sensitive to light than the CCDs used by most desktop or flatbed scanners. They can scan at resolutions higher than film can record. Drum scanners are much more expensive than desktop flatbed scanners, so their use is declining, especially as prices drop on desktop scanners. Drum scanners require that the image to be scanned be soaked in a special oil, to ensure that good contact is made with the glass-cylinder scanning drum. This wet mounting is much less convenient to use than a flatbed scanner. See also *scanner.*

DSLR

See *digital single lens reflex; camera.*

DSP

See *digital signal processor.*

DSTN

See *Double SuperTwisted Nematic.*

DTC

See *direct to card.*

dual processors

A computer that contains two separate CPUs that are not part of the same integrated circuit (I/C). An integrated circuit is a miniature circuit made up of electronic components that are designed to be smaller and cheaper than the transistor and vacuum tubes that they replaced. Dual processors should not be confused with dual core processors, which have two CPUs in the same I/C. Ideally, a dual-processor computer will operate much faster than a computer with a single processor. See also *CPU; integrated circuit.*

Dual SuperTwisted Nematic

See *Double SuperTwisted Nematic.*

Dublin Core schema

More properly called the *Dublin Core Metadata Element Set*. This schema was created at a workshop in Dublin, Ohio, in 1995. It is a set of fifteen different elements used to describe digital assets. The fifteen

elements are: *contributor, coverage, creator, date, description, format, identifier, language, publisher, relation, rights, source, subject, title,* and *type*. The Dublin Core not only lists the elements but also defines what each of them means. Digital images use many of these elements to describe an image; they are stored as metadata in the image itself. The information can be added in a program such as Photoshop. See also ***metadata.***

D

duotone

Images printed with two colors of ink. One of these ink colors is usually black. Using Photoshop or a similar program, the photographer can now create duotone images that can be printed on a standard color printer. Some photographers use duotone techniques in Photoshop to create sepia prints.

DVD

See ***digital video disc; disc; and disk.*** *(see figure below)*

DVD versus CD - The disk on the left is a gold archival CD and the disk on the right is a gold archival DVD. They are the same size and can only be distinguished by reading the hub printing.

DVD-

See *digital video disc.*

DVD+

See *digital video disc.*

DVD-R

See *digital video disc.*

DVD+R

See *digital video disc.*

DVI

See *digital visual interface.*

dye-based inks

Inks made primarily from dyes for use in inkjet printers. These dyes are relatively inexpensive and easy to use. They also have the widest gamut and saturation of colors of the four types of inks available for inkjet printers. The four types are *dye inks* (also called *dye-based inks*), *archival dye inks, pigmented inks*, and *pigment inks.* Dye-based inks are water-soluble, so they will run or spot easily with water. They also have a tendency to fade more than the other types of inks. See also ***archival dye inks; pigmented inks; pigment inks.***

dye inks

See *dye-based inks.*

dye-sub

(1) Slang term for *dye-sublimation*. (2) Prints made by a dye-sublimation printer or the printer itself. See ***dye sublimation; dye-sublimation printer.***

dye-sublimation

A process used in printing photographs. The process uses solid dye in the form of ribbons that are vaporized by the use of a small heater. This colored gas solidifies on the special paper to produce the image. Extremely fine control of the three colors cyan, magenta, and yellow is possible, enabling the printing of good-quality photographs. See also ***dye-sublimation; dye-sub.***

dye-sublimation printer

A photo-quality printer that utilizes the dye-sublimation technique of printing. It is capable of producing relatively good-quality photographs. See also ***dye-sublimation.***

dynamic random access memory (DRAM)

See ***DRAM and DRAM Buffer.***

dynamic range

Refers to the light sensitivity of an image sensor (as well as the light sensitivity of a film or paper in analog photography). Dynamic range is

measured by the sensor's ability to capture shadow detail and pure black, as well as to highlight detail and pure white.

early Z test

An algorithm that tests to see if pixels will be visible in the final image. If they will not be, they are discarded. By using this algorithm test early, before sending the image to the rendering engine, efficiency is increased. The *early* in the name distinguishes it from other tests done later in the process. Early Z tests are used in three-dimensional gaming applications to increase processing speed.

EB

See *exabyte.*

ECF

See *eye control focus.*

ECPS

See *effective candlepower seconds.*

ED

(1) An abbreviation for *enhanced definition images.* A new television format that is better than standard television but not as good as high definition television (HDTV). (2) An abbreviation for *extra-low dispersion.* See *Extra-low dispersion.*

editing

(1) The selection of images by an editor—to show to a client, for example. Photographers edit their photographs to show their portrait, wedding, commercial, or other clients a selection of images. Editors at stock agencies edit image submissions made by photographers to select images to include in the stock agency's collection and to choose images from their collection to show to potential stock image licensors. (2) The retouching done on individual images. Software used for retouching is sometimes called *photo-editing software.*

EEPROM

See *electrically erasable programmable read only memory.*

effective aperture

The size of a noncircular aperture expressed as the size of a circular aperture. Variable apertures are adjusted with a series of interwoven blades used to reduce the size of the largest opening. Because the blades do not make a perfect circle, the actual aperture is expressed as an

effective aperture size, as if it were a circle of a certain size. The more blades, the closer the aperture is to a circle, and the closer it is to the effective aperture size. See also **aperture.**

effective candlepower second (ECPS)

The unit of measurement of the light output of an electronic flash. See also **beam candlepower second; candlepower.**

effective megapixels

Not all pixels end up in the image produced by the camera. Some of the pixels are used for other purposes. For example, pixels along the edges of an image are often masked out or used to determine black or complete darkness needed to compute image light levels. *Effective megapixel* refers to the actual number of pixels in the final image plus the *ring pixels*. Thus there will be slightly more effective megapixels than the megapixel count in the final image. See also **pixel; megapixel; ring pixels.**

effective pixels

Similar to *effective megapixels*, except for the *mega* multiplier. See **effective megapixels.**

effective resolution

(1) A way to measure and compare a film original to a digital original. (2) Scaling an image in a page-layout program. Unless data is added when the image is scaled up, or thrown away when the image is scaled down, the same number of pixels will exist in the larger or smaller image. The resolution of the image has to change proportionally to make up for this phenomenon. This new resolution is known as the effective resolution. See also **resolution.**

E.I.

See **exposure index.**

EISA bus

EISA is the acronym for *enhanced industry standard architecture*, which is a bus designed for PCs. The EISA bus uses multiprocessing, using 32-bit architecture. It was designed to compete with another bus from IBM. It has been replaced in more current computers with a local bus called PCI. The type of bus determines the type of expansion card needed in a particular computer. See also **bus.**

EL

(1) A type of lens interface used by Hasselblad. (2) A series of lenses developed by Rollei, called the *EL-series*. (3) A series of enlarging lenses called *EL-Nikkor*. (4) An abbreviation for *electroluminescent*. See **electroluminescent.**

electrically erasable programmable read only memory (EEPROM)

An erasable programmable read-only memory (EPROM), that can be erased electrically instead of having to use ultraviolet light, making it

much more convenient. See also ***erasable programmable read only memory.***

electroluminescent (EL)

Light given off by a material when an electric current is passed through the material. Besides the common use of low-current nightlights, electroluminescent panels are used to back-light LCD displays and monitors.

electromagnetic radiation

Energy made up of two parts: *magnetic* and *electric*. This energy occurs in waves that are in right angles to each other. There are different types of electromagnetic radiation depending on the frequency of their waves. These include radio waves, microwaves, infrared radiation, visible light, ultraviolet radiation, x-rays, and gamma rays. Digital photography is mainly concerned with visible light and, in some cases, infrared radiation.

electronic display

Any kind of display that converts information to a visible display. Some examples are CRTs, which displays analog information, and digital display devices such as LCDs and LEDs. Computer monitors are some of the most common types of electronic displays for digital photography.

electronic document

A computerized document designed to be kept in a computer and viewed on an electronic display rather than distributed and viewed in a paper form. There are a number of different formats in which the electronic document can be kept. Two of the most popular are PDF and HTML. Some formats require special viewing software, others can be viewed by a wide variety of software. See also ***PDF; HTML.***

electronic image stabilizer

See ***image stabilization.***

electronic rangefinder

(1) The electronic display of distance information. (2) An indication, frequently a dot displayed in the viewfinder, that an image is in focus. This indication is useful when focusing manually. (3) A system that measures the distance to a subject electronically, as opposed to an optical rangefinder.

electronic retouching

Retouching a digital image with an image-manipulation program such as Photoshop. See also ***digitally retouch; retouching.***

element

(1) A *picture element* or *pixel*, the basic building block in digital photography. (2) A portion of an image, as in an element of an image needs to be removed. (3) A single lens in a group of lens elements in a compound lens. See also ***pixel.***

E

elliptical dot

A type of halftone dot that has an elliptical shape instead of the more usual round shape. It is designed to give better tonal values, especially in the middle tones. See also **halftone.**

ELN

An abbreviation for *electronic lab notebook*. ELN is software designed to replace a paper notebook used in a laboratory. Lab notebooks also provide a legal trail for research; thus it is important that the ELN software provide the same capability.

embed

The process of adding metadata to an image. The resulting data is stored within the image file in most cases, except for proprietary raw files that have an XMP sidecar created. Thus the data is embedded into the image. See also **metadata.**

embedded profile

Describes a color profile for an image that has been stored within the image itself. An embedded profile will enable software such as Photoshop to interpret the colors correctly in an image and display them properly. It is especially important to embed color profiles into images that are sent to others for future processing, output, or printing. Some web browsers are color-aware and can read embedded profiles. See also **color management; color profile.**

embossing

A tool or filter that creates a two-dimensional effect that appears to be three dimensional, as if an embossing stamp were used. Embossing can be done digitally in Photoshop. *(see figure on page 131)*

EMR

See **electromagnetic radiation.**

encapsulated postscript (EPS)

A file format based on vectors (continuous lines) rather than raster images (made up of pixels). This type of file is used with Postscript printers. See also **vector; vector graphic; vector image; vector path.**

encryption

The process of hiding information by changing it so that it requires special software to read it. Some portions of proprietary raw digital image files are encrypted so only the camera maker's software will be able to read them. This makes it difficult for third-party software—such as Adobe Camera Raw (ACR)—to read raw files in the way that the camera recorded it.

enhancement

The process of digital retouching for the purpose of improving an image.

embossing – This is an example of the use of the Photoshop embossing filter.

Portrait photographers often use this term instead of *retouching* to describe what is done to a portrait image. See also **digital retouching.**

EPROM

See **erasable programmable read only memory.**

EPS

See **encapsulated postscript.**

erasable programmable read only memory

Also known as an *EPROM memory chip* and *non-volatile memory*. A hardware device used in the past to store images. One advantage of EPROM is its data stays in the chip even when the power is turned off. The main use of EPROM is for programs or data that needs to be accessed frequently but erased and changed infrequently. F*irmware* is an example of software that needs to be changed infrequently. Erasing an EPROM requires ultraviolet light. See also **electrically erasable programmable read only memory; firmware.**

erase

The process of removing data. Portions of an image can be erased with the eraser tool in Photoshop. An entire image or data file can be erased from a hard drive or from computer memory. In the case of an entire image, the file is usually erased by deleting the entry from the computer's directory. The actual image is still there until it is written over. This information can come in handy if an image is accidentally erased. Special software is designed to recover erased images. Most photographers will need this special software at some time—when they accidentally erase an image. See also **eraser.**

eraser

A Photoshop tool used to erase portions of an image. It is often used with layers, where only portions of a layer are erased, leaving the original image underneath. There are many creative uses for the eraser tool.

eSATA

An abbreviation for *external Serial Advanced Technology Attachment*. A technology designed for rapid data transfer to a hard drive. This is important for digital photographers because of the large number of images and huge storage requirements they have. Installing an eSATA card in the photographer's computer enables him or her to add a tower with external hard drives, which are connected through the eSATA card. The rate of data transfer is much higher than is possible with FireWire or USB 1.0 or 2.0. The data transfer speeds are similar to those available with an internal hard drive. The eSATA standard will support cable lengths of up to two meters. The cables tend to be expensive. Two-meter cables are much more expensive than one-meter cables due to the difficulty involved in manufacturing them. *(see figure on page 133)*

eSATA - This figure shows an eSATA connector.

Ethernet

A technology designed to connect computers in a *local area network*, or *LAN*. It is especially suitable for the small networks that many photographers have, such as a laptop, a desktop computer, and perhaps an older computer set up as a print server. Many or most new computers come ready to plug into an Ethernet network. Others require the addition of an Ethernet card. The Ethernet cables that plug into the computer look a bit like an oversized modular telephone plug and jack. See also ***local area network.***

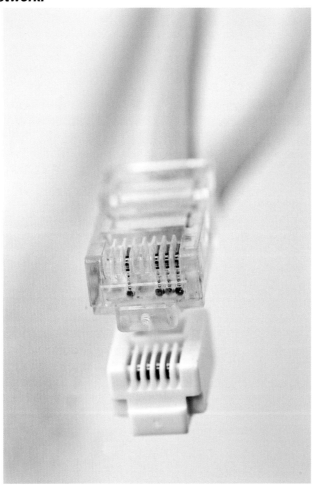

Ethernet - This figure compares the size of an Ethernet connector (on top) to the size of a standard modular phone connector.

E-TTL

> An abbreviation for *evaluative through the lens*. A flash exposure system developed by Canon that measures a pre-flash to calculate what the flash output should be for the main flash. This enables the flash to operate in an automatic mode.

EV

> See **exposure value.**

evaluative metering

> An automatic metering system developed by Canon. The scene is divided into a number of zones. The exposure is calculated for each zone separately. Then a complex calculation is made of all of the individual zone exposures to create the best possible exposure automatically.

exabyte (EB)

> (1) A large amount of storage. (2) One billion gigabytes. (3) A type of storage that uses an 8 mm tape data cartridge. See **gigabyte.**

exchangeable image file format (Exif or EXIF)

> A file format used to save data primarily in digital camera images. The data usually includes date, time, aperture, shutter speed, focal length, metering mode, and ISO speed. It also tells the photographer if a flash was used. In addition, there is space for location information, such as from a GPS receiver, and copyright information. Only a few cameras currently offer the last two capabilities. Exif data can be seen in a number of image processing programs such as Photoshop. See also **metadata.** *(see figure on page 136)*

EXIF

> See *exchangeable image file format.*
>
> *(see figure on page below)*

File Name	DSCF9731.JPG
File Path	Originals
Dimensions	2848 x 4256
Cropped	2848 x 4256
Date Time Original	10/27/04 2:56:19 PM
Date Time	10/27/04 2:56:19 PM
Exposure	$1/90$ sec at $f / 5.6$
Focal Length	64 mm
Brightness Value	3.66
Exposure Bias	– 1 EV
ISO Speed Rating	ISO 400
Flash	Did fire
Exposure Program	Normal
Metering Mode	Pattern
Make	FUJIFILM
Model	FinePixS2Pro
Software	Digital Camera FinePixS2Pro Ver1.00

EXIF – Metadata from the camera, called EXIF data, that gives information about the exposure is shown here in the panel from Adobe Photoshop Lightroom.

expansion board

> A device plugged directly into the motherboard to add additional capabilities to the computer. There are a variety of different types of expansion boards, such as modems, sound cards, graphic cards, video cards, and network cards. One of the most common types of cards is the PCI-Express.

expansion memory

A type of memory that could be added to early computers.

expansion slots

Slots in a computer that allow the user to add additional features. For example, an expansion card can be added to allow external hard drives in a stacked enclosure to be connected to the computer. That card is known as an *eSATA card*. Such features are important to digital photographers with growing quantities of digital images that have to be stored. Another option would be to add another video card so that the computer could use two monitors at the same time.

export

The process of sending a file or data, such as an image out of a computer to another device. For example, the photographer might export an image from a software program to import it into a different program or to send it to a client or photo lab. See also *import.*

exposure compensation

Scenes photographed with very bright or very dark subjects, or regular subjects against a very bright or very dark background, will often need to have their exposure adjusted from the "average" one calculated by an automatic camera. This is usually done by setting an exposure adjustment or compensation in one-third or one-half stop increments on the digital camera. These adjustments can be either positive or negative, and there is usually a possibility of having up to two or three stops in total. Some trial-and-error experimentation is often required to get the perfect exposure.

exposure factor

An exposure adjustment used to correct the exposure when using filters when the camera does not have through-the-lens metering, or for special lighting situations. Typically the exposure factor is given as a number of stops, or fractional stops, which the exposure must be increased to compensate for light loss through a filter.

exposure index (E.I.)

A numerical rating of the sensitivity of a film or a digital sensor to light. The higher the number, the more sensitive the film or sensor. E.I. is still sometimes called *film speed*, even when used to represent the sensitivity of the digital sensor. It is a numerical scale in which a doubling of a value represents a doubling of the sensitivity. Most digital cameras have a range of 100 to 800 or to 1,600. Exposure index is the same as *ISO*. In the past, *ASA* was the term used. See also *ASA, ISO.*

exposure latitude

A range of exposure that will provide an acceptable image. Exposure latitude is often given as x stops of overexposure and y stops of underex-

posure. Digital cameras typically have more tolerance for underexposure than overexposure, which tends to blow out the highlights of an image. See also **blown out.**

exposure meter

Also called a *light meter*. A device, often built in to cameras, which tells the photographer the exposure to use. Some exposure meters are *incident meters*, which indicate the amount of light falling on the meter. An incident meter is commonly used at the subject location and aimed back at the camera. Another type of meter is a *reflected light meter*. These meters are used at the camera position and measure the amount of light reflected back toward the camera from the subject. In both cases, the exposure meter assumes that the world is 18% gray and indicates the amount of exposure necessary to render the subject an 18% gray. Using a reflected light meter when the subject is not 18% gray (for example, in black or white), results in the meter's value having to be adjusted to provide the correct rendering of the subject. *(see figure on page 139)*

exposure setting

The values of the shutter speed and aperture (f-stop) settings used on the camera to create an exposure.

exposure value (EV)

A number assigned to a particular exposure level no matter what combination of shutter speed and aperture are used to get to that exposure. By convention, EV 0 is set at an aperture of $f/1.0$ and a shutter speed of 1 second. Each increase of one in the EV corresponds to a halving of the amount of light. So each step of EV corresponds with a step in aperture or shutter speed. Light meters and some cameras have markings for EV.

extended graphics array (XGA)

A computer monitor with a resolution of 1024 x 768 pixels.

extensible markup language (XML)

A method of marking data that is designed to allow sharing of information across different computer platforms and systems. XML is especially useful for systems connected across the World Wide Web. It is not really a language; it is a set of rules of ways to organize and tag data so that a variety of computer systems can understand that data. It is often used to create customized vocabularies known as *XML schemas*. By referring to the particular XML schema document, anyone can understand the data, and software can manipulate it. The *World Wide Web Consortium*, also known as *W3C*, developed it in 1996. An XML schema is used by programs, such as Apple's Aperture, to define how they store and order metadata with a series of tags in their metadata files. See also **metadata.**

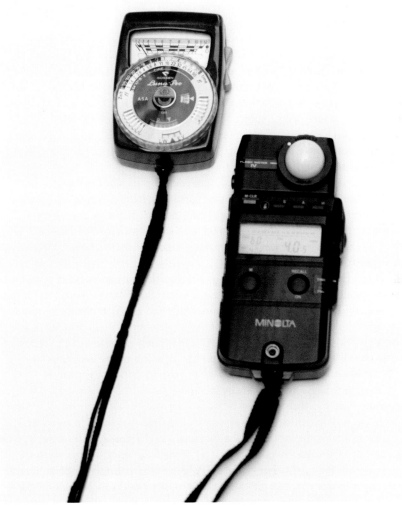

exposure meter - This figure shows two light meters. The one on the left is a
traditional light meter and the one on the right is a flash meter.

extensible metadata platform (XMP)

Defines how metadata is stored within images. Because it is *extensible,* users can add to it. The most common use of XMP is to include information about the image that is added by the use of Photoshop or similar programs and stored within the image file itself. Common metadata that is added include the elements found in the *Dublin Core schema.* IPTC has developed a set of custom panels that can be downloaded for XMP to store IPTC data through the use of Photoshop CS. Photoshop CS2 has these IPTC panels built in. See also ***Dublin Core schema; metadata.***

extract

(1) The process of getting information from a digital image. This can be extracting the Exif (camera information) or the IPTC (metadata). The extraction of data is done with various software programs such as Photoshop. (2) A tool, which Photoshop calls a filter. This tool is designed to assist in removing a subject from a background, with the intention of having no background or to place the subject on a new background. See also ***Exif; metadata.***

extra low dispersion (ED)

A type of glass, often made with rare earth metals, used to manufacture lenses. ED is used to reduce chromatic aberrations, especially those on longer telephoto lenses. Nikon first developed ED for its camera lenses. Other manufacturers have come up with similar ideas as well, although they may use a different name or designation for their lenses.

eye control focus (ECF)

A technology developed by Canon that enables the camera to know where the photographer's eye is looking and select that point to focus on. The viewfinder uses a group of very small infrared LEDs to bounce infrared light off of the photographer's eyeball to determine which way he or she is looking. It then selects the closest focus point in the automatic focus system and activates it. The system has to be trained by each user to calibrate it. Even then, it is not 100% accurate, but each version is improving in reliability and speed.

eyedropper

A tool in Photoshop used to measure or sample the color values of an image at a particular point. The tool can select a single pixel or can average the values over a 3 x 3 or 5 x 5 block by selecting one of those blocks in the eyedropper options. By using the eyedropper tool, a photographer or designer can pick up a color from an image to use in a font or a background, or in another graphical element.

f

Refers to the *f-number* or *f-stop*, as in *f*/2.8. The *f* is an abbreviation for *factor, focal*, and *focal length*. See ***f-stop.***

factor

See ***f stop; f.***

factory default

The original setting of the parameters in a software program when it is initially installed. See also ***default setting.***

fading

(1) Deterioration of a print or of film, which shows up gradually. Fading can be caused by exposure to light or pollutants, among other things. Sometimes the entire print fades evenly; at other times, only some colors are affected and the print develops a color cast, such that it turns orange or green. The color inks or dyes have a lifetime that is often less than that for black-and-white images. Usually photographs are best protected by storing them in the dark, where possible, or framed behind glass or ultraviolet plastic. If they are kept away from sunlight, fluorescent light, and pollutants, they will generally last longer. (2) Areas on a print that are intentionally made to gradually disappear, especially along an edge.

Fahrenheit (°F)

A temperature scale in the English measurement system. Water freezes at 32 °F and boils at 212 °F. The name comes first proposed the scale in 1724. To convert from Fahrenheit to Celsius, °C = (°F-32)/1.8. To convert from Celsius, °F = °C x 1.8 + 32. See also ***Celsius; Kelvin.***

fair use

Part of the US copyright law that allows the free use of intellectual property, such as images, without the copyright holder's permission and without infringing the copyright. Other countries have similar provisions under different names. There are only certain conditions under which this is allowed: criticism, journalism, research, scholarship, and teaching. The amount of the work used is also a factor considered when determining if a use is *fair use* as defined under the law. With images, for example, an image of Canada might be used freely and without permission if it appeared in an article that was about the image, but probably not if the article were just about Canada. This area of the law is extremely complex and an intellectual property attorney should be consulted when necessary before attempting to exercise fair use. Fair use is one of the most misunderstood areas of copyright law.

FAQ

An abbreviation for *frequently asked questions*. A FAQ is usually a document or page with a number of questions and their answers and is found on many websites. If the photographer is looking for information on a website, a FAQ is a good place to begin.

FARE

An abbreviation for *Film Automatic Retouching and Enhancement*. FARE is a technology developed by Canon to eliminate dust and scratches when scanning film. It is similar to *Digital ICE*. The earlier version of FARE does not work with Kodachrome. FARE works only with Canon-brand scanners. Like ICE, FARE uses two scans, with the first one being infrared. It can use the IR scan to subtract out the dust and scratches automatically. The generic term for this is *infrared cleaning*. See also **Digital ICE.**

fast lens

A lens with a large aperture (represented by a small f- number). The term came into being because the "faster" a lens is, the higher or faster the shutter speed can be.

FAT

See **file allocation table.**

Fax Group 4

A type of fax machine. The group number indicates the speed and resolution of the fax. *Group 4* is fast, with higher resolution, and needs a high-speed phone line (ISDN) to operate. Slower-speed and resolution faxes that use a regular phone line are known as *Fax Group 3*.

FET

See **field effect transistor.**

FF

An abbreviation for *full-frame digital camera*. See **35mm equivalent; digital camera; full frame.**

field effect transistor (FET)

A transistor that controls the conductivity of semiconductor material by using an electric field to control the shape of a channel in the semiconductor material. A FET can be thought of as a simple switch. FET's are used in CMOS integrated circuits for low-power amplification. They are generally found in integrated circuits of all kinds as one of the many components. They are used in digital photography as part of the image sensor in some digital cameras.

field curvature

A type of monochromatic aberration. See **aberration; curvature of field.**

FIF

See **fractal image format.**

FIIPS

An abbreviation for *fix it in Photoshop*. Also spelled *FIPS*. Rather than fixing something on a photography set, the photographer will say, "Don't worry, I will *FIIPS* it."

file

A group of data. In digital photography, another name for a digital image, as in *digital file*.

file allocation table (FAT)

The primary file system for Windows-based computers, disk drives, and digital memory cards for cameras. FAT is a table that tells the computer where the pieces of a file are stored on a hard drive. The description usually contains the number of bits that it supports, such as *FAT12, FAT16*, and *FAT32*. A simple system that was designed in 1977 by Microsoft, FAT is prone to fragmentation, where bits and pieces of a file are spread out over the entire disk. Drives that use this format must be periodically defragmented. The Macintosh operating system can read and use the FAT file format, except on the boot disk drive.

file converters

A hardware or software device for converting a file or image from one type of format to another. Photoshop is an example of software that has the capability to convert an image file from one format, for example a TIFF file, to another, for example a JPEG file.

file extensions

The three letters on the end of a file format that tell the computer, and the user, what type of file is being accessed. Some examples are .jpg, .tif, and .gif. See also **file format.**

file format

Also called *image format*. A method of storing data in a computer file. Usually, the file will be saved on a computer hard drive or optical disc. Some common image file formats are JPEG, TIF, BMP, GIF, PDF, raw, and DNG. See also **file extensions.**

file info

(1) The metadata, including IPTC and Exif, stored in an image file. (2) The name of a command in Photoshop that is used to access this information. Besides IPTC and Exif, file info can store custom information generated from custom panels. See also **EXIF; IPTC; custom panels.**

file naming

The process of assigning a file name to an image file or other file. It is important that a file name is unique; it makes searching for it easier. There are a variety of different naming schemes, including those with

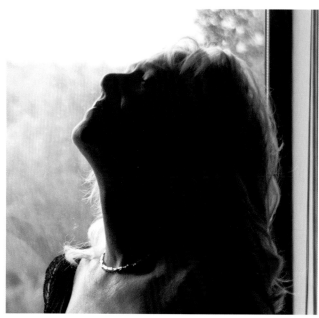

fill flash – no – This backlit image does not use any sort of fill flash. Compare to the next image that was taken with a fill flash.

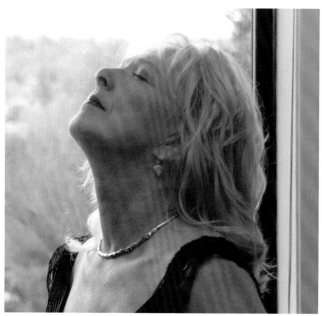

fill flash – yes – This backlit image was taken with a flash used to fill in dark shadows, a technique known as fill flash. Compare to the previous image that was taken without a fill flash.

dates and times or other logical elements. It is best to have a file name made up only of numbers, letters, the - (dash), and the _ (underscore) so that they will be acceptable on all computer systems.

file size

How much space a file takes up on a hard drive or other media. The file size can be stated in bytes, kilobytes, megabytes, gigabytes, or larger quantities. For images, file sizes are often in the megabyte range, depending on file format.

file size formula

To calculate the size of an image file, multiply the pixel dimensions (horizontal and vertical) to get the total number of pixels. Next, multiply the number of pixels by the number of colors (three for RGB; four for CMYK for example), and then by the number of 8-bit bytes (usually 1 for 8-bit RGB, 2 for 16-bit RGB). This formula will give the total number of bytes needed. Divide by 1,048,576 to convert to megabytes.

file transfer protocol (FTP)

Used to transfer information or files from one computer to another over the Internet. Photographers use this technique frequently to upload photographs to a photo lab for printing, to a stock agency, or to a client's computer. Under a typical arrangement, a user, called the client, needs an account and a password to access the other computer, called the server. Sometimes an anonymous FTP is available where the user does not need an account or password to transfer information. See also ***anonymous FTP.***

fill command

Also called *paint bucket tool* and *fill tool*. A Photoshop tool designed to fill a selection on an image with a color or a pattern that is selected by the user. It is especially useful when adding graphic elements to an image as part of a design. An example would be using Photoshop to create wedding album pages with photographs and graphic elements.

fill flash

Also called *flash fill*. A flash unit used with ambient light to create the exposure. The fill flash is used to add a bit of light when the subject is backlit. It is also used in outdoor portraits in the shade to add some contrast and a catch light to the eyes. It is used in sunlight to reduce the contrast by filling in (and thus the name) the shadows, for example, on a subject's face. *(see figures on page 144)*

fill tool

See ***fill command.***

film scanner

A device that can convert an image on film to a digital file. The film can

be inserted in the machine, and by using a lighting source and a digital
sensor, the analog information on the film is converted to digital bits and
bytes. See also *scanner.*

finite element analysis

Computer software used in analyzing engineering problems, creating 3D
images, and running computer simulations. Finite element analysis can be
used, for example, to create virtual photographs of vehicle that is only in
the concept stage.

FIPS

See *FIIPS.*

firewall

A protective software system on a computer designed to prevent unautho-
rized access to a computer from another outside computer. Firewalls are
only needed on computers connected to a network or to the Internet.
There are firewalls for single personal computers and for larger computer
networks. Photographers can set up firewalls inexpensively on their
computers.

FireWire

Also known as *IEEE 1394* and *i.link.* A high-speed serial bus interface
standard designed to connect peripherals to a computer. FireWire has the
advantage of being hot-swappable. It was originally developed by Apple
Computer in the early 1990s. It can connect up to 63 devices at 3,200
Mbps (Megabytes per second). It also provides power, making it possible
for some devices to operate without a separate power connection. The
first version of FireWire was known as *FireWire 400.* A later version with
a higher speed is known as *FireWire 800.* See also *hot-swap.* *(see
figure on page 147)*

firmware

Computer software stored on a ROM, a PROM, an eROM, an ePRom, or
in other ways and used in a hardware device of some kind. Firmware is
not lost when power is turned off. In some cases the user can update the
firmware. Digital cameras and computer peripherals often have firmware
in them. See also *ePROM.*

fixed memory

Also called flash memory. Nonremovable memory built into a digital
camera to store images . Fixed memory is used in inexpensive digital
cameras that do not have or need removable memory cards.

fixed pattern noise

Noise with a repeatable pattern of *hot pixels.* This noise usually becomes

FireWire - This is a photograph of a FireWire connector.

more obvious at longer exposures and as the image sensor increases in temperature. The noise is referred to as *fixed pattern* because the hot pixels typically occur in the same place for each image. See also **hot pixel.**

flag

To mark an image so that it can be worked on or added to a group of other images. Photoshop, for example, has a flag icon that can be set in the browser. Photographers often use this function to run actions on groups of images. For example, all vertical images can be flagged and then an action designed for vertical images can be run on them.

flash card

Also called *flash memory card*. A memory card that utilizes flash memory storage methods to store images. See also **memory card; CompactFlash; flash memory.**

flash card reader

A device designed to attach to a computer in which a flash memory card is inserted for reading or downloading the card's contents. See also **memory card; CompactFlash; flash memory.**

flash duration

The length of time that the light from a flash is active above a certain threshold. Short flash durations are important to stop motion in some photographic situations. Typical flash durations in camera-mounted flashes are around 1/1,000th of a second. With auto flash settings, the flash is cut off once the amount of light needed is reached so flash durations can be shorter, in the range of 1/20,000th of a second for subjects that are closer to the auto flash sensor.

flash exposure bracketing

As in other types of bracketing, using various combinations of flash and ambient light to make the most pleasing photograph. Flash exposure bracketing is typically done with *fill flash* and *ambient light*. The flash is either set to manual, or various compensation settings of + (plus) and - (minus) are used. Some digital cameras allow the flash exposure compensation to be set on the camera itself. This is a different setting than the regular exposure compensation setting on the camera. See also **exposure compensation; flash exposure compensation.**

flash exposure compensation

Also called *flash output level compensation*. Varying the amount of flash exposure that is set by the auto feature of the flash. This exposure compensation can be set on the digital camera or on the flash, depending on the model of the digital camera and the flash. This typically can be changed in discrete steps of 1/3 stop or 1/2 stop. See **flash output level compensation.**

flash, fill

>See *fill flash.*

flash memory

>Also called *flash RAM.* An erasable and non-volatile memory often used to create memory cards for digital cameras. The memory is not volatile, which means that, unlike the memory in a computer, no power is required to maintain the images inside once they are stored there. Although similar to EEPROM chips, flash memory is much less expensive. Internally, it operates slightly differently than EEPROM, notably in the way that it is erased. Flash memory cards have replaced microdrives, once used in digital cameras, for storing large amounts of images. Flash memory cards are very robust and can stand a fair amount of abuse. Photographers have reported leaving flash memory cards in their pockets and then washing their clothes. The cards came through the wash cycle without damage and continued to operate without problems once they were dried. This practice is not recommended, of course. Flash memory is the technology basis of SmartMedia, Secure Digital, Memory Stick, and xD-Picture cards, among others.

flash memory card

>See *flash card.*

flash output level compensation

>Also called *flash exposure compensation.* A feature of auto TTL-type flashes to allow the amount of flash to be increased or decreased over what the automatic flash calculates. Flash exposure compensation is especially useful in digital photography where the results of a test photograph can be seen to be over- or under- exposed, which can be caused by the amount of light or dark in the background, for example. See also *flash exposure compensation.*

FlashPix (FPX)

>A file format that stores images in different resolutions all in one file. Each resolution has dimensions equal to twice the length and twice the width of the previous resolution. FlashPix was developed by Eastman Kodak, Microsoft, Hewlett-Packard, and Live Picture, Inc., working together. It is not a common image file format, and most imaging software does not support it.

flash RAM

>See *flash memory.*

flash, ring

>See *ring flash.*

flash shooting distance range

>The distance from the flash that a correctly exposed image can be created when the flash is firing at its minimum and maximum flash power and

duration. The range will vary based on lens aperture and ISO setting on the camera. If a subject is farther from the flash than the maximum range, the image will be underexposed. The aperture can be *opened up*, the subject can be brought closer, or the ISO setting can be increased to fix this problem. If the subject is closer than the minimum flash shooting distance, then the aperture can be *closed down*, the subject can be moved away, the flash can be bounced off of a white card, the ISO setting can be reduced, or the flash output can be reduced with a filter over the flash or even by placing a white handkerchief or white cloth napkin over it.

flash, slave

A flash that detects the flash of another flash and is thus triggered to fire. It is also called a slave flash.

flash sync

The process that allows a camera to open a shutter and fire the flash at appropriate times so that the shutter is fully open when the flash fires. See also **flash sync speed.**

flash synchronization

See **flash sync**

flash sync speed

The highest shutter speed that can be used with an electronic flash. This number varies with the model of camera and type of shutter mechanism. Typically speeds are $1/60^{th}$, $1/90^{th}$, and $1/125^{th}$ of a second with modern digital SLR cameras. These cameras use a focal plane shutter, and the speeds are lower than those available with a leaf shutter, found mainly on medium-format film cameras. A few digital cameras will allow faster flash sync speeds.

flash terminal

The method of connection between the flash and the camera so that its operation can be synchronized. There are two types of terminals used in modern digital cameras. The first is the *hot shoe terminal*, where the flash makes contact through its foot when attached to the top of the camera. The second is a small connector called a *PC connector*, where a cord from the flash unit can be attached. See also **PC connector; hot shoe connector.** *(see figure on page 151)*

flash unit

A separate lighting device that produces a brief flash of very bright light to light a scene. Flash units are usually electronically powered. A flash unit can attach directly to a camera with a shoe mount, or it can be a studio unit that is mounted on a stand. A flash unit can be powered by batteries, either disposable or rechargeable, or by standard electrical power. The price can vary from a few dollars to many hundreds or even thousands of dollars. The duration of the flash is typically around

F

flash terminal - This figure shows a flash terminal mounted on the side of a
 camera.

flat – This grayscale image (usually called black-and-white) has no pure blacks or pure whites and is low in contrast. This is known as a flat image.

1/1,000th of a second. See also ***flash duration.***

flat

The quality of having many tones between the whitest and blackest parts of an image. Often, a flat image has no pure white and pure black tones. Most of the tones are middle gray variations. An image that does not have

a lot of contrast is said to be flat. A *flat image* is the opposite of a *contrasty image*. See also **contrasty.** *(see figure on page 152)*

flat-bed scanner

A scanner that uses a flat bed with clear glass, instead of a drum, to hold the original. A flat-bed scanner does not require the use of oil to hold the original flat, so it is generally easier and less messy to use. In addition, the original is stationary and the linear CCD sensor array moves to scan it. Usually, the sensor array has three rows of CCDs, with one row each for red, blue, and green. Some flat-bed scanners have a transparency adapter so transparencies can be scanned. Due to the resolution limits of a flat-bed scanner, as with the glass-bed, transparencies are typically not scanned as well as on a dedicated transparency scanner. See also **scanner.**

flatten

(1) To make curled prints flat by carefully reverse rolling them. (2) The process of flattening an image by collapsing various layers to the single background image in an image-manipulation program such as Photoshop. The Photoshop command to collapse the layers is *flatten image*. All of the active changes made to the image in the layers are applied to the base image when the flatten command is used.

flexible program

A feature designed by Nikon for its digital cameras. When the camera is set on *P*, for *program*, the camera selects the shutter speed and aperture best suited for the exposure it has calculated. By turning the main command dial, the photographer can change the shutter speed and aperture settings to another combination that produces the same exposure. In this way, the photographer can decide whether he or she needs a higher shutter speed to stop action or a slower one to blur motion. Or perhaps the photographer wants a larger f-stop so he or she has more depth of field. All of these adjustments can easily be done without leaving the program mode.

flicker

Also known as *screen flicker*. A rapid changing in the brightness of an image on a display. Flicker is more common with CRT displays than with other types. The *screen refresh rate* usually will determine if a screen will flicker. This rate can usually be set on the display. The exact rate needed to prevent flicker will be determined by how the screen is used and the environment it is used in. Typically, computer displays are set at 70 to 80 Hz to prevent flicker.

flipping

Changing an image by inverting around a horizontal or vertical axis, producing a mirror image. Flipping is similar to the effect seen through

the ground-glass viewfinder on a large-format film camera. Digitally, it is easy to do in Photoshop: use the commands Rotate Canvas > Flip Canvas Horizontal or Rotate Canvas > Flip Canvas Vertical.

floppy disk

Also called *diskettes*. A small, removable magnetic disk that is used to store images or other data. Its storage capacity of only 1.44 MB is very limited, so its use is not as common now as it once was. At one time, floppy disks, also called *floppies*, were 8 inches in diameter. Later they were reduced to 5 1/4 inches. Those first floppies were flexible and could be bent, but not folded. Subsequently, even smaller disks were made. Now the most common size is 3.5-inches. The smaller ones are encased in a hard plastic shell and no longer flexible, but they are still called floppies. Sony manufactured a line of digital cameras, called Mavica, that used diskettes as the image storage media. As image file sizes grew, diskettes could not hold enough images (only three to four per diskette on the highest image-quality settings) to make them practical for use in a camera. See also ***disk.*** *(see figure on page 155)*

fluid head

A type of head used on a tripod to hold a camera. Typically, a fluid head is used with video cameras because they operate smoothly and can produce jerk-free pans of the camera. A fluid head was first patented by Eric Miller in 1946. The moving parts in a fluid head are immersed in lubricating fluid to provide the smoother operation, and it was this characteristic that gave the tripod head its name.

f-number

See ***f-stop.***

focal length

A measurement from the point at which a lens focuses to the center of the lens. The measurement is most often made in millimeters (mm). With full-frame digital SLR cameras, lenses with focal lengths less than 50 are considered *wide-angle*; those larger are considered *telephoto*. Digital cameras with less than full-frame sensors have focal length multipliers and thus multiple 50 mm by their focal length multiplier to get the focal length of their "normal" lens. See also ***35mm equivalent; focal length multiplier.***

focal length multiplier

A term used with digital cameras that have sensor sizes smaller than 35mm to indicate what the 35mm equivalent size of a particular lens would be. Thus, if a digital camera has a 1.5 focal length multiplier, a 50 mm lens used on that digital camera would be equal to a 75 mm lens (50 x 1.5 = 75) used on a 35mm camera. Full-frame digital cameras have a

floppy disk – This is a 1.44 MB floppy disk that is also called a diskette.

focal length multiplier of 1.0, which means that a lens used on that digital camera would have approximately the same field of view of a 35mm camera.

focus and recompose

A photographic technique in which the desired focus point is off-center in the scene. The photographer shifts the center of the viewfinder and activates the automatic focus of the camera. Then, by holding the focus lock button, which is often done by holding the shutter release down halfway, the camera is shifted back to the desired composition. In theory this technique should work, but in actual practice it often produces an out-of-focus subject. This problem occurs because most lenses are designed to produce a sharp image of a plane that goes through the center point of the

scene. Thus the edges in an image are actually farther from the camera than the center is, yet they are in focus. When the camera view is shifted, the distance to the off-center subject is now shifted and the focus point is different. This is especially noticeable when large apertures (small f-stops) are used.

folksonomy

Also known as *socially created classification scheme*. A user-created classification scheme, usually for images. This system is used on popular websites, such as Flickr.com, to *tag* images. Individuals add their tags or keywords to each image. This system works well for some purposes. One advantage is that many minds are coming up with new descriptive names. A disadvantage is that, because there isn't a controlled vocabulary, the same tag is not necessarily used on similar images. Users can create new words and new tags; they are not limited to existing ones. So, for example, one photograph can be tagged with *car*, a similar one with *auto*, and a third with *automobile*. Doing a search on any of these terms will not bring up all three images. See also *controlled vocabulary.*

foofing

A term created by Denis Reggie for bouncing flash off of walls, ceilings, and other objects. Foofing also has slang meanings of *goofing off* or *sexual intercourse*, so it is necessary to watch the usage of the word around non-photographers. See also *bounce flash.*

format

(1) The format of the camera, such as *35mm, medium-format, 4 x 5*, or *digital*. (2) Camera sensor format or size, such as *APS-C* or *35mm*. (3) The capture file format such as raw, JPEG, or TIFF. (4) Erasing a camera's memory card by erasing the directory. See also *formatting.*

formatting

The process of erasing a hard drive or camera memory card by erasing the directory. Erasing camera's memory card should always be done in the camera and not in a computer. The computer may do it in a slightly different way than the camera and later cause corruption or loss of data and images. Always format or reformat a memory card before using it, rather than just erasing individual images. This provides better data safety over the long run.

forming

A process that is performed on the capacitors of electronic flashes to ensure that they will hold a complete charge. Forming involves gradually charging and discharging the flash to build up insulating deposits in the capacitors and to build the dielectric between the plates. To reform a capacitor, it needs to be fully charged for about fifteen minutes and then discharged by firing the flash about five or six times. If the unit has not

been used for several years, the forming process may be more technical because it needs to be done over a longer period of time and more slowly. This involves short applications of current. Guidance in this case should come from the manufacturer.

for position only (FPO)

A low-resolution image used when laying out a page for design purposes. FPO shows approximately what the document will look like, but it is not as large a file size. Once a document is ready to be printed, the FPO images are replaced with high-resolution copies.

four-color process printing

An offset printing technique that uses four ink colors—cyan, magenta, yellow, black (CMYK). Screening is used for reproduction of images. High-quality printing of images is possible with this method.

four thirds

A standard developed by Olympus and Kodak for digital cameras. *Four thirds* refers to the *aspect ratio* of the length of the digital image sensor to its height in the system. One reason to select four thirds as the aspect ratio is that it is the same ratio used by computer monitors. A number of other companies have joined the four-thirds consortium since it was first introduced.

Foveon sensor

A new type of digital image sensor. Most image sensors have pixels that are sensitive to only one color. They are grouped together in an array known as a Bayer array. The camera's processor combines these pixels to produce a full-color image. In a Foveon sensor, all of the pixels are sensitive to all three RGB (red, green, and blue) colors because there are three photo sensors, set in layers, at each location. No demosaicing is necessary for Foveon sensors because they do not use a Bayer array. Thus a processing step and a potential source of image degrading are eliminated. So far, Foveon sensors have not become popular with the major camera manufacturers. See also *demosaicing.*

FPO

See *for position only.*

fps

An abbreviation for *frames per second*. A unit of measure of how fast the camera mechanism can take pictures. Higher fps is especially useful when photographing fast-action subjects. With digital cameras it is important to know how many frames the camera can store in its buffer before it has to stop to record them on a media card, thus limiting the duration of the continuous shooting mode. See also *buffer.*

FPX

See *FlashPix.*

fractal

A geometric shape that can be subdivided into shapes similar to the original. Benoit Mandelbrot, a mathematician who was born in Poland, educated in France, and worked in the United States, created the term in 1975. He created fractal geometry and applied it to natural objects such as mountains, coastlines, and plants. Fractal geometry is used to create image compressions. See also *fractal image format.*

fractal image

An image created with fractals. See also *fractal; fractal image format.*

fractal image format

An image file format that uses fractal mathematics to compress images. Fractal image format is a lossy format that seems to work best on scenic images. The technology has a number of patents on it that limited its popularity as compared to other compression formats such as JPEG, which had fewer legal restrictions. It is much slower at compression than JPEG as well. It has been replaced for the most part by wavelet compression techniques.

fractional stops

Refers to f-stops located in between the whole stops. Digital cameras will allow for usually one-third or even one-eighth stops. Some examples of one-third stops are $f/2.8, f/3.2, f/3.5, f/4, f/4.5, f/5, f/5.6, f/6.3, f/7.1$, and $f/8$. The *whole stops* are shown in bold; the *one-third stops* are the two stops in between the whole stops.

frame

Refers, as a noun, to the image itself, as in "one frame of a series." Used as a verb, *frame* refers to the process of composing an image, as in "frame it in the viewfinder."

frame buffer

A portion of RAM memory designed to hold one frame of data to be sent to a computer monitor. The size of this buffer depends on the resolution and size on the monitor. See also *buffer.*

frame counter

The device on a camera that counts the number of frames. In a digital camera the photographer can usually get a count of how many images will fit into the remaining space on the media card. There is also, usually, a counter displaying the image number currently being created. This frame counter can often be set to continuously count upward or to start over again at *1* whenever a new media card is inserted.

frame grabber

A device that "grabs" a video frame and converts it to digital. In newer

versions, frame grabbers can digitize video and compress it in real time. See also **analog to digital converter.**

frame rate

The speed of frames being shown, usually expressed in *frames per second* or *Hz*. Frame rates can apply to both film and video. Typical frame rates are 24 frames per second for film and 30 frames per second for video. In computer monitors, frame rates of 70 to 80 Hz are enough to avoid flicker. See **flicker.**

free transform

A function in Photoshop and other image-manipulation programs designed to manipulate and distort images. An image can be stretched or compressed in any direction, or in multiple directions, or it can be rotated. *(see figure below)*

free transform – The free transform function in Photoshop allows the user to stretch an image as shown here.

fringe

The discoloration around the edge of a digital image caused by chromatic aberration or by over-sharpening. See also **fringing.**

fringing

A discoloration around the edge of a digital image. Purple fringing is caused by chromatic aberration. White fringing is caused by over-sharpening. There are software applications and tools designed to help reduce fringing, called *defringing*. See also **defringing.** *(see figure below)*

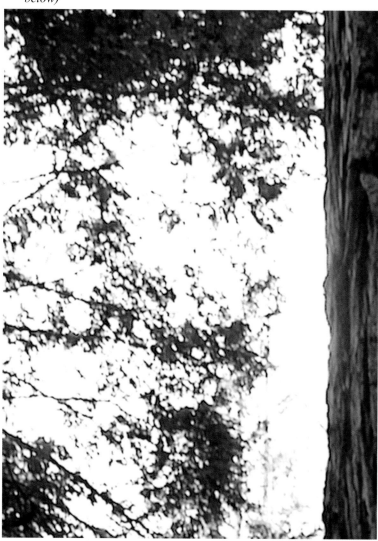

fringing – In this figure, the purple and yellow coloring around the fine detail is known as fringing.

f-stop

A number calculated by dividing the focal length of the lens by the diameter of the diaphragm opening. The term can be written as *f*-stop or f-stop. The difference between f-stop and f-number is that f-number is a continuous number and f-stop is adjusted to certain discrete steps. The standard, full f-stops are $f/1.0$, $f/1.4$, $f/2.0$, $f/2.8$, $f/4$, $f/5.6$, $f/8$, $f/11$, $f/16$, $f/22$, $f/32$, $f/45$, $f/64$, and so on. Notice how the numbers increase by multiplying by the square root of 2, which is approximately 1.4, while each step also represents one-half the amount of light. The numbers are rounded off to make them easier to deal with, especially when mentally calculating exposures. Since an f-stop is a ratio, it should be notated as $f/1.4$, but often the slash (/) is left out. Many cameras allow for half stops or third stops. See also ***fractional stops.***

f-stop ratios

The ratio of f- stops shown on a lens, indicating the maximum aperture available for that lens. For example, a ratio of 1:2.8 means that the lens has a maximum aperture of 2.8 (widest opening, smallest f-stop, or f-number). If there are two numbers printed, such as 1:2.8-3.5, it means that the maximum aperture is variable. The latter is usually seen on zoom lenses. The $f/2.8$ applies at the widest focal length, and the $f/3.5$ applies at the narrowest. In between focal lengths, the maximum f-stop varies between the two values. See ***f-stop.***

FTP

See ***file transfer protocol.***

full bleed

An image that does not have a border. The image extends off of the page in a printed piece. Full bleed is equivalent to a borderless print. Unlike a photographic print, when a full bleed is called for in a printed document, the image is usually extended a small amount past the edges of the document and then trimmed off when being bound. Allowances must be made for this the pre-trimmed size in any design or specification for an image. See also ***bleed.***

full frame (FF)

A digital sensor that is the same size as a full 35mm film frame, or 24 x 36 mm. Most digital cameras are not full frame because the larger sensor size is very expensive to manufacture. See also ***35mm equivalent.***

fuzziness

The *anti-aliasing* along the edges of a graphic, such as type. The amount of the fuzziness is dependent on the amount of anti-aliasing applied. The fuzziness is created to reduce the *jaggies* that appear. See also ***anti-aliasing.***

fuzzy

The appearance of anti-aliasing fuzziness, applied to reduce the *jaggies.* See also *anti-aliasing; fuzziness.*

G4 compression

The compression used in a Group 4 fax machine. G4 compression is also used with black-and-white images in the TIFF format and with PDF documents. See also *Fax Group 4; PDF; TIFF.*

gain

The amount of increase in output over input. In digital photography, increasing the gain increases the contrast, and therefore the brightness, of an image, as well as any noise in the system. Gain is more apparent when light levels are low and random noise is a large part of the image signal.

gain and level

The controls that adjust the contrast and brightness of an image. The level makes everything in the image brighter or darker in a linear fashion. The gain contracts or expands the range of intensity in the image, which changes the contrast. See also *gain.*

gallium photo diode

More properly known as *gallium arsenic phosphorus photo diode* or *GAP cell.* A light-sensitive diode used in camera light meters. The GAP cell reacts more quickly to light than a CdS cell. See also *CdS cell.*

gamma

Also called *gamma correction.* A correction applied to digital imaging devices to correct their inherent nonlinearity to a linear function. This correction is needed to ensure that digital displays, such as CRTs and computer monitors, display the correct brightness of an image. Gamma is used for the most basic form of color management of a display. Each color (red, green, and blue) will have its own gamma correction to provide a linear output. Not to be confused with the mathematical function *gamma.* In film photography, *gamma function* refers to the straight-line portion of a film's characteristic curve.

gamma correction

See *gamma.*

gamut

Also called tonal range. The complete range of colors found in an image, displayed or output on a specific device, or represented in a particular color space. Each device, image, and color space has a different range of

possible colors. These ranges of colors are *gamuts*. See also ***color space; color management.***

gamut compression

Also known as *tonal-range compression*. The compression of a gamut of colors such that a device can display or output an image containing colors outside the range of possible colors of that device. See also ***gamut.***

gamut mapping

The mapping of colors from one color space onto another. No two color spaces or devices have exactly the same gamut, or range of colors, available. Therefore, when an image is moved or converted from one color space or device to another, the gamut of each has to be taken into consideration and adjusted or mapped from one to the other to make the image look as close to the same as is possible. See also ***color space; gamut.***

ganging

Combining a group of images so they can be scanned or printed together. Ganging often makes for a more efficient workflow, and it can be less expensive if the work is a billable item. The photographer needs to take care that the color values and levels are similar so they will have the same scanning or printing characteristics. Otherwise, quality will suffer.

GAP cell

See ***gallium photo diode.***

gateway

(1) The first page of a website, or *home page*, is often called the *gateway page* because it leads visitors to the rest of the site. (2) A computer that controls access to other computers through a network. (3) A method of entering one computer program from another so that data can be shared over a link.

Gaussian blur

A type of blurring used in image-manipulation programs such as Photoshop. Gaussian blur is used for creative purposes to focus attention on other parts of the image. It can be used to reduce noise or detail as well. It produces a very smooth blur, the amount of which can be controlled in the software. The technique uses a mathematical function called a Gaussian distribution, hence the name. See also ***blur.***

GB

See ***gigabyte.***

GCR

See ***gray component replacement.***

GDI

Stands for Graphics Device Interface, a component of the Microsoft

Windows graphics subsystem. It is used to represent graphical objects in computers. See also ***BMP.***

general protection fault (GPF)

A computer error that causes a program to crash. When one program tries to use computer memory assigned to another use or program, this causes a GPF. GPF is designed to protect the computer system from program-created errors.

general purpose register memories (GPRM)

Used in programs such as DVD Studio Pro to have interactive features when using scripting. GPRMs are separate locations used by the script to deal with different features such as preferences for audio format, language, subtitles, commentary options, and deleted scene options. GPRMs are also used to store numbers while executing a script.

generation

In analog photography, each copy increases the generation by one. So if a transparency is copied, the original is first generation and the copy is second generation. One of the major benefits of digital photography is that each digital copy of the original image file is still a first generation. There is no generational loss in copying. A print from a digital original is a second-generation copy.

generic printer description (GPD)

A file extension. The GPD is a text-based file that describes the printer to software programs and the computer operating system.

giclee

An alternative name for a photographic print made by an inkjet printer. A giclee is supposed to refer to high-quality printing of images on fine art paper, focusing as much attention to archival qualities as possible, but that definition continually gets pushed downward. Giclee (pronounced gee-CLAY) is a French word for *spurt* or *spray*, and it was chosen to enhance the marketing appeal of inkjet prints. It has now come to mean duplicates or copies of paintings and watercolor images, as compared to originals, because of its heavy use in the fine art world. Giclees sell for less than the original artwork. When used with digital photographs, some people have confused the concept of *copies* with a description of a printing process. Each digital photograph produced on an inkjet printer is an original print; some people, however, when they see the term giclee, believe it to be a copy of the original—that is, just like a giclee made from a painting. Be careful when using the term: giclee has a slang meaning in French that causes those who understand the true meaning to snicker when hearing it.

GIF

See ***graphics interchange format.***

GIF 89a

The latest version of GIF or *graphics interchange format*. Some of the changes from earlier versions are the introduction of transparency, interlacing, and animation. See **graphics interchange format.**

gig

A slang expression for gigabyte. See **gigabyte.**

gigabyte (GB)

Equal to 1,000 megabytes, or 10^9 bytes in terms of hard disk storage. Computers count bytes a little differently, so a gigabyte is equal to 2^{30} bytes, or 1,073,741,824 bytes, when the term is used to measure computer memory. Just to add to the confusion, hard drive manufacturer Seagate uses 1,024,000,000 as a GB on their hard drives. Note that Gb refers to *gigabit* and GB refers to *gigabyte*. People often use *gig* to mean gigabyte.

GIMP

Originally, an acronym for *general image manipulation program*, but now refers to *GNU Image Manipulation Program*. See **GNU Image Manipulation Program.**

Global Positioning System (GPS)

A navigational system based on at least 24 satellites that transmit signals continuously. Various types of receivers, including small hand-held units, are used to receive the signals and tell the user exactly where he or she is. The official name is *Navigation Signal Timing and Ranging Global Positioning System*, or *NAVSTAR GPS* for short. The system was set up and is maintained by the US Department of Defense. There are two versions of the system: a civilian and a military version. The civilian version is accurate to within +/- 15 meters, while the military version has error corrections built-in to make it much more accurate. Some digital cameras are now being built with a GPS input.

GN

See **guide number.**

GNU Image Manipulation Program (GIMP)

An image-manipulation program created as a student project in the mid 1990s by Spencer Kimball and Petter Mattis, two University of California at Berkeley students. GIMP became the first major application software program offered free to end users instead of programmers. It was originally designed for Linux operating systems, but now there are versions available for Windows and Mac OS X. Although freely available, it lacks features important to higher-level digital photographers, such as native support for adjustment layers, support for color management, 16-bit images, native support for CMYK, and a few other features. For someone just starting out, it can be a powerful as well as a free tool. See also **XCF.**

Gouraud shading

> A graphical shading technique used in computer graphics to create smooth shading on polygons with lower computational requirements.

GPD

> See *generic printer description.*

GPF

> See *general protection fault.*

GPRM

> See *general purpose register memories.*

GPS

> See *Global Positioning System.*

gradient

> A smooth transition from one shade to another or from one color to another. A gradient is often created as a background for a graphic effect in a software program such as Photoshop. In Photoshop this is done with the gradient fill tool. See also *gradient fill tool.* *(see figure on page 167)*

gradient fill

> A tool in Photoshop and other image-manipulation programs used to create a background color that is evenly shaded or blended from dark to light or from one color to another. The smooth transition can be from top to bottom, side to side, or on a diagonal. All of these options can be selected by using the gradient fill tool. See also *gradient.*

grain

> Small speckles seen in the emulsion of prints or in negatives. Grain is actually clumps of silver particles in the film. See also *graininess.*

graininess

> The visible grain seen in images created from film. In some cases grain is a desired effect, in others it is simply a by-product. In digital photography, noise is the closest equivalent. Usually, noise in a digital image is not very attractive and needs to be avoided. When graininess is desired in digital images, grain can be added by using a filter in Photoshop or in another image-processing program.

graphical user interface (GUI)

> A computer interface that uses graphical icons instead of words to represent data files and folders, programs, and other objects used to interact with the computer. Anyone who has used a desktop computer is familiar with the concept, even if he or she is not familiar with the name. The first implementation of GUI (sometimes pronounced "gooey") was on Apple's Lisa computer. It was too expensive, so it did not catch on. Instead, the Macintosh computer came out in 1984, bringing with it the

gradient – The color changes from bright orange in one corner to white in the other in a gradual way known as a gradient.

first popular implementation of GUI. Apple copied the idea from the early Xerox Alto computer. Later on, Microsoft used Apple's ideas to create the first Windows operating system. GUIs are one of the things that make personal computers easier to use than the early minicomputers.

graphic image file format

A generic term referring to any file format that can be used for graphic images. Graphic image file format is sometimes used incorrectly for *GIF format* because it has the same initials. The correct term for GIF is *graphics interchange format*. See **graphics interchange format.**

graphics interchange format (GIF)

A graphic image file format. GIF was introduced by CompuServe in 1987. It is designed to store low-resolution images, which makes it perfect for many web-based applications where the speed of transmitting or downloading is a problem. It uses only 256 colors instead of 16 million, which is one way it keeps its file size down. The latest version is GIF 89a. See also **GIF 89a.**

graphics tablet

See **digitizing tablet.**

gray

Besides being a color, gray is sometimes used to refer to gray market goods. As a color, gray is a combination of white and black. Black and white images are properly referred to as grayscale images for example. In a grayscale image there are 254 levels of gray between white and black, for a total of 256 shades of gray. See **gray market.**

gray balance

The mixture of primary colors to make a neutral gray color. Gray balance is used in CMY printing to generate a neutral gray from cyan, magenta, and yellow colored inks.

gray card

A card, usually with a single shade of gray of 18%, that is used to test the linearity and color balance of a photographic system. It is often used in lighting tests to ensure proper exposure. It is sometimes used as a shortened name for an *18% gray card*. See also **18% gray.** *(see figure on page 169)*

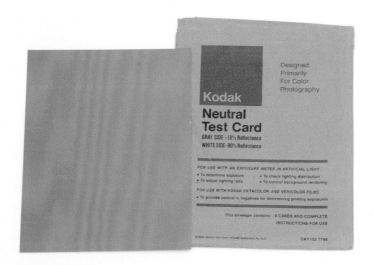

gray card - This shows a sample of a used Kodak gray card that they call a "Neutral Test Card".

gray component replacement (GRC)

The replacement of neutral tones in an image with black to prepare it for four-color printing. Cyan, magenta, and yellow inks are replaced with black ink in areas where the tone is neutral. This is done to save ink usage and increase image detail. An image is processed during color separation with GRC. If done properly, the printing will use less ink and the image will look the same or better than if GRC were not used.

gray level

A number representing the brightness or lightness of a pixel. The number runs from black, where gray level equals 0, to white, where gray level equals 255, for a total of 2^8, or 256 levels.

gray market

Refers to goods sold legally (thus not *black* market) but not through the manufacturer's authorized distributors. Goods are purchased in a country that has a favorable wholesale price and then exported to the country where they are sold in order to provide lower pricing. Sometimes warran-

ties will be honored only in the original country and not in the third country, where goods were purchased. Some camera stores in New York City will advertise using the terms *USA* and *gray* to distinguish between the two items. In some cases the product or packaging is slightly different, or the manual may not be in English.

gray scale

A series of gray images, from pure black to pure white, in even increments. There are often 256 levels of gray in a gray scale because the 8-bit gray scale is one of the most frequently used types.

gray scale image

An image containing no color. *Gray scale image* is another name for a *black-and-white image*. Often, gray scale images are represented by pixels with 8-bits, which translates to 256 levels of gray for each pixel. See also *8-bit grayscale.*

GRC

See *gray component replacement.*

green

One of the three primary colors: red, green, and blue. In an additive color system, all of the colors can be created with various combinations of these three primary colors. See also *additive color system.*

green eye

A phenomenon in which an animal's eyes reflect back-light to a camera in such a way as to cause its eyes to glow green. Green eye is caused by an electronic flash being too close to the visual axis of a camera. Usually this happens because the built-in flash is used or a flash is mounted on the camera's hot shoe. Green eye is similar to *red eye* in humans. See also *red eye.* *(see figure on page 171)*

Gretag Macbeth color checker chart

Also called *MacBeth color chart*. The standard for measuring and comparing colors in photography, printing, and graphic arts. Gretag Macbeth is a printed chart with different colors and different gray scale levels. There are a total of 24 squares, including pure white, pure black, and four levels of gray in between. Gretag Macbeth is used to determine the color balance of various systems.

grids

An arrangement of both horizontal and vertical lines laid out in regular intervals for layout purposes. Grids are used in page-layout software programs and applications such as Photoshop to help line up elements to make pleasing graphical layouts.

GUI

See *graphical user interface.*

green eye – The eyes of the dogs reflect the light of the flash. Because the reflection is green it is known as green eye. It is similar to red eye in photographs of people.

G

guide number

A numerical rating for the power of an electronic flash. By convention, the guide number is set for ISO 100. It is calculated by multiplying the f-stop by the distance for a proper exposure of the subject at the maximum distance from the flash. Thus, if a subject at 15 feet were properly exposed at $f/4$, then the guide number would be 15 x 4, or 60. Some manufacturers have been known to be "generous" when describing the guide number of their flashes. Be sure to test a flash or rely on an independent source before accepting a guide number. Note that the conditions of the test, such as a small room, a room with light-colored walls, diffusion attachments, or zoom settings on a flash, will significantly affect the results.

guide print

A print created by a photographer and sent with the image file to the printer so the printer will know what the image should look like when printed properly. In the past, when using film, this was not necessary because the printer would have the original transparency to compare with the printed work.

halftone image

A photograph or image that has been converted for use in printing by changing the continuous image to one made up of dots. The gradation of tones of the photograph are represented by varying sizes of black dots.

halftone screen

A glass or film screen that has a pattern of fine lines etched in it, typically at a rate of 50 to 200 lines per inch. When an image is photographed through these lines using a high-contrast film, it is broken up into very fine dots that are easier for a printing process to reproduce. The size and shape of the dots is by determined the type of screen used.

halo

The glow around an object caused by the diffusion of light. This problem

is increased when an uncoated lens is used, when a lens surface is dirty, or when the subject is backlit. Halos are created by the unsharp masking filter in Photoshop as a way to increase the contrast of edges, making the image appear sharper.

handholding

Holding the camera by hand, rather than mounting it on a tripod or other support, to take photos.

handholding rule

A rule of thumb suggesting that the photographer can handhold a camera with acceptable sharpness at a shutter speed of 1/focal length of the lens. Thus a 400 mm lens needs a shutter speed of about 1/400 to be reasonably sharp. If you learn to hold the lens properly and time your breathing, you might pick up one f-stop (dropping it to 1/200). If you are not very good at holding the camera, you might lose an f-stop (needing 1/800). Use of image-stabilization cameras or lenses will also affect this calculation.

hard drive

Another name for disk drive. See **disk drive.**

HD

An abbreviation for *hard drive*. An abbreviation for *high definition*, as in *high definition television*, but in this case the entire abbreviation, *HDTV*, is commonly used. See **hard drive; disk drive.**

HDR

See **high dynamic range (imaging).**

HDRI

See **high dynamic range (imaging).**

header

(1) Extra data at a data block's beginning. (2) The printing at the top of a page, as in a *page header*. In digital photography, EXIF and metadata are often stored within an image by utilizing the header of the image file. EXIF is a type of header file. See also **EXIF.**

heads up display (HUD)

A display of information projected onto a transparent screen, such as a

window or goggles, through which the viewer is looking. Without looking away, for example, an automobile driver using a HUD can look through the windshield at the road but still see the instruments, such as the speedometer, projected on the clear glass. A term used by Apple's Aperture software to describe its *floating panels*, such as the *Adjustments heads up display* (*Adjustments HUD*).

healing brush tool

A tool in Photoshop and Lightroom used to repair blemishes and other defects in a digital image. The tool uses the texture from the sampled location to replace the texture at the destination, but it uses the destination color. It then blends both the texture and the color at the destination to make a nearly invisible change. It was first used in Photoshop 7 and is one of the most popular tools among digital photographers.

Hertz (Hz)

A term used for *cycles per second*. It is named after Heinrich Rudolf Hertz (1857–1894), a German physicist credited with discovering electromagnetic waves.

hierarchical z

Refers to the *hierarchical z-buffer*. This buffer is used when processing three-dimensional images to check each pixel and compare its z-value against the z-buffer. Pixels that aren't needed can be thrown out before rendering to save on processing time. See also **Hyper-Z; z-buffer.**

hierarchies

A method of organization used in computers to specify the order of operation in software application. Hierarchies are often used by digital photographers to set up folder-based organizational systems for their images. Folders are arranged inside other folders in hierarchies. Keywords are also set up in hierarchies, using *parent* and *child keywords*. For example, the parent keyword *mammal* could have child keywords of *dog, cat, deer*, and *rat*.

high-bit

Has a number of meanings. (1) 16-bit images (or, in the case of digital camera images, they may actually be 12- or 14- bit), to differentiate them from 8-bit images. Also called *high-bit color*. (2) In computing, the most significant bit in a byte of data.

high color

See **16-bit color.**

high dynamic range (imaging), (HDR or HDRI)

A technique used to increase the dynamic range of digital images. Typically, the technique involves combining several digital images taken of the same subject with different exposures. These images are usually combined and worked on in higher bit-level processing, using 16-bit rather than 8-bit, for example. Because the dynamic range of HDRI is much greater than that of monitors or prints, the images must be converted using techniques known as *tone mapping* in order to view them. See also *tone mapping.*

highlight

The brightest part of an image. Highlight most often refers to the white areas in an image. By convention, the term usually excludes *specular highlights* (the brightest points of light caused by a reflection of light).

highlight detail

Also called *detail in the highlights*. Small gradations in the brightest part of an image. Highlights without detail are known as *specular highlights,* which could be a bright spot on a windshield or reflective chrome. When there is no highlight detail in a larger, nonspecular part of the image, it is said to have *blown highlights* or simply is called *blown out*.

high res

See *high resolution.*

high resolution

Also called, informally, *high res* and *high rez*. An arbitrary term specifying the resolution of a digital image. For example, clients might request a *high-resolution file* when they want a 300 ppi image. In this case, they probably saw the image on a website, at 72 ppi, considered a low-resolution image for print usage.

high rez

See *high resolution*

high-speed sync

Since the typical flash synchronization speed in cameras with focal plane shutters is around 1/60th of a second, anything higher is often considered *high speed*. Leaf shutters commonly sync flashes at any speed they offer (usually up to 1/500th of a second). Modern digital cameras using the latest digital flash units can often sync their shutters up to 1/90th or 1/125th of a second. This speed varies by individual camera and flash combination. See also *flash synchronization*

histogram

A graph displaying brightness along the bottom (x-axis) and the number of pixels falling within that brightness value along the vertical (y-axis). Black is displayed on the left; white is displayed on the right. Depending on the type of image, the best overall exposure will feature a bell-shaped curve in the center, tapering off in both directions to the edges of both sides. Images in which the curve runs either to the right or left and then drops suddenly have either the shadows or highlights clipped. Clipped means that the image exposure exceeded the range of the image sensor and the curve suddenly ends or is clipped off. If the curve is mostly on the left, the image is dark in tone; if the curve is mostly on the right, the image is light in tone. *(see figure below)*

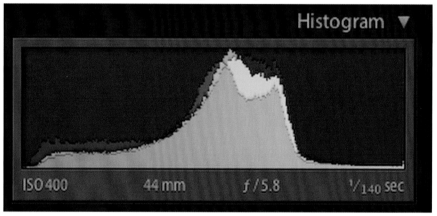

histogram – This graph of the color and exposure values of an image is known as a histogram.

history brush tool

A tool in Photoshop that allows the user to paint back the former state of a changed image. This function can be useful when blurring an image, for example, and then painting back certain areas to be sharp. Alternatively, an image can be sharpened, and those areas with sharpening artifacts can be painted such that the former unsharpened state appears.

history palette

A palette or panel in Photoshop that displays each step, or function, a user has performed on an image. The number of history steps shown is user-selectable in the preferences menu. By having each step displayed, it is easy to step backward (multiple undos) to earlier versions of an image. This information is kept only while the image is open; once the image is closed, the history of how that image was produced is lost. (see figure on pge 173)

history palette – The history palette in Photoshop shows the various edits that have been done to an image.

HLS

An abbreviation for hue, saturation, and lightness. See **HSL.**

HMI

An abbreviation for *hydrargyrum medium-arc iodide.* A type of continuous lighting used especially in the film industry. While most continuous lights produce their light with an incandescent bulb, HMI lights use an arc lamp instead. HMI lights are expensive, but produce light close in color temperature to daylight, are nearly flicker-free, and are several times more efficient than standard lighting. Because they are flicker-free, they are a good choice for long exposures with digital cameras.

horizontal resolution

The measurement of resolution in video in the horizontal axis. Different sources of video signals will have different resolutions (horizontal) that typically vary from 240 to 540 lines (or pixels) across the video image. The vertical resolution for analog sources is usually 480 lines at all horizontal resolutions. The resolution is determined by the number of lines that can be discerned and varies by source. See also **resolution.**

hot mirror

A mirror that reflects infrared radiation and transmits other forms of radiation such as visible light. Hot mirrors are used in optical devices to protect them from heat. An example would be the use in a slide or digital projector to protect the slide or internal components of the projector from the heat produced by the very bright and hot projection bulb. See also **cold mirror.**

hot pixel

Also called *stuck pixel*. Each pixel is made up of a red, green, and blue (RGB) element. On occasion, in digital image sensors as well as in LCD monitors, one or more of these elements will adhere permanently. Then, when images (or the monitor) are viewed, there is a red, green, or blue dot in the same location on every image. As cameras age, they will sometimes develop more hot pixels over time. Depending on the brightness or darkness of an image, the hot pixels will be more or less obvious. At the present time, there is no real cure for a hot pixel except to retouch the images. Some software programs, such as Apple's Aperture and Adobe Photoshop Lightroom, have a feature enabling the user to retouch one image and then apply the corrections to all images, greatly speeding up the retouching task. *(see figure on page 179)*

hot spot

(1) A Wi-Fi reception location. (2) A part of an image that is too bright.

hot pixel – The bright red dot in the lower part of this enlarged section of a photograph is a single red pixel that is lit even though light is not falling strongly on it. It is known as a hot pixel.

This bright spot is usually a blown-out highlight (a large highlight without any detail) or a distracting specular highlight, such as one caused by perspiration on a subject's face.

hot-swap

The ability to remove a device, such as a disk drive or other peripheral, from a computer without having to turn the device and the computer off. In the case of a disk drive, the unit still must be ejected before unplugging

to prevent data loss. USB and FireWire devices are examples of hot-swappable devices.

HSB

An abbreviation for *hue, saturation and brightness*. See **HSV.**

HSL

An abbreviation for the *hue, saturation, and lightness* color space. Sometimes referred to as *HLS*. It is similar to but different from HSV color space. Each pixel in the HSL color space is made up of the three values. Hue is measured in degrees (0 to 360), utilizing a standard color wheel. Saturation is measured from 0.0 to 1.0, with 0.0 being gray and 1.0 being the pure color. Lightness is also measured from 0.0 to 1.0, with 0.0 being black and 1.0 being white. The middle value of 0.5 represents the pure color or hue. Thus a pixel with the values of (x, 1.0, 0.5) represents the pure hue for the color *x,* with *x* being the location on the color wheel. See **HSV.**

HSV

An abbreviation for the "hue, saturation, and value" color space. Sometimes called the HSB or HSB color model. HSV is similar to HSL, but not the same. HSV is not symmetrical to darkness and lightness, but HSL is. Each pixel in the HSV color space is made up of the three values. Hue is measured in degrees (0 to 360), utilizing a standard color wheel. Saturation is measured from 0.0 to 1.0, with 0.0 being gray and 1.0 being the pure color. If the Value is at a maximum, then Saturation will go from white to the pure color, unlike HSL. Value (or brightness) is also measured from 0.0 to 1.0, with 0.0 being black and 1.0 being white. A value equal to 1.0 gives the pure color or hue. Thus a pixel with the values of (x, 1.0, 0.5) represents the pure hue for the color "x" with x being the location on the color wheel. See **HSL.**

HTML

An abbreviation for Hyper Text Markup Language. HTML is the language used to create web pages and other electronic documents. Besides the actual words used on a web page, HTML contains formatting information in a way that allows a web browser to display the words and images in the way the designer intended.

HUD

See **heads up display.**

hue

In working with colors, hue is the specific color, such as red, green, or blue. It is one of the main attributes of color. (The others are *saturation* and *value*, or *brightness*.) Each hue refers to light of a specific wave-

length. The hue can be specified by its location on the color wheel. This location is stated in degrees around the circle, with red at the 0°/360° location. See also *saturation; value.*

hue error

The difference in hue of a color between the color as reproduced and the desired color. This difference can be due to the limitations of the printing process, contamination, or errors made in the set-up or operation of the printing press. See also *hue.*

Huffman encoding

A technique used to provide lossless compression of data. It is used in conjunction with other compression techniques such as JPEG and MP3. Note that although the part of JPEG utilizing the Huffman encoding is lossless, the total technique of JPEG compression is lossy, not lossless.

hunting

The situation in which an automatic focus lens is unable to find the correct focus, such that the mechanism continues to run the automatic focus motor back and forth as it is trying to find the focus point. This occurs most often in low-contrast or low-light situations. See also *automatic focus.*

Huygen's wave theory

Also known as *Huygen's Principle.* First developed in 1678, the theory explains, among other things, why waves do not diffuse. It also was used to derive the laws of refraction and reflection. Later, it was expanded into the *Huygens-Fresnel Principle,* a method of analyzing wave propagation in a way that better explains diffraction events. The latter principle is named after Dutch physicist Christiaan Huygens and French physicist Augustin-Jean Fresnel. See also *diffusion; diffraction; refraction; reflection.*

hyperlink

A reference or link in one electronic document, such as a word-processing document or webpage, that, when clicked on with the cursor or mouse, will take the viewer to another location. This other location can be another point in the original document, another document in the database, or a location at a website. The link can be created by underlined, colored, or highlighted words, or it can be a graphical element such as a photograph or a map.

Hyper Text Markup Language

See *HTML.*

HYPER Z™ III

A graphical processing technique developed for ATI Technologies for its Radeon video cards. Three functions are used to speed up graphical processing of three-dimensional images. The *Z* refers to the third axis of a pixel in three-dimensional space. See also *hierarchical z-buffer; z-buffer.*

Hz

See *hertz.*

I/C

See integrated circuit.

ICC

See *International Color Consortium.*

ICC profile

An abbreviation for *International Color Consortium profile*. The color profiles used to describe the color characteristics of various devices, such as printers, to enable software to convert colors between devices so that they look as similar as possible. See also *International Color Consortium.*

ICE

See *digital ICE.*

icon

A small graphical link to a program, command, or other object used in a computer interface. Thus a link to the trash is a drawing of a trashcan, a link to a folder is a picture of a file folder, and a link to a disk drive looks like a miniature disk drive. Often, each program will have a picture to represent it, so as to make it easier and faster for users to find and use the link. *(see figure on page 183)*

identifier

The way a specific item can be referenced so that it is unique to that resource. The identifier is generally made up of numbers and letters.

IEEE-1284

A standard method of bi-directional, parallel communications between various devices such as printers and a computer. This standard was

icon – This figure shows a small picture of various devices, disk drives in this case, to represent the drives attached to the computer, instead of a list.

developed as an inexpensive replacement for SCSI communications for many devices including disk drives and scanners. IEEE-1284 was first released in 1994. Since then, USB has replaced IEEE-1284 for many purposes.

IEEE-1394

See *FireWire.*

IIM

See *information interchange model.*

i.Link

A version of FireWire developed by Sony. See *FireWire.*

image area

The space on a printed piece where things—such as texts, figures, and images—can be printed. Image area is sometimes described as any area on the paper where ink can appear, in other words, inside the margins.

image browser

A software application program designed for viewing images. Many image browsers have additional features to enable the user to modify the image by converting it to another format, renaming it, rotating it, or resizing it.

image capture

Another term for creating a digital image (i.e., taking a photograph) with a digital camera, a screen-shot grabber, or a scanner.

image circle

Each lens projects an image in the shape of a circle, not a rectangle, the shape seen in the viewfinder. The image circle needs to be large enough to cover the image sensor of a digital camera. Special digital lenses are now being manufactured that have a smaller image circle, or area of coverage, to fit the smaller image sensors often used. Thee manufacturers do this so that more-compact and less-expensive lenses can be created. It is important to note that these lenses may attach to other cameras (including film cameras), but that their image circle is not large enough to cover the larger sensor, or film area, and will vignette around the edges.

image conversion

The process of changing the format of an image from one format to another. There are many different software programs capable of doing this. An example would be to change the format of an image from a TIFF in the master file to a JPEG for use on the Web or for e-mailing. See also *file format.*

image database

A collection of images stored in digital format for easy access. Specialized database software is designed to make accessing images easy through the use of keywords and other metadata. There are a number of new programs available, such as Apple's Aperture and iPhoto, and Adobe Photoshop Lightroom that provide a simple image database to go along with image editing and processing software. See *image editing program; keywords; metadata.*

image development

The process of preparing an image for final output. The term is commonly used for the more basic operations rather than for complete retouching. See also *image processing.*

image editing program

Software designed to edit, process, and manipulate digital images. Most images coming directly from a digital camera can benefit from some sort of editing. Editing can include adjusting for color, sharpening, cropping, retouching dust spots, retouching hot pixels, adjusting highlights and shadows, enlarging or reducing, and other types of manipulation. Many

different software programs offer some or all of these functions, with Adobe Photoshop generally considered to be the most powerful and versatile. Some types of editing software are often included with a digital camera when it is purchased. Free and inexpensive software is also available online.

image editor

(1) The software used for image editing. (2) The person who edits an image. See also *image editing program.*

image file size

The amount of space that an image file requires for storage on a hard drive, CD, DVD, or other media. The size is usually measured in kilobytes or megabytes. The image file size is often different than the image size because some file formats are compressed and use less space to store an image than is needed to open it. In some cases the image file size may be larger than the image size because the image file size also includes metadata. See also *kilobyte; megabyte; file format; metadata.*

image format

See *file format.*

image management

The process of managing an image database. Management includes ingesting images (adding them to the database), tracking them, reorganizing them, backing them up, adding keywords and metadata to facilitate finding them, resizing them, and outputting them as necessary. All of this is usually done with software programs designed especially for this purpose. See also *image database.*

image processing

Most commonly used to describe the processing of an original digital image capture, whether from a digital camera or a scanner, to produce the final image. The basic process of adjusting the color, highlights, and shadows is often called image developing, which is a subset of image processing. Image processing also includes digital retouching and interpolation, among other things. In scientific fields such as digital astrophotography, it also includes more complex computer analysis of images.

image resolution

The total number of pixels in an image, expressed as pixels per linear distance, such as *pixels per inch* or *pixels per millimeter*. The image resolution is a measure of the amount of detail available in an image. In lens measurement charts, the resolution is expressed as line pairs per millimeter where the measurement describes the smallest amount of separation between two lines that can be resolved or seen through a particular camera-lens combination. Image resolution is also sometimes

expressed as the total number of pixels in the horizontal direction by the total number of pixels in the vertical direction. A sample would be 3040 x 2016, which means 3040 pixels in the horizontal direction by 2016 pixels in the vertical direction.

image resource block (IRB)

Also called *legacy IPTC metadata* and *legacy IPTC header.* Wrapper structure designed by Adobe to hold metadata for images within certain file formats such as JPEG, TIFF, and PSD. Photoshop has included this function since version 7.0. IRB is being replaced by a new system called *XMP.* The IRB is now commonly referred to legacy IPTC metadata. The IRB is a subset of the *Information Interchange Model.* See also **Information Interchange Model; IPTC metadata; XMP.**

image sensor

The part of the digital camera that converts the light that strikes it to a digital signal. There are several types of image sensors in use in digital cameras. One is the *CCD*; another is *CMOS.* See also **CCD; CMOS.**

image size

(1) The physical size of the image. This size can be expressed in pixels, such as 3040 x 2016 pixels, or it can be expressed as a physical measurement, such as 10.133 inches by 6.72 inches. In the latter case, it is best to add the resolution (300 pixels per inch, in this example). Note that this size may be different than the size shown on the monitor because the monitor's resolution is not necessarily the same. Image size is most often used for images in print form, in which case only the height and width of the image area of the print need be given. (2) A function in Photoshop used to change the size or resolution of an image.

image size command

A function or command in Photoshop that allows the user to change the physical dimensions of a digital image, its resolution, or both. This command is useful for making images larger (*uprezzing*) or smaller (*downrezzing*). The image size command increases the size of an image by averaging the surrounding pixels to create new ones in between. There are several different averaging methods to choose from. Generally, when uprezing an image, it is best to choose *bicubic smoother* as the averaging method. If downrezzing, choose *bicubic sharper.* Older versions of Photoshop (version 7.0 and earlier) only have *bicubic* as the averaging method, so that method should be used for both uprezzing and downrezzing.

image stabilization

The process of reducing the effect of camera and lens movement. This process is done by an image stabilizer, a device built into some digital cameras or lenses. There are several ways to accomplish image stabiliza-

tion: (1) moving the optical path slightly to counteract the movement (a method called *optical image stabilization*); (2) moving the image sensor slightly to accomplish the same goal (a method called *anti-shake*); (3) adjusting the image in digital video cameras from frame to frame to counteract the movement. See also **optical image stabilization.**

image storage

The manner or media used to store digital images. Some common media include hard drives or disk drives, which are both magnetic storage methods. Optical media such as CDs and DVDs are also often used, especially for backup. Less-frequently-used media storage include floppy disks and zip disks, both popular magnetic media in the past. Camera media cards such as CompactFlash (CF) cards are used in the camera for temporary storage of images but are not generally used for long- term storage needs.

imaging

Also called *digital imaging*. The digital capture of images. In digital photography, imaging is usually called *digital imaging*, to distinguish it from the other types of imaging. See **digital imaging.**

import

Transferring images from the camera, or from media used in the camera, to the computer for further processing. Many computers allow the images simply to be *dragged* from the media card or camera to a folder once the camera or media card is attached to the computer and their icons appear.

indexed color image

Color space that uses a *color lookup table* to reduce the sizes of images. Rather than the more typical 3-color-per-pixel representation used in an RGB color space, an indexed color space uses only 8 bits of color information to represent a pixel. These 8 bits refer to a table with all of the colors listed. Because of the fewer possible colors, an indexed color image does not have all of the fine gradations of color. The sizes of images are greatly reduced, but blockiness in smooth tone areas can occur. It is possible to use fewer or more than 8 bits, but 8 bits, which translates to 256 colors, is the usual number of colors possible with an indexed color image. The GIF format, popular for web usage, is an example of an indexed color space. See also **color lookup table.**

indexing

The process of creating metadata and attaching it to images to describe them, making it easier for database software to locate the images. This metadata is usually stored within the file itself. In the case of raw images, a sidecar file is created to hold the metadata. See also **metadata: sidecar file.**

info palette

A palette or information window in Photoshop that allows the user to move the cursor and read the color values of pixels. The information shown is selectable by the user. The palette can include the RGB value on an 8-bit, 0 to 255 scale, or on a 16-bit, 0 to 32,768 scale, depending the version of Photoshop being used. It can also include grayscale value, CMYK value, and several other values. Two values can be shown at the same time, along with their location on the x- and y-axes. See **RGB and CMYK** *(see figure below)*

info palette – This figure shows the Info palette in Photoshop. It shows the value of each of the colors, RGB (red, green, and blue) at a certain X, Y point. This color value varies from 0 to 255 for an 8-bit image. It also shows the CMYK (cyan, magenta, yellow, and black) values as percentages.

Information Interchange Model (IIM)

Developed by Adobe Systems to gather and insert metadata into image files such as JPEG, TIFF, and PSD. This IIM is a subset of IPTC and became the IPTC header. The data is wrapped in an image resource block before inserting into the header. Today this process is being phased out and replaced by XMP, also developed by Adobe Systems. The old format is now known as *legacy IPTC* or *legacy image resource block.* See also **IPTC; ITPC header; image resource block; XMP.**

infrared

A spectrum of light (electromagnetic radiation) not visible to the human eye. The wavelength of infrared is longer than that of visible light and appears on the electromagnetic spectrum near red light in the visible spectrum. Some digital cameras are sensitive to infrared and others can be modified to be so. Photographs made with infrared light are very empheral and other-worldly in their appearance. There are a number of uses for digital infrared imaging in medicine, science, and night-vision applications. *(see figure below)*

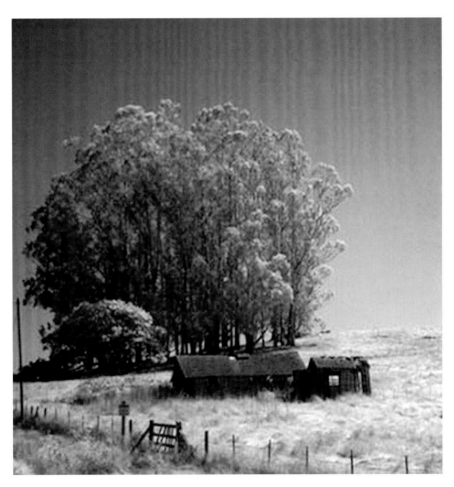

infrared – This figure shows an image taken with infrared light instead of visible light by using an infrared filter on a digital camera.

infrared compensation index

Also called *infrared focus indicator*. The extra marking on a camera lens for adjusting to the different focus point needed when working with infrared light. Infrared light focuses slightly farther away than does visible light, so the focus must be adjusted to compensate for this.

Infrared Data Association

See ***IrDA.***

infrared focus

Infrared light focuses at a point farther away than does visible light. Cameras working with infrared photography must have their focus adjusted to compensate. See also ***infrared compensation index.***

infrared focus indicator

A mark on a lens indicating where the different focus point is when using infrared light. Typically, the mark is a short red line or small red dot. See also ***infrared compensation index.*** *(see figure on page 191)*

Infrared focus point

The point at which infrared light rays come to a focus with a lens. This point is different than the point where visible light comes to a focus and that most cameras are set up to use. This infrared focus point must be allowed for when doing digital infrared photography. Autofocus systems will not operate properly. Sometimes the depth of field will be enough to compensate. Older film camera lenses had a mark on the lens to indicate the amount of adjustment needed to correct for this effect. See ***infrared focus indicator.*** *(see figure on page 187)*

initializing

The process of preparing digital media such as disk drives and CompactFlash cards for use in a digital camera. This process is also called formatting. See ***formatting.***

inkjet

A printing technology used for printing digital images. Tiny amounts of ink spray from a nozzle that forms images made up of extremely small ink dots. Commonly, the ink dots can be 1,440 dots per inch to 2,880 dots per inch. Inkjet printers are relatively inexpensive, although the cost of ink typically is not. Even consumer versions of inkjet printers can make fairly high-quality prints. Some caution is needed to create long-lasting prints. Prints can last as little as six months or as long as a number of decades, depending on the printer, the ink, and the paper. Typically, glossy papers do not last as long as matte-finished papers. Pigment inks tend to last longer than dye inks. Special paper designed for inkjet use is usually required for optimum results. See also ***pigment ink; dye-based ink.***

infrared focus indicator – This figure shows the focus indicator on a lens. The lower numbers are f-stops. The red line on the right side of the figure between the 11 and 16 has an R by it to indicate that it is the location of the focus point of infrared light. It corresponds to the orange line in the figure, which is the focus point of visible light.

instrument metamerism

Metamerism is when two colors are seen as different or identical by an observer but an instrument, such as a scanner, reports the two colors as the opposite from what the observer reports. That is, if the viewer sees the colors as different, the instrument measures them as the same. The reverse, where the viewer sees the two colors as the same, but the instrument measures them as different, is a particular type of metamerism known as instrument metamerism. It is considered an instrument error.

Integrated circuit. (I/C)

A tiny electronic circuit made up of semiconductors. An I/C is a lower cost and smaller version of circuits that used be made up of individual transistors, capacitors, and other electronic components. They are the core portions of nearly all electronic devices such as computers, cell phones, and other modern digital devices. Even automobiles have a number of I/C's. Digital cameras have a number of I/C's inside.

intellectual property

A general description applied to works created by photographers, artists, musicians, writers, inventors, and others. Intellectual property is generally protected by copyrights, trademarks, and patents. National governments give protection to creators through laws defining periods of time that creators have exclusive rights to their intellectual property. Intellectual property rights are what copyright law is based on, and copyright law is the basis upon which professional digital photographers make their living. Without copyright law, anyone could use the intellectual property created by digital photographers, or others, without payment. Such a situation would make it very difficult to make a living as a professional digital photographer. Intellectual property is a term recognized by most national governments throughout the world. See also **copyright.**

intelligent scanner

An optical scanner that has a built-in microprocessor designed to operate more automatically than simpler scanners. Intelligent scanners can provide post-scanning functions such as converting a scan to a PDF; reducing the size automatically so it is appropriate for the desired use, such as e-mailing; auto correcting for graininess, fading, or improper exposure; and scanning multiple items at the same time. See also **microprocessor; PDF.**

interface

A technology for connecting peripheral devices to a computer. Examples

of interfaces include AppleTalk, Ethernet, serial, and parallel. Another type of interface is a *user interface*, which is the way users interact with computers or other devices such as digital cameras. See also **user interface.**

interference

In scanning halftone photographs, interference creates moiré patterns that require special effort and techniques to minimize or remove. Interference can also occur when digitally photographing fine patterns, such as herringbone fabric, or when photographing monitors or televisions whose pictures are made up of fine lines. See also **halftone image.**

interlaced scanning

A technology used in video and television to display images electronically. The television image is made up of a series of lines (525 in the case of analog television in the United States). The picture is divided into two fields: one made up of even-numbered lines and one made up of odd-numbered lines. The fields are presented one after the other instead of both at the same time. Because of the persistence of human vision and the speed at which the fields are presented, the fields appear to blend together into one image. Each field is presented for $1/60^{th}$ of a second, so it takes $1/30^{th}$ of a second to present an entire image. When photographing images on a television or monitor, this phenomenon needs to be taken into consideration. Usually, selecting a shutter speed longer than $1/30^{th}$ of a second will minimize the scan bar that will show up at faster shutter speeds.

International Color Consortium

An organization cofounded by Apple Computer to develop cross-platform versions of ColorSync. The original ColorSync was developed solely for the Macintosh computer. See also **ColorSync.**

International Organization for Standardization (ISO)

An international organization that sets many commercial standards. Its members are representatives of national standards organizations. Many of its standards are adopted as laws by individual countries or internationally through the use of treaties. The standards set by ISO for film speed are used by digital cameras. The ISO has also developed standards for computers, the Internet, and digital media cards. Without the work of the ISO, there would be much less interchangeability in digital photography. Founded in 1947, the ISO is headquartered in Geneva, Switzerland.

International Press Telecommunications Council (IPTC)

A council set up by a group of news organizations to develop standards for news exchange. The IPTC is made up of news organizations and news industry vendors. It is best known in digital photography for its development of metadata standards. See also *Information Interchange Model; IPTC headers; IPTC Core; XMP; metadata.*

International Standards Organization

Widely but wrongly held to be the name of the organization known as ISO. ISO actually stands for the International Organization for Standardization. ISO is not an acronym, but derives from the Greek word *isos*, meaning equal. See *International Organization for Standardization.*

Internet protocol address

See *IP address.*

internet service provider (ISP)

A company that provides a connection from a computer to the Internet. These connections can be by dial-up, cable modem, DSL, satellite, among other technologies. Most digital photographers have an ISP, and usually try to get the fastest connection possible to the Internet in order to send their images—often very large files—online to commercial clients, publishers, album companies, and photography labs.

interpolate

The action of creating pixels in between other pixels to enlarge an image. The new pixels are created by averaging the pixels surrounding the new pixel using different techniques. The process itself is usually referred to as *interpolation*. See also *interpolation.*

interpolation

The result of interpolating, that is, a larger image with additional, newly created pixels. See also *interpolate.*

IP address

An abbreviation for *Internet Protocol address*. Also called Internet address. The web address of a computer connected to the Internet. Every computer connected to the Internet must have a unique address so that messages sent to it electronically will be received by the correct machine. The address is in the form of four numbers separated by periods, such as:

68.85.33.61. Each number can have from one to three digits, from 0 to 255 The current version, v4, uses 32-bit addressing. A new protocol, v6, using 128-bit addressing is being developed to allow more addresses and to allow large blocks of addresses to be reserved for specific purposes.

IPTC

See ***International Press Telecommunications Council; metadata; IPTC Core.***

IPTC4XMP

An alternative name for IPTC Core Schema for XMP. See ***IPTC Core; International Press Telecommunications Council.***

IPTC7901

Also known as *IPTC Recommendation 7901*. Designed to facilitate computerized text messages by recommending standards for international usage. IPTC7901 is designed to accommodate different languages and alphabets. See ***International Press Telecommunications Council.***

IPTC Core

The more common and short form for *IPTC Core Schema for XMP*. IPTC Core is a group of metadata used primarily by photographers to describe their images and embed this information within the image file for a number of common file formats. It is the replacement for *IPTC Headers*, now known as *legacy IPTC header information*. Because the new IPTC Core utilizes XMP, it is user-extensible (the definition of XMP). This means users can expand the metadata capabilities for their own specific requirements. IPTC Core can be used with Photoshop 7.1 and later versions. Photoshop 7.1 and Photoshop CS require a modification to work properly with IPTC Core. IPTCv4 is the current version of the IPTC Core. When the term IPTC is used by itself, it usually refers to IPTC Core even though it is the abbreviation for the International Press Communications Council. See also ***metadata; International Press Telecommunications Council; IPTVv4.***

IPTC header

Also known *as legacy IPTC*. Metadata stored in the header of an image file. IPTC header has been replaced by *IPTC Core Schema for XMP*. See ***IPTC Core; International Press Telecommunications Council; metadata.***

IPTC metadata

Refer either to the legacy metadata of *IPTC headers* or to the more current metadata of *IPTC Core*. See also **IPTC header; IPTC Core; metadata.** *(see figure on page 197)*

IPTCv4

Refers to IPTC4XMP or IPTC Core Schema for XMP. See **IPTC Core.**

IRB

See **image resource block.**

IRC

An abbreviation for *Internet relay chat*. Software that allows live, real-time communication between groups of users using text communication. Different channels are set up to talk or chat about different subjects.

IrDA

An abbreviation for the *Infrared Data Association*. The organization set up to create and maintain standards for the use of infrared light to transmit data over short distances. Some digital photography devices, such as laptops, use infrared light to connect to other devices. A laptop computer can connect to a printer or another computer via infrared interfaces. Camera and flash remote controls are another common application of this technology.

IR setting

An abbreviation for *infrared setting*. The infrared compensation index or the infrared focus point. See **infrared compensation index; infrared focus point.**

ISDN

An abbreviation for *Integrated Services Digital Network*. A circuit-switched telephone network system governed by an international set of standards. Established to allow higher-speed digital data transmission over standard two-wire telephone lines, ISDN requires the use of specialized equipment at both ends of the phone line. It is commonly used as a connection to the Internet and allows faster speed than traditional dial-up access. It also allows two simultaneous connects over the same phone line. A user can thus have standard telephone operation and be connected to the Internet over the same two-wire phone line. For many uses, *DSL (digital subscriber line)* has replaced ISDN.

ISO

See **International Organization for Standardization.**

ISO-9660

A standard developed for CD-ROM media by the International Organization for Standardization (ISO). See **International Organization for Standardization; CD-ROM.**

File Name	an00073f.jpg
	Contact
Creator	© John G. Blair
Job Title	
Address	
City	Occidental
State / Province	CA
Postal Code	95465
Country	USA
Phone	
E-Mail	hello@johngblair.com
	hello@johngblair.com
Website	www.johngblair.com
	Content
Headline	
Caption	A group of California Quail sit on a fence rail under the redwoods in Occidental California having a discussion.
IPTC Subject Code	
Description Writer	
Category	
Other Categories	
	Image
Date Created	
Intellectual Genre	
Scene	
Location	
City	Occidental
State / Province	CA
Country	USA
ISO Country Code	
	Status
Title	Morning Gossip
Job Identifier	
Instructions	
Provider	John G. Blair
Source	
	Copyright
Copyright	¬© John G. Blair-ALL RIGHTS RESERVED- www.johngblair.com
Rights Usage Terms	
Copyright Info URL	© John G. Blair - ALL RIGHTS RESERVED - www.jgblair.com

IPTC metadata – Information about an image, known as IPTC metadata, is stored within the image file. This information is shown in this figure from Adobe Photoshop Lightroom.

ISO speed

Originally a measurement of the sensitivity of film to light. *ISO speed* has now been adapted for usage in digital cameras as a rating of their image sensor's sensitivity to light. It replaced the ASA ratings of the past but is numerically equivalent. The ISO speed scale is linear. A doubling in the ISO number implies a doubling of the sensitivity to light.

ISP

See ***Internet service provider.***

IT8

Also called *IT8 target.* A color calibration chart and a group of ANSI color standards. These charts are used to color-calibrate devices, such as scanners and printers, and to create profiles for these devices.

IVUE

Formally known as *live picture multi-view format.* A proprietary digital image file format used by the image-editing software called Live Picture. Images have a file name such as *image.ivue.* Because IVUE is a vector format rather than a bitmapped format, image display is faster. Images can be quickly scaled for display once the viewing device size is known by the software.

jaggies

Also known as *aliasing artifacts.* The stair-step-shaped artifacts seen instead of straight or curved lines. Jaggies are often caused by increasing the resolution (uprezzing) of an image more than the original resolution will permit. A software technique called *anti-aliasing* can be used to smooth the jaggies where possible. Other smoothing functions are also available. The jagged edges are actually individual pixels or small groups of pixels. Increasing the real resolution of an image by creating a higher-resolution original at the time of photography is the best way to prevent this problem. Jaggies are most noticeable on diagonal and curved lines. *(see figure on page 199)*

Japan Electronic Industry Development Association (JEIDA)

Best known as an electronic standards association in Japan, although it also engaged in research and development. In 2000, JEIDA was combined with the *Electronic Industries Association of Japan* (*EIAJ*) to form the *Japan Electronics and Information Technology Industries Association* (*JEITA*). One of JEIDA's best-known accomplishments was the development of the graphical file format known as Exchangeable Image File

jaggies – The diagonal lines in this figure are jagged in a phenomenon known as jaggies.

Format (Exif). See also ***Exchangeable Image File Format; Japan Electronics Information Technology Industries Association.***

Japan Electronics and Information Technology Industries Association (JEITA)

Formed in 2000 with the merger of Japan *Electronic Industry Development Association (JEIDA)* and the *Electronic Industries Association of Japan (EIAJ)*. JEITA is a trade association that was set up, in its own words, to "foster a digital network society for the 21st century, in which IT advancement brings fulfillment and a higher quality of life to everyone." Digital imaging, both still and video, are among the product areas within JEITA's scope.

Java

A programming language. Java is designed to run easily on different types of computer systems. Small programs called *Java applets* can run on web pages; these account for much of Java's popularity. The Java applet will run on many different browsers and multiple computer systems, including Macintosh, Windows, and UNIX. Java was developed by Sun Microsystems, which allows much of Java to be used at no charge.

JavaScript

A simple programming language designed to run on web pages. Although both Java and JavaScript are owned by Sun Microsystems, JavaScript is only distantly related to the Java programming language. Netscape developed JavaScript. JavaScript is known as a *scripting language*, that is, a programming language in which each step is interpreted sequentially rather than being compiled and converted to machine language before beginning. The most common usage seen is on web pages to implement the *mouse-over* feature, where images change as the cursor is hovered over them.

JBOD

An abbreviation for *just a bunch of disks*. Refers to an array, or stack, of hard disk drives contained in the same box but that are not connected in a RAID system; rather, they are accessed individually. Technically, the correct usage of the term JBOD means that the stack of disk drives should appear as a single huge disk array on the computer and called a *JBOD*. However, usage of the term is starting to accept JBOD as meaning the disk drives showing up individually on the desktop as well as when they show up as a single large array. See ***RAID.***

JCII

An abbreviation for *Japan Camera Inspection Institute*, a shortened version of *Japan Camera and Optical Instruments Inspection and Testing Institute*. JCII has been replaced by the *Japan Camera Industry Institute*, which enjoys the same abbreviation. JCII was formed to improve the

quality of Japanese optical instruments, including camera lenses. At one time, a small, oval gold sticker was placed on each lens that passed inspection that stated, "Passed. JCII."

JEIDA

See *Japan Electronic Industry Development Association.*

JEITA

See *Japan Electronics and Information Technology Industries Association.*

JFIF

Stands for *JPEG file interchange format.* A file specification standard. JFIF is the actual name of one of the common file formats that uses the JPEG compression technique. The formal name is *JPEG/JFIF*, but most of the time just JPEG is used. The JPEGs used online are generally JPEG/JFIFs, while JPEGs used in cameras may be another type, such as Exif. JPEG/Exif images are similar and can often be treated the same as JPEG/JFIF images. See also *JPEG.*

Joint Photographic Experts Group

The committee that created the JPEG and JPEG 2000 file compression techniques. See *JPEG.*

JP2

The filename extension for JPEG 2000, a compressed file format based on wavelets instead of the discrete cosine transforms technique used for JPEG. See also *JPEG; JPEG 2000.*

JPEG

One of the most common file compression techniques for images currently in use. Although JPEG is actually a compression technique using two different image formats, it is widely used as a descriptor for a file format. The actual file formats are JPEG/JFIF, which is used mainly on the Web, and JPEG/Exif, which is commonly used by digital cameras that produce JPEG images. Many software applications can read both, so the difference between the two is transparent to the user most of the time. To add to the confusion, both formats use .jpg as the file extension. JPEG is a lossy file compression technique. It uses a technique known as *discrete cosine transform* to do the compression. Great reductions in image size are made possible by throwing away similar pixels. When the image is then uncompressed for display, it looks approximately the same as the original. How similar it looks is greatly dependent on how much compression is used. When using Photoshop, there are quality settings of from 1 to 12, with 12 being the highest quality and lowest compression. Image qualities of 10 to 12 are very high quality and there are few differences within this range. Those levels are generally safe for transmitting images to clients. For web use, high compression can be used, which will reduce

storage requirements and increase downloading speed. While JPEG files can be opened any number of times without a problem, because of its lossy nature, repeated resaving of the image will degrade the quality. Higher compression levels will cause it to degrade quickly. See also *JFIF; Exif.*

JPEG 2000

A new compression technique for images developed by the Joint Photographic Experts Group (JPEG). JPEG 2000 uses *wavelet compression* techniques instead of the *discrete cosine transforms* used in the standard JPEG techniques. JPEG 2000 will produce fewer compression artifacts and produce a higher level of compression than JPEG. It provides the capability to perform either lossless or lossy types of compression. It also provides improved scalability and editing capabilities. At the present time, JPEG 2000 has not been widely accepted, and there are few software applications that can work with it. Fear of legal issues and the underlying patents are the main issue. See *JPEG; lossy; wavelet compression; Joint Photographic Experts Group.*

JPEG compression

A popular compression technique that uses discrete cosine transforms (or DCT) to reduce image size. See *discrete cosine transforms, JPEG.*

JPF

An abbreviation for *Java Plugin Framework*. JPF is designed to find and load *plug-ins* in Java systems. See also *Java.*

.jpg

The file extension used for an image that uses JPEG compression. See also *JPEG.*

jukebox

An automated storage mechanism used to store multiple optical discs such as CDs and DVDs. Jukebox can access, or bring them up, as needed and put them in the reader. It saves the user from having to handle a large number of CDs or DVDs. It is similar to the old-fashioned jukeboxes that held records and played them upon request. It has been updated to work in the digital era; a computer with a jukebox attached can call up the discs as needed. A similar mechanism exists for magnetic media as well.

°K

Improper notation referring to *Kelvin*, a temperature scale. The correct abbreviation is simply *K*. See *Kelvin.*

kb

An abbreviation for *kilobit*. 1,000 bits. kb can also mean 1,024 bits (2^{10}). The exact quantity is dependent upon how it is used. Not to be confused with *kB,* or *kilobyte*. See also ***bit; kB.***

kB

An abbreviation for *kilobyte*. 1,000 bytes. kB can also mean 1,024 bytes (2^{10}). The exact quantity is dependent upon how it is used. Not to be confused with *kb*, or *kilobit.* The abbreviation is sometimes seen as *KB.* See also ***byte; kb.***

kbps

An abbreviation for *kilobits per second*. A unit of measure for the speed of data transmission. Usually means 1,000 bits (and not 1,024 bits) per second. See also ***bit; kb.***

Kelvin

A temperature scale. The unit is the *kelvin* (not capitalized), while the scale is *Kelvin* (capitalized). The unit is not *degrees kelvin*, but simply *kelvin*, with the symbol *K*. It is similar to the temperature scale of Celsius, except the zero point of the Kelvin scale is absolute zero, the coldest temperature that is possible. The individual whole-number temperature intervals (called degrees in Celsius, but not in Kelvin) are the same in each scale. Absolute zero is equal to -273.15 °C. The Kelvin scale has no negative numbers because of this definition. In digital photography, the Kelvin scale is used to specify the color temperature of light. The temperature of light at noon on a sunny day is about 5500 K. Ordinary incandescent light bulbs are about 3200 K. The Kelvin scale was named after Lord William Thomson Kelvin, who created it in 1848. See also ***color temperature.***

kernel size

Relates to the number of pixels used when sampling during image manipulations, such as sharpening and interpolation. For example, when sharpening with unsharp masking, using a larger kernel size will increase the width of the edge-sharpening and enhancement effect, causing that effect to be more apparent. This may increase the apparent sharpness. Increasing it too much will tend to make an image appear to be over-sharpened.

kerning

Adjusting the space between characters in typography. In the digital world, this is done in the word-processing or page-layout software application. The goal is to make everything look balanced, so the spacing is varied depending on which letters or characters are next to each other. Some combinations require more space than others.

keystoning

When a projector is not perpendicular to the screen, a distortion in the

projected image occurs where the rectangular image is not projected as rectangular on the screen. Sharpness is also reduced on the affected edges. This can be adjusted by making sure that the projector is placed so that it is square to the screen. This generally means that it is at the center of the screen in height. With the advent of digital projectors, adjustments can usually be made electronically to digitally distort the image vertically before it leaves the projector so that it appears rectangular on the screen.

keyword catalog

An alphabetical listing of keywords. The best type of keyword catalog is a hierarchical one, with keywords grouped under logical categories. An example of a hierarchical keyword catalog might include the following hierarchy of terms, extending from *parent* to *child* terms: animal > mammal > dog > German Shepherd. Applying the child keyword, "German Shepherd," to the image would also include all of the upper-level ones as well. This speeds up the keywording process considerably. Using a keyword catalog with a controlled vocabulary makes it much easier to find all of the images when conducting a search. See also ***controlled vocabulary.***

keyword generator

Software used to generate additional keywords after one keyword has been introduced. A thesaurus can serve this function as well, but it typically requires more manual work. See also ***keywords.***

keywording

The process or activity of attaching keywords to an image. See also ***keywords.***

keywords

In digital photography, words designed to help the user find an image. The user could be a professional photographer trying to locate the wedding photographs of a couple ordering reprints on their tenth anniversary. Keywords are used extensively in stock photography. An individual image could have a dozen or many dozens of keywords added. Creating keywords entails describing where the image was taken, predominate colors used, actions that occurred, content or subject matter contained, moods or feelings evoked, among other things. Synonyms can be added as well. When there are thousands or millions of images to search, good keywords are vital.

kilobyte

See ***kB.***

kilobytes per second

A data transmission speed of 1,000 (and usually not 1,024) bytes per second. See also ***byte; kilobyte.***

knock out

 The removing of the background behind an inserted type, photograph, or
 graphic element such that the type or element will be printed directly on
 the paper and not on the printed background. This process keeps the
 printed piece looking cleaner because it prevents the ink mixing of the
 element and background.

Kodak PhotoCD

 Known more commonly as *Photo CD*. See **Photo CD.**

L*a*b*

 A unique abbreviation of a color space. Specifically, it refers to the color
 space CIE 1977 L*a*b*, or CIE LAB. See **CIE LAB.**

Lab color

 Refers to two different color spaces: *L*a*b** (*CIE LAB*) and *L, a, b*
 (*Hunter Lab*). Note that the asterisks and commas are part of the names of
 these color spaces. CIE LAB is probably the more popular of the two.
 Although similar, the two color spaces are derived using different
 mathematical functions. The purpose of both Lab color spaces is to
 produce a linear color space. There are conversion techniques to convert
 images that are in Lab color spaces to and from specific RGB color
 spaces (such as *sRGB* and *Adobe RGB*) and specific CMYK color spaces.
 The color spaces were developed by the Centre Internationale
 D'Éclairage (CIE). See also **CIE; CIE LAB.**

lag time

 The amount of time expired between pressing the shutter on a digital
 camera and the actual firing of the shutter. The longer the delay, the more
 difficult it is to photograph action subjects or fleeting events. The user has
 to anticipate the event and press the shutter slightly before the action
 takes place. Lag time should definitely be tested before purchasing a
 digital camera.

Lambda print

 A traditional photographic print for which the paper is exposed digitally
 instead of using an optical enlarger. The prints are made with a *Durst
 Lambda printer*, hence the name. Lasers are used to create the exposure.
 A Lambda print can also be called a *digital type-C print*. A similar print is
 made on an Océ Lightjet printer. These prints are sometimes referred to

by their specific name or by the combination of the names, that is, a Lambda/Lightjet print.

LAN

An abbreviation for *Local Area Network*, which is often an Ethernet network. See **Ethernet Local Area Network.**

landscape mode

A horizontal image, that is, one in which the longest dimension of the image is parallel to the horizon. Landscape mode is so named because most landscape images are horizontal. The opposite of landscape mode is *portrait mode*, which is the term sometimes given to vertical images. See also **portrait mode.**

laser printer

A printer that uses lasers as part of the printing process. The laser printer is designed to be attached to a computer. It uses the xerography process made popular by the Xerox Corporation beginning in 1971. A laser printer produces high-quality output, even from small personal computers. Although it is usually not considered a photographic-quality printer, it is used quite frequently for text documents. Black-and-white laser printers are the most common, but color laser printers are available. The lasers write the data on a photoreceptor drum by electrostatically charging (or not charging) individual dots on the drum. Toner particles are also charged, in an opposite polarity, and then allowed to be attracted to the drum. The toner particles are then transferred to sheets of paper, which are passed through heated rollers to fuse the toner to the paper. Laser printers can operate fairly quickly. Most laser printers operate at about 600 dpi, producing fairly high-quality text output.

lasso

A tool in Photoshop used to make a free-form selection in an image. The cursor is simply clicked and moved through the image to select a feature for further work. Holding down the *alt* (PC) or *option* (Mac) key at the same time will draw a straight line. When closing the selection the ending point must connect to the beginning point. If the two points are different, the program will automatically connect them with a straight line.

lateral chromatic aberration

One of two types of *chromatic aberration* found in lenses that are often seen as purple fringing. The other type is *longitudinal chromatic aberration*. The purple fringing—found especially in the super-wide-angle lenses used in digital photography to make up for their magnification factor—is caused by different wavelengths of light rays focusing at different points in the image. The lateral chromatic aberration usually increases with the distance from the center of the image and is more pronounced at the edge of the image. One of the differences between

lateral and longitudinal chromatic aberration is that the former has two colors on each side of an object, while the latter has only one color that surrounds the object. Some corrections can be made in Photoshop and in specialized image-enhancement programs. See also ***chromatic aberration; longitudinal chromatic aberration.*** *(see figure below)*

lateral chromatic aberration – This figure is an enlarged section of a photograph which shows purple and green bands known as lateral chromatic aberration.

layered file

An image or graphic file in Photoshop or a similar program that has multiple layers attached to it. See also ***layers.***

layer masks

A technique used in Photoshop to control how a layer is applied to an image. On a layer mask, painting in black will block that area of a layer from being applied to the background image. Painting in white will allow that part of the layer to be applied. Varying shades of gray will allow some of the layer to be applied. A photographer could create a layer that was very blurred, then use a layer mask to block parts of it so that the underlying portrait would have, for example, sharp eyes and lips. The layer mask is a very powerful tool in Photoshop because it does not change the underlying image, only the layer. When the image is saved with layers intact (not flattened), the image can be reopened and reedited at any time without losing information. See also *layers.*

layer match command

A command in ImageReady, a separate Adobe program commonly used in conjunction with Photoshop. It allows the user to apply the attributes of the current layer to other layers either individually or all-inclusively. It is often used in rollovers and animations. See also *layers.*

layers

A function in Photoshop and some other graphical editing programs that allows the user to create new images and stack them on top of the original image without changing the original. In effect, layers allow the user to manipulate the end result and still go back to the original image and start over. These stacked images can be a graphic elements, such as text, that will be printed on the image. The text can be edited repeatedly—changing the color, position, and font, for example—without changing the original image. Layers is a very powerful tool that offers huge creative possibilities to the photographer and graphic designer. A layered image can be taken apart at any time and adjustments made to a single layer (image) without distributing the rest of the layers.

layout

Also called *page layout*. Graphically designing a page. Digital photographers often manually create layouts for a brochure or a client's album. They also use software such as Photoshop to automatically produce products, such, as contact sheets, that require layout.

LCD

An abbreviation for *liquid crystal display*. A type of display used for computer monitors, televisions, and other devices. An LCD is a digital device made up of pixels, unlike a CRT display. An LCD, which has

liquid crystals in a layer between two transparent panels, also uses much less electricity, is thinner, and is lighter than a CRT. These transparent panels polarize the light that passes through them. Electricity is applied, causing some liquid crystals to align and turn dark. A light source behind the panels is blocked in the areas of dark crystals. Each pixel is made up of three sub-pixels that have either a red, green, or blue color filter in front of them. These color filters convert the black-and-white LCD into a color display.

LCD screen

Refers to the small LCD display often found on the back of digital cameras. See also *LCD.*

LCSH

An abbreviation for *Library of Congress Subject Headings*. LCSH is a controlled vocabulary that, besides being used by most libraries, is useful for basic keywording of digital images. See also *controlled vocabulary; keywording.*

leading

In the past, when type was set with lead, additional lead was used between lines of type to keep them separated. *Leading* is still used to refer to that space. It is measured in *desktop publishing points* (or *Postscript points*) of which there are 72 points in an inch.

LED

An abbrevieation for *light-emitting diode*. A small semiconductor that emits light when powered. LEDs can be made in various colors, they require much less power than an incandescent light to operate, and they have a much longer life. Both of these factors make LED lights increasingly popular, even though initially they are more expensive. LEDs have begun to be used as a light source in some projectors. Because of their purity of light, LED safelights are being made for traditional wet-chemistry darkrooms.

legacy files

Images created in the past using equipment and software that is no longer current. These images may have been created on film. They may be stored on old media such as floppy disks or zip drives. They may have been modified by older versions of software that are difficult to read today. In any of these cases, the images need to be given special care to keep them accessible.

Lempel-Ziv-Welch
 See *LZW.*

levels

A function in Photoshop. A *histogram* of the image displayed, providing a graphical representation of where pixels fall in the range of dark to light. Three triangles are used to set the white point (highlights), middle gray, and black point (shadows) of an image. Adjusting these three points will remap or redistribute the pixels so that the image will take the full range of tones that are possible. It is a quick and easy way to adjust the image to make it appear more the way the photographer had in mind. This process can be done for the image as a whole or for each color channel individually. This process is meant to quickly improve the image. In this way, the entire range of the image can be used to display the colors involved. See *histogram.* *(see figures below)*

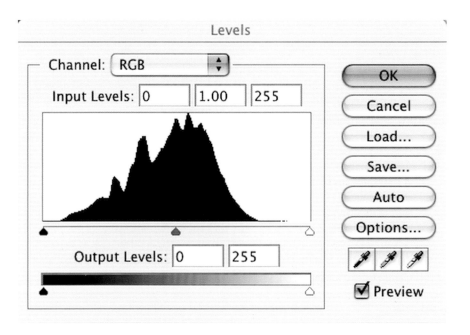

levels – This figure is the Levels palette from Photoshop, which shows the number of pixels of each value in an image.

light-fastness

The length of time a print will last under a particular lighting source. All photographic images fade over time. Some may last only a few months while others may last two hundred years Factors that determine light-fastness include the type of light, how the print is displayed (e.g., under glass, and if so, the type of glass), the paper or media the image is printed on, the technique used to print the image, and other materials used in the image's production or that touch the print.

light meter

See *exposure meter.*

lightness

Refers to how bright a color is. Lightness is a property of color along with hue and saturation. Colors that have a low lightness will be grayer. A color with zero lightness will be black. See also *hue; saturation.*

lightroom

(1) Another term for *digital darkroom.* (2) A new program created by Adobe to speed up the photographer's workflow. Its official title is *Adobe Photoshop Lightroom.* See also *digital darkroom.*

light source

The type of light being used for taking photographs. Light sources include daylight, incandescent light, flash, and fluorescent, among many others. The actual choice of a light source depends heavily upon the photographer's purpose in creating the photographs, the photographer's skill level, and the types of lighting equipment available, among other factors. Making the choice is often a creative decision that depends on the *look* desired for the image.

li-ion

An abbreviation for *lithium-ion.* See *lithium-ion.*

linear-array

Also called *linear CCD.* See *linear CCD.*

linear CCD

A group of CCDs arranged in a linear manner. Linear CCDs are used in specific applications such as flat-bed scanners, high-speed document scanners, copiers, bar code scanners, satellite imaging, and some special-ized scientific applications.

linearity

The property of a function that its graph is a straight line. This means that increasing the input of a signal increases the output by a proportional amount.

linear scanner

A scanner that uses a linear CCD as its scanning sensor. The linear CCD is moved across the object to be scanned, or the object is moved under-

neath the linear CCD, in order to scan the object completely. See also
linear CCD.

lines per inch (lpi)

A unit of measure used for a printing system's resolution. Successively
finer pairs of lines are scribed onto a chart that is photographed or
scanned and reproduced as a printed halftone. The pair of lines with the
smallest distance between them that can be discerned in the final print
will determine the printing resolution in lines per inch. See ***halftone.***

link

A web link to a website. The web link can be to another page within the
same website or to a page in another website., Most websites have
multiple links in them. Clicking on a link will take the user to that
location on the same website or on another. The link is one of the most
powerful features of the World Wide Web (WWW). See also ***website;***
WWW.

li-ion

See ***lithium-ion battery.***

liquid crystal display

See ***LCD.***

liquify filter

A tool or function in Photoshop. Despite its name, the liquefy *filter*
operates more like a *tool*. When turned on, it allows tools to push pixels
around in the image. This can be a very useful and powerful function
when retouching portraits. It is easy to push in a bulge here or to stretch
something out there. For example, when someone leans against a rail, it
pushes their thighs out making them look wider than normal. Using
liquefy allows the photographer to push the sides of the thighs back in so
they look more natural. When pushing, the pixels are not smeared, just
pushed and stretched. The filter can also be used for creative effects or to
make interesting or unusual compositions.

lithium-ion

See ***lithium ion battery.***

lithium ion battery

Also called a *li-ion battery* or a *LiOn battery*. A type of rechargeable
battery often used in digital cameras and other devices. Li-on batteries
tend to be lighter than other types of batteries, without the memory effect
that hampers some rechargeable batteries. Thus they tend to be more
expensive than other types of batteries. Since they are usually custom-
designed for a particular purpose, they are often the only type of battery
that can be used in a particular device

Local Area Network (LAN)

A small computer network often set up to operate in a home or business.

liquify – The liquefy filter/function in Photoshop allows an image to be manipulated and the pixels moved around. This figure shows an example of the filter in use, and also shows all of the options.

LANs are often based on Ethernet technology. Many computers now come with Ethernet connections built in, so that it is just a matter of plugging the computers together or using a small hub to set up a small, simple network. LANs can also be set up to use Wi-Fi technology for wireless networks. Digital photographers often use multiple networked computers, such as a desktop and a laptop computer, to share data, hard drives, and printers. A LAN, whether wired or wireless, is the method most often used to network computers. See also *Ethernet; Wi-Fi.*

longevity

The length of time images will last in the original digital format or photographs will last as prints. All photographic prints deteriorate over time. Some may last only a few months, others may last several hundred years if stored under controlled conditions. There are a number of factors that enter into the longevity of photographic prints. These include the materials used in the production of the print, the materials used to display

the print, and the environmental conditions (light and air quality) under which the prints are stored. The media used to store the original digital image, such as *magnetic media* (floppy disks, hard drives, and zip drives) and *optical media* (CDs and DVDs), also deteriorate over time and can be damaged by improper handling as well as environmental conditions. Selection of media and storage conditions should be carefully considered by users to ensure the greatest longevity for their images.

longitudinal chromatic aberration

One of the two types of *chromatic aberration* found in lenses. The other type is *lateral chromatic aberration.* The color fringing of longitudinal chromatic aberration is generally found equally on all sides of an object and is of the same color. It is caused by different wavelengths of light rays focusing in different planes in the image, causing some colors to be slightly out of focus. One of the differences between lateral and longitudinal chromatic aberration is that the former has two different colors on each side of an object, while the latter has only one color surrounding the object. Some corrections can be done in Photoshop and in specialized image-enhancement programs. See also ***chromatic aberration; lateral chromatic aberration.***

look-up table (LUT)

Used frequently in image processing to speed up computer operations. LUTs are used as palettes and color maps. They are tables of available colors based on the color space and other limitations. The computer program looks up a color for the image in the table and chooses the closest one available to use. See also ***palette; color space.***

lossless

See ***lossless compression.***

lossless compression

A data compression technique in which no data is lost in the compression. The original image can be exactly reproduced from the compressed version. For image compression, *TIFF-LZW* and *PNG* are two formats of lossless compression. See also ***TIFF-LZW; LZW; PNG.***

lossy

See ***lossy compression.***

lossy compression

A data compression technique in which duplicate or near duplicate data

are tossed out to reduce the size of a file. In the case of digital images, the very popular *JPEG* image file format is a lossy compression technique. The image, when uncompressed from a lossy compression technique such as JPEG, is visually similar to the original image, but not exactly the same. For many uses, such as web images, the loss of quality is worth the large storage-space savings and the reduced download times. The amount of compression—and therefore of quality—is user selectable in most cases. The more compression chosen, the lower the quality of the compressed image. When using lossy compression file formats, it is important that the image not be repeatedly resaved. Each resaving operation will reduce the quality. See also *lossless compression; JPEG.*

lossy format
> See *lossy compression.*

low-pass filter (LPF)
> Also called *anti-aliasing filter.* As the name implies, a filter that passes lower frequencies and cuts off higher frequencies. An example would be the filter located in front of the image sensor in to reduce *moiré* or *aliasing* patterns. The low-pass filter has a tendency to reduce the sharpness of the image. It is usually designed to remove infrared light (IR). See *anti-aliasing; infrared.*

low res
> See *low-resolution.*

low-resolution
> Also called *low res* or *low rez.* A subjective description of images in which the number of pixels is less than would be normally expected. Thus an image used on a website that is 72 ppi would not necessarily be considered low-resolution, but the same image printed on a quality magazine page would be. A low-resolution image is usually recognized by a tendency for pixilation or coarseness in the overall look of the image. Generally, when an image is said to be low-resolution, it is small as well as having a small resolution number. See also *resolution.*

LPF
> See *low-pass filter.*

lpi
> See *lines per inch.*

LPT port

An abbreviation for *line printer text.* A parallel communications port used mainly by IBM-PC types of computers to connect to printers. USB and FireWire interfaces are replacing LPT ports.

lumen

A unit of measure for *luminous flux.* A lumen indicates the amount of light coming from a light source, but it does not translate directly into brightness unless a specific area is taken into a consideration. As an example, a single 100-watt light bulb will not provide enough light to walk around a large enclosed auditorium. Yet that same bulb in a small closet is nearly overwhelmingly bright. See also ***lux; candela.***

lumen seconds

The amount of light coming from a light source measured in lumens over a period of time measured in seconds. See also ***lumen.***

luminance

Luminance is the light reflected from a surface or emitted by an object. It is also known as *lightness and it is s*imilar to the brightness of an image, Lightness is one of the three properties of light (the others are *hue* and *saturation*). Luminance is the brightness as perceived by the eye. The unit for measuring luminance is *candela per square meter* or *cd/m².* See also ***lightness.***

luminosity

The amount of luminance emitted over a period of time. See also ***luminance.***

LUT

See ***look-up table.***

lux

A unit used in measuring illumination. Also called a *candle-meter* or *meter-candle.* A lux is equal to one lumen per square meter, which is equivalent to the amount of light on a surface one meter away from a single candle. A single candle produces one candela. Moonlight produces light of approximately one lux and sunlight on an average day varies from 32,000 lux to over 100,000 lux. See also ***candle; candela.***

Lynx

(1) A programming language. (2) A web browser. (3) An operating system.

LZW

An abbreviation for *Lempel-Ziv-Welch*, a lossless data compression technique. LZW is used in the GIF format, within the Adobe Acrobat format, and, optionally, with TIFF images. Savings in size can be as high as 50%. With the TIFF format, the compressed image may show small or even negative data compression, depending on the image. TIFF-LZW is not widely used, although Photoshop offers that option when saving images as TIFF files. Not all programs support TIFF-LZW. See also **GIF; Acrobat.**

Macbeth color checker

See **Gretag Macbeth color checker chart.**

Macintosh PICT Format

Also known as *Macintosh PICTure Format* and *PICT format.* A file format used only on Macintosh computers to support the Quickdraw drawing protocol. It was used for many graphics applications in earlier Macintosh operating systems. Beginning with Mac OS X, *PDF* replaced PICT as the main format, although many Macintosh programs still support PICT.

macroblock encoder errors

Macroblock coding is a video lossless compression technique. A macroblock encoder error occurs when the software is unable to properly compress the video data.

macro lens

A lens used for its capacity to focus very closely. A macro lens is used for close-up photography. Often, the lens is specially designed to have a flat field as well.

macrophotography (also macro photography)

Another name for *closeup photography*. Macrophotography refers to photography of small objects, generally using macro lenses, specialized extension tubes, or closeup attachments, because of their capacity to focus more closely. Within macrophotography are special fields such as insect and coin photography. Macrophotography usually refers to the photogra-

phy of objects more greatly magnified than is possible with a standard lens, so as to fill the frame of the image.

magenta

One of the four colors used in the CMYK four-color printing process. The others are cyan (C), yellow (Y), and black (K). Magenta (M) is opposite green on the color wheel and is made from red and blue. In 8-bit RGB, magenta is (255, 0, 255). See also *four-color printing; CMYK.*

magenta – RGB – This shows approximately what the magenta color looks like in the RGB system. The variations in the color printing process mean that this is only an approximation of the color.

magic eraser tool

A tool in Photoshop designed to erase a color specified by the user. The user can specify how close to that color the tool should work. For example, a blue sky is not all one shade of blue. By giving the tool a wider tolerance, the user can erase the sky without touching the foreground, as long as the foreground is not blue. Other settings adjust this tool to behave in different ways. This tool is very useful for removing objects from their background by erasing the background. After it erases, the erased area is transparent.

magic wand

A tool in Photoshop that allows the user to select an area in an image by clicking on a color in the image. Other areas with that same color are selected as well. The user can choose how close to the original color the selected area is. The user can also select whether he or she wants only contiguous (joined) areas to be selected.

magnetic lasso tool

A tool in Photoshop, similar to the *lasso tool*, used to make selections freehand within an image. As the user draws with the lasso tool and the mouse, the line created will snap to the nearest, strongest existing line. A user can outline an object simply by drawing near the edge; the tool snaps to the edge of the object as if it were magnetic. The magnetic lasso tool is similar to the *magnetic pen tool*. The main difference is that, with the magnetic pen tool, the user is drawing, or creating, a vector path. With the magnetic lasso tool, the user is selecting an area within an image. See also ***magnetic pen tool.***

magnetic pen tool

A tool in Photoshop similar to the *magnetic lasso tool*. The main difference is that, with the *magnetic pen* tool, the user is drawing, or creating, a vector path. With the *magnetic lasso tool*, the user is selecting an area within an image. See also ***magnetic lasso tool.***

mAh

An abbreviation for *milliampere hour*. (1) The amount of current that a device draws in milliamperes multiplied by the amount of time it is drawing that current in hours. (2) A measure of the capacity of a battery. If the capacity of the battery is known and the current draw of the device is known, then an approximate period of use can be calculated.

malware

An abbreviation for *malicious software*. Software created to enter or harm a user's computer or data without the user's permission. Types of malware include spyware, viruses, adware, worms, and trojan horses.

manipulate

In digital photography, processing an image by changing it. Forms of

M

manipulation can include retouching and making creative changes. Manipulating an image usually requires the use of photo software such as Photoshop. See also **retouching.**

marquee

A dashed line created in Photoshop by the one of the marquee tools. The dashes move very much like the marquee lights on the fronts of old theaters. The marquee indicates a selection made within an image. The marquee tools include the rectangular, elliptical, single-row, and single-column tools.

mask

A tool in Photoshop or other image-manipulation software allowing the user to select part of an image and place it into a *layer* so that changes to the mask do not affect the image underneath. The created mask will block the image underneath it so that a viewer will see the mask on top of the original image.

master image

A term used to describe the original image saved to make derivative images. The master image is full-resolution and not cropped. Occasionally the term refers to the fully color-corrected image that has not been cropped but has been saved for making other derivatives.

Mb

An abbreviation for *megabit*. One million bits. Not to be confused with *MB*, which stands for *megabyte*. See **megabit; megabyte.**

MB

An abbreviation for *megabyte*. One million bytes. Not to be confused with *Mb*, which stands for *megabit*. See **megabit; megabyte.**

MBR

An abbreviation for *master boot record*. MBR is typically the first sector of the hard disk; it contains a small program that is run when the computer is first started or "booted up". The term can refer to the location on the disk, or to the program contained there, or both.

Mbyte

See **megabyte.**

measure tool

The tool in Photoshop that looks like a ruler. It is used to measure angles by clicking and dragging along a straight line. It can be used with the arbitrary rotation tool to straighten images or to measure the distance between two points in an image. The measure tool is located under the *eyedropper tool*.

media

Media has several meanings in digital photography. (1) Used to describe materials on which images are saved or recorded, such as CDs, DVDs, CompactFlash cards, and hard drives. These are known as digital or recording media. (2) The material on which images are printed, such as various types of paper.

megabit (Mb)

One million bits. Not to be confused with megabyte (MB). See ***bit; megabyte.***

megabyte (MB)

Also called *Mbyte*. One million bytes. A measure of storage in a computer or memory chip. A megabyte is a group of bits. By convention, a byte is now recognized as being made up of 8 bits. A byte is 2^8 bits. That means that a byte can have values from 0 to 255, or a total of 256 different values. When prefixes are added, such as *kilo*, *mega*, and *giga*, the terms are widely used in digital photography to measure the storage capacity of hard drives and memory cards. See also ***byte.***

megahertz (MHz)

One million hertz. *Hertz (Hz)* is the name used for *cycles per second*. Heinrich Rudolf Hertz (1857–1894), a German physicist, is credited with discovering electromagnetic waves. See also ***hertz.***

megapixel

One million pixels. Used in describing the resolution of a digital camera. See also ***pixel.***

memory

Part of a computer system, as well as a part of a digital camera system. The location where data or images are stored on a temporary basis. Usually, data is held in memory only as long as power is on. When the computer is shut off, data and images stored in memory are usually lost. Memory capacity is often stated in terms of *megabytes* or *gigabytes*. See also ***megabyte; gigabyte.***

M

memory card

Also called *flash memory cards*. Memory location where images are stored on a camera to be transferred to a computer. The memory card is removable from the camera. Memory cards are used in other digital devices besides cameras. Images stored on memory cards will remain there even if power is removed. Popular types of memory cards include CompactFlash, Memory Stick, Secure Digital, and xD-Picture Card. *(see figure below)*

memory cards – Three different memory cards are shown in this figure. In the upper left, a 1 GB microdrive is shown. On the right is a 1 GB CompactFlash card. The bottom left shows a 512 MB xD-Picture Card.

memory stick

A type of memory card developed by Sony. The memory stick gets its name from its unusual shape. It is longer and narrower than other types of memory cards. Memory sticks now come in several different sizes to fit different cameras. See also ***memory card.***

metadata

Text data used to describe an image. Since the most current method for

searching for images is with text searches, the application of appropriate metadata to an image is very important in the ability to find it among thousands of other images. Some metadata, such as exposure information, is added to an image file by the camera at the time of exposure. Other metadata, such as the location of the image or the identity of the people in it, are added by the photographer later.

metadata template

A template used to speed up the addition of metadata to an image file. In some cases, standard metadata, such as the copyright-holder contact information, is the same on all images. Standard templates can be used perpetually; special metadata templates can be created for a particular client or job. The latter is used once for a group of images and then discarded. See also *metadata.*

metafile

A file that can be shared with various programs or that can contain different types of data. A metafile can be a graphic, or image, file.

metalogging

The process of adding metadata to images. The term was created by combining *metadata* and *cataloging*. See also *metadata.*

metal-oxide semiconductor

An abbreviated form of *metal-oxide semiconductor field effect transistor*. Also called a *MOS* or *MOSFET*. A type of *field-effect transistor*. One of the most popular MOSs in digital circuits is the *CMOS* or *complementary metal-oxide semiconductor*. MOS is currently the most widely used type of transistor in digital circuits. MOSs are basically miniature switches and are widely used in digital cameras and computers. See also *CMOS; field-effect transistor.*

metamerism

An effect seen with some digital printing paper-and-ink combinations where the image looks different under different types of light, such as incandescent and sunlight. Pigment-based inks seem to exhibit this problem more frequently than other types of inks. Instrument metamerism can also occur in a scanner when two different colors scan the same or two identical colors scan differently.

metamers

(1) Occasionally used as another term for *metamerism*. (2) Two color samples that appear the same under certain lighting conditions but different under other lighting conditions. See *metamerism.*

meta-tagging

Also called *metalogging*. The process of attaching a meta-tag to an image (or other data). See also *metalogging.*

M

microdrive

A miniature hard drive the size and shape of a *CompactFlash (CF) card*. When CF cards first came out, microdrives were the only way to get larger storage amounts of up to 1 GB. Microdrives are more delicate than CF cards and subject to destruction if dropped on a hard surface. Since they are a miniature hard drive, they have moving parts that are subject to wear and tear. Microdrives have largely been replaced by larger and cheaper CF Cards. See also **CompactFlash.** *(see figure below)*

microdrive – An IBM 1 GB microdrive is shown next to a penny for a size comparison.

middle-tone

Also called *midtones*. In digital photography, the middle gray color in a print or image. See also **midtones.**

midtones

The neutral, middle gray tones in an image or a print. Occasionally midtones are defined as a range of values of about 25%-30% to about 70%-75% of the full range of brightness available.

mie scattering

The scattering of light in the atmosphere caused by particles such as dust. Mie scattering generates the red hues of sunrise and sunset as well as the

red hues seen after dust storms, volcanic eruptions, and forest fires. All of these activities release dust, smoke, soot, and ash particles into the air that cause low-angle scattering and produce the red, orange, and other colors associated with those events.

millions of colors

Also called *Truecolor*. The term applied, generally on Macintosh and Linux computers, to representations of color that utilize one byte per channel for three channels of color. This leads to 256 colors per channel or 16,777,216 (256 x 256 x 256 = 16,777,216) colors.

minidisk

A magneto-optical recording disk format developed by Sony in the early 1990s to replace audiocassettes. Minidisks never became popular outside of Japan. The version developed for storing computer data was called *MD data*, but it too failed to catch on. There were rewriteable versions as well as read-only versions. A higher-capacity version called *Hi-MD* was also developed.

MIP map

Also called *mipmap* or *texture map*. A bitmap image that has a reduced level of detail used with a texture or pattern in a digital image to speed up processing speeds. MIP maps are used in three-dimensional computer graphics programs, such as games, because of the detail in the images and the speed of the action. MIP is an abbreviation for the Latin phrase *multum in parvum,* or *many in one*.

mired (M)

A measurement system used with filters to make color temperature adjustments easier. A mired is equal to one million divided by the color temperature in kelvins. The most common term used is *decamired*, or ten mireds. See also ***decamired; Kelvin.***

mirror lens

See ***catadioptric lens.***

MLPS

See ***MPLS.***

modulation transfer function (MTF)

A measurement of an optical system's frequency response. It is also sometimes called modulated transfer function or spatial frequency response. It is the measurement an optical system's spatial frequency response often done by photographing line pairs, expressed as line pairs per millimeter in film systems or line widths per picture height with digital cameras. The higher the spatial frequency or MTF, the finer the detail that can be resolved. MTF can be used, for example, with a scanner or similar system to measure the system's frequency response.

moiré pattern

An interference pattern that occurs when two different grid patterns are combined. This can occur in a scan of a halftone image or in a digital image of a fine pattern such as a herringbone suit. In the case of the digital image, the CCD-array pattern registers interference relative to the pattern of the fabric. The moiré artifacts are considered undesirable and are to be avoided when possible. There are some software techniques, such as blurring, designed to minimize this problem after the fact. Changing the angle and the lighting at the time of the photography, or changing the screen angles and halftone frequencies in printing can sometimes be helpful in reducing moiré. *(see figure on page 227)*

monitor calibration

The process of adjusting a computer monitor to a known standard. This is a vital function for a digital photographer to perform on his or her computer system; it ensures not only color accuracy but also repeatable results when dealing with other computer systems, such as those used by color labs to make color prints. There are software calibration tools such as Adobe Gamma that rely on a user's eyes to match colors. Hardware calibration techniques using a device called a *puck* to measure the color values on the monitor are much more accurate. The calibration procedure involves (1) setting the monitor to standard conditions, usually 6500 K (known as D65) and a gamma of 2.2; (2) setting the black and white levels; (3) eliminating colorcasts by balancing the red, green, and blue levels; (4) using the hardware device, with software, to measure known colors. The software constructs a *monitor profile* to adjust the monitor to its calibrated state.

monitor profile

The software result of a *monitor calibration*. A monitor profile is applied to the monitor to adjust its values to a known standard. See also ***monitor calibration.***

monitor RGB

An RGB color space specific to a particular monitor. Monitor RGB refers to all of the colors that can be displayed by that particular monitor. See also ***color space; RGB.***

monochromatic aberration

A type of aberration caused by the shape or geometry of the lens. Monochromatic aberration means that a point on the subject, when seen through the lens, is seen as a shape other than a point, such as a blob. All colors or wavelengths of visible light are affected equally. Monochromatic aberration can be broken down into *astigmatism, coma, distortion, field curvature*, and *spherical aberration*. See ***astigmatism; chromatic aberration; coma; distortion; field curvature; spherical aberration.***

moiré pattern – This section of a photograph of a suit shows an interference pattern known as a moiré pattern.

monochrome

One (*mono*) color (*chrome*). In general, monochrome refers to grayscale (sometimes called black-and-white) images, although technically it could refer to any single color. A sepia image, for example, is a monochrome image. The first computer monitors were monochrome and were often green. See also *grayscale.*

moony 11 rule

Related to the *sunny 16 rule*. Used to photograph the moon when the photographer doesn't have a light meter. The photographer sets the camera to *f*/11 and then uses the shutter speed closest to 1/ISO as the shutter speed. For example, photographing the moon with an ISO 400 setting on a digital camera, the photographer would use 1/400 (or 1/500, if that were the closest setting) at *f*/ll. See also ***sunny-16 rule.***

Moore's Law

An observation made by Gordon Moore, a co-founder of Intel, that transistors on an integrated circuit double in capability every 18 months for minimum component cost. Since his initial observation in 1965, the law has been modified slightly to 24 months and applied to other computer components such as hard disk storage and RAM storage capacity.

moral rights

Those rights given to creators—such as photographers, authors, artists, and composers— of copyrightable intellectual property that are separate from the copyright and that always belong to the creator. These rights are differentiated from the economic rights of copyright ownership. Moral rights include the right of attribution (to be known as the creator of the work regardless of who owns the copyright), the right not to have authorship falsely attributed, and the right of integrity (the creator may object to the derogatory treatment of the work). Not all countries recognize moral rights to the same extent.

MOS

See ***metal-oxide semiconductor.***

MOSFET

See ***metal-oxide semiconductor.***

motherboard

The main circuit board of a computer. The motherboard is where the processors, memory, and all of the connections needed to operate the computer are located. At one time, computers were made up of separate circuit boards for each of these functions. Once they were all placed on one board, this became known as the *main board* or motherboard of the computer.

Motion Pictures Expert Group (MPEG)

An industry standard group established to develop standard formats for compressed video and audio. The group was first formed in 1988. See also ***MPEG.***

MPEG

(1) A video format, usually accompanied by a number such as MPEG-1 or MPEG-4, developed by the *Motion Pictures Expert Group*. (2) An abbreviation for the Motion Pictures Expert Group. See ***Motion Pic-***

tures Expert Group.

MPLS

An abbreviation for *multiprotocol label switching.* Also known as *MLPS.* A technique for carrying data on a network. MPLS enables Ethernet data to be carried over more networks. See also ***Ethernet.***

MTF

See ***modulation transfer function.***

multi-megapixel

In general, refers to the resolution of a digital camera and means more than one million pixels. See also ***resolution; megapixel.***

multitasking

The technique utilized in microprocessors and computer systems to do more than one operation at a time to speed up processing. Even though the central processing unit (CPU) portion of the computer only performs one operation at a time, the computer is running multiple programs at the same time. These programs are switched in and out of the CPU to maximize CPU usage while the rest of the computer is performing other operations such as input and output. Digital photographers often multitask, for example, by printing images, working on other images in Photoshop, and downloading e-mail simultaneously.

multum in parvum (MIP)

See ***MIP map.***

Munsell system

A color system developed by Professor Albert H. Munsell, who was also an artist. The Munsell system is based on *hue, value* (or lightness), and *chroma.* It is based on the five hues of red, yellow, green, blue, and purple. One of the system's deficiencies is the lack of cyan and magenta. See also ***hue; value; chroma.***

nanometer (nm)

A unit used in measuring distance, including the wavelength of light. The wavelength of visible light ranges from about 380 to 780 nanometers. A nanometer is equal to one billionth of a meter, or a millionth of a millimeter. It is also equal to 10 angstroms.

native resolution

Refers to the actual number of pixels on a display device. Native resolution is often used to describe the physical number of liquid crystal cells in a LCD monitor because this is the resolution that will provide the best

display. If any other resolution is used, the image will be degraded by interpolation.

natural language systems

Software programs designed to understand commands written in regular language—for example, English—rather than special computer languages. Google and similar search engines are examples of natural language systems. The user can simply type a group of words or a phrase into the search box and the search engine software will attempt to match and interpret what is written as closely as possible, ignoring short common words (*a* and *the*, for example). These systems even try to correct misspellings.

NAVSTAR GPS

The official name for a *satellite-based navigational system*. Commonly known as *GPS*. See *GPS.*

nearest neighbor

A method of interpolation of data that is also known as piecewise constant interpolation. In digital image processing, when a digital image is enlarged, one way that the new values are calculated is by interpolating each new point based on an average of the values of the nearest neighbors. Another way is simply to use the value of the nearest neighbor. Both of these are quick and easy ways to interpolate the image file, but there are better methods available such as linear interpolation, polynomial interpolation, or bicubic interpolation. See also *interpolation.*

NEF file

A proprietary raw image file produced by Nikon digital cameras. An NEF file is basically a modified TIFF image with additional information stored. Specialized software is required to interpret the file. See also *raw image format.*

network

A group of computers linked together. The advantage to linking computers in a network is they then have the capacity to share peripherals, data, and other resources.

neutral gray

In general, a gray color with an 18% reflectance, usually in the form of a test card printed with a flat surface. Neutral gray is used with a reflective meter to determine an exposure. It is a gray color without any colorcast to it. See also *neutral test card.*

neutral test card

Also called a *neutral gray card* or *gray card*. A test card printed with a neutral gray color. A neutral test card is used with a reflective meter to determine an exposure. In digital photography, a *neutral gray card* is also used to adjust the white balance of the scene and exposure. See also

neutral gray.

news codes

A type of metadata used with news items. This metadata describes the content of news items such as text, photographs, graphics, audio files, and video files and is stored in a standard controlled vocabulary format within the file itself. See also *controlled vocabulary; metadata.*

Newton rings

An interference pattern in the form of rings that occurs when two surfaces are in close contact with each other with a thin layer of air between them. Newton rings occur in scanning when using a glass carrier and film or when using a flat-bed scanner and film.

NIC

An abbreviation for *network interface controller*. Also known as a *network card* or *network adapter*. Computer systems use NICs to connect to and communicate over a network such as an Ethernet network. Many recent computers have built-in networking capabilities and no longer need NIC cards. See also *network; Ethernet.*

NiCad

An abbreviation for *nickel cadmium*, a type of rechargeable battery. NiCad is a trademark for nickel cadmium batteries made by the SAFT Corporation. The generic abbreviation is *NiCD*. See also *nickel cadmium.*

NiCD

An abbreviation for *nickel cadmium*, a type of rechargeable battery. NiCD is the generic term for nickel cadmium batteries, as opposed to the trademark *NiCad*. See also *nickel cadmium; NiCad.*

nickel cadmium (NiCD)

Also abbreviated as *NiCad*. A type of rechargeable battery. Nickel cadmium is an especially useful rechargeable battery in high-current draw situations and is often used in camera flash units. These batteries have a lower voltage (1.2 volts) than normal batteries (1.5 volts), so the device must be designed to accommodate the lower voltage.

nickel metal hydride (NiMH)

A type of rechargeable battery. NiMH is used in digital photographic applications because it has two to three times the energy storage of a nickel cadmium battery of the same size. See also *nickel cadmium.*

NiMH

See *nickel metal hydride.*

nm

See *nanometer.*

NMOS

A type of semiconductor or logic that uses *metal-oxide-semiconductor*

field-effect transistors (*MOSFET*) in a digital integrated circuit. These semiconductors are widely used in digital devices such as microprocessors.

noise

In digital photography, unwanted electronic noise in images. Noise is most often found in shadow areas when the exposure is increased during post-processing. It looks like multicolored confetti. In general, noise increases as the temperature of the sensor increases. Noise also increases as the camera's ISO setting is increased. Different cameras have different noise characteristics. Some software programs are specifically designed to help remove noise from images after they are created.

noise – The multicolored pixels shown in this enlargement are random noise.

noise measurement

The attempt to measure the noise produced in digital images produced by digital cameras. There is some controversy about the ability to measure noise in digital cameras. Because the human eye is more sensitive to some colors than to others, the complexity increases when noise measurement

techniques are attempted. Some cameras have noise reduction software built in, and this has to be accounted for as well. Many noise-measurement techniques utilize flat, neutral gray targets. Since most photography is not of flat, neutral gray subjects, and since noise reduction techniques work best on flat areas in an image, measurement techniques that utilize flat, neutral gray targets are not as useful in determining how noisy a camera is when used in real-world photographic situations. See also *noise.*

noise reduction

Refers to a type of software used either in a camera or, later, in a computer to reduce the noise in digital images. Some software works by slightly blurring the noisy areas, which also tends to blur fine details in the image. Other software works by operating individually on the red, blue, and green channels in the image. Some techniques work as plug-ins for photo-manipulation software, such as Photoshop, and other noise-reduction software works on a stand-alone basis. See also *noise.*

noise reduction – This figure shows the results of noise reduction software that has been applied to the image shown under the term "noise".

non-lossy

Also known as *lossless*. A type of image compression that can reproduce exactly the original image when the image is uncompressed. A lossy image compression achieves its compression by discarding similar data points. Non-lossy image compression does not throw away any data, so it does not typically achieve as high a compression as lossy image techniques. *TIFF-LZW* is an example of a non-lossy technique. See also **LZW.**

non-volatile memory

Computer memory that retains information without power being applied. Examples in digital photography include the memory cards that images are stored on. Even hard drives, CDs and DVDs are a form of non-volatile memory. See also **memory.**

NTSC

An abbreviation for *National Television Systems Committee*. The group that developed the analog television standard of the same name currently in use in the United States and other countries. The NTSC standard uses 525 lines, a frame rate of 29.97 frames per second, and 60 cycles per second (hertz). The frame rate was reduced from 30 frames per second to allow for the addition of a color sub-carrier signal. There are current plans to replace NTSC with an entirely digital standard to allow for more channels and HDTV within the same frequency bandwidth.

Nyquist frequency

Also called critical frequency. It is one-half of the *sampling rate* or *frequency*. The Nyquist frequency must be at least as large as the bandwidth of the sampled signal to avoid aliasing. See also **aliasing.**

OCR

See **optical character recognition.**

OEM

An abbreviation for *original equipment manufacturer*. A company that manufacturers a product for sale by another company, usually under the second company's name. OEM can also refer to the company doing the selling, instead of the manufacturing.

off-screen memory

Memory not available for the display but used to store information used by graphics accelerators. This is information that does not need to be visible on the screen.

OIS

See *optical image stabilization.*

OLE

An abbreviation for *object linking and embedding.* OLE was developed by Microsoft to embed objects from one application into another; for example, placing an image or spreadsheet into a document.

on-board processing

The technique of processing data at the current location rather than having to send it to another device. For example, digital cameras have on-board processing capability to process the raw-sensor data into an image for display or recording.

online photo printer

A photographic processing lab that accepts digital images for printing from an online or web-based source. The user does not have to physically mail the images to the lab. The user uploads the images to the lab using web-based software or FTP. The lab then prints the images and returns them to the user. This process can be done very quickly, usually within a matter of a few days from the time of upload to the time of receiving the final prints.

online service

Also called *online service provider.* A business offering users more than just a connection to the Internet. The extras usually include shopping, news, weather, search engines, chat rooms, games, and other features.

opening up

The process of increasing the size of the aperture on a camera. See also *open up.*

OpenRAW

An organization dedicated to the promotion of open standards for raw image storage, as opposed to the existing system in which each manufacturer has a closed, undocumented, proprietary format or formats. See also *raw format.*

open up

A means to allow more exposure by increasing the size of the aperture on a camera, which allows more light in. A larger aperture is denoted by a smaller f-number. See also *exposure; f-number.*

operating system (OS)

The system software a computer uses to operate. Windows and Macintosh OS X are two common operating systems. The OS controls all of the application programs, handles the input and output of data, and manages all of the other hardware connected to the computer.

optical character recognition (OCR)

Software that allows a document to be be scanned and its content con-

verted to machine-readable text, such as ASCII characters. Typewritten documents can now easily be converted, but a process for reading handwritten documents still requires more work.

optical disc

A storage mechanism that relies on optical media, such as CDs and DVDs, rather than magnetic media, such as floppy disks and hard drives. New optical disc formats are under development, notably to hold HDTV video information and the additional storage requirements of digital photographers. See also *CD-ROM; DVD.*

optical image stabilization (OIS)

Also called *vibration reduction.* A technique used to reduce image shake in digital still and video cameras. OIS works by using electromagnets to move a floating lens element in opposition to the movement of the lens. Lenses that have this feature tend to be more expensive than non-OIS lenses. Typically, an OIS system will allow a photographer to handhold an exposure about twice as long (one stop in shutter speed).

optical resolution

Refers to the native resolution of a scanner before any electronic or digital interpolation of the image. The higher the optical resolution, the finer the detail resolved by the scanner.

optical scanner

Commonly known as *scanner.* A device that converts an analog image—in the form of a print, negative, or transparency—into a digital image that can be processed by a computer. There are several types of scanners, including the drum scanner, flat-bed scanner, and transparency scanner.

optical storage

A storage technique that uses optical discs to store digital information. See *optical disc.*

optical transfer function (OTF)

A complicated function used in microscopy to measure the ratio of the *image contrast* to the *specimen contrast.* Other variables, such as spatial frequency, are involved as well. If the optical system were perfect, the OTF would be equal to one (or 100%). In worst-case scenarios, the image contrast can be reversed from that of the specimen so that dark areas appear light instead of dark, for example.

orientation sensor

A sensor that communicates to the camera microprocessor whether the camera is being held vertically or horizontally. The microprocessor uses this information to automatically rotate vertical (portrait orientation) images, relieving the photographer of that duty at a later stage. The images are properly displayed straight from the camera.

orphan

An image without metadata to identify the owner of the copyright. Currently attempts are being made to amend US copyright law to allow people to use without restriction or payment creative works such as photographs when the owner cannot be determined. Metadata allows the copyright owner (usually the creator or photographer) to embed contact information inside the image format. This information is easily read by programs such as Photoshop. It is therefore important for photographers to always embed contact metadata into all images to keep them from becoming orphans. Also photographers need to be aware that some software or software features such as Photoshop's Save for the Web function, will strip out metadata before saving the image. See *metadata.*

OS

See *operating system.*

OTF

See *optical transfer function.*

output pixel

The pixel displayed on a digital display. If the number of input pixels is exactly the same as the number being displayed (the output pixels), no scaling is required. If the number being input is smaller, additional output pixels must be created by *scaling* or *interpolation*. If the number is larger, the image being input must be scaled downward by creating new output pixels to represent the greater number of input pixels such that the image looks the same. See also *interpolation.*

output resolution

The resolution at which the image is displayed or printed. This resolution is dependent on the display device or printer. The output resolution can be adjusted before output in image-manipulation software such as Photoshop, or it can be adjusted by the device itself. See also *output pixel.*

oversampling

(1) Scanning at a resolution higher than one that would produce the best result. (2) A technique used in some new image-sensor designs when converting the analog signal from individual pixels on an image sensor to a digital signal.

page description language (PDL)

A special programming language used to describe in exact detail the

layout of a page for use in a printer. Adobe PostScript is an example of a page description language.

palette

A set of colors available in a given *color space* or on a specific computer or device. Each color space has a palette of colors available for use. These colors are usually numbered and accessible to software that displays color information in an image.

panoptic

To see everything in one view. An example would be an aerial view from which all elements on the ground can be seen.

parity

An error-checking routine used in computers. An extra bit is added to data so that the data is always even or odd. Parity checking is used when transmitting or storing data.

parse user input

To check user-created data being input into a computer, such as a database. This check is done to keep the database safe.

patch tool

A retouching tool in Photoshop used to transfer patterns from one area in a digital image onto another area. It is used frequently when retouching facial features or repairing tears or scratches in a scanned image. By using layers and reducing the opacity, users can control how realistic the patching looks.

path

Like a walking path, a way to get from one place to another. The location of an image (or other) file down through multiple levels of hard drives and folders. The complete hierarchical location is the path. See also *clipping path.*

PCB

An abbreviation for *printed circuit board*. A PCB is a substrate that mechanically supports and electrically connects electronic components. Used in computers, a motherboard is an example of a PCB. See *motherboard.*

PC cord

The wire connecting the PC socket on a camera to an electronic flash. It is generally used with older flashes or older cameras that do not have a *hot shoe* connection. A PC cord usually has a male PC connector on one end to attach to a PC socket, and a household two-prong electrical connector on the other end to plug into the flash unit. See also *PC socket; hot shoe.* *(see figure on page 239)*

PCD

See *Photo CD.*

PC cord - This is an example of a PC connector on a PC cord.

PCMCIA card

An abbreviation for *Personal Computer Memory Card International Association card*. At one time this abbreviation stood for *Peripheral*

Component MicroChannel Interconnect Architecture, but was changed to its current meaning. A form factor for a small card designed to be plugged into a slot on a laptop computer to add additional capabilities such as hard drives and modems. Adapters were made to allow media cards from digital cameras to be plugged into the PCMCIA slot. Now, PCMCIA cards are often simply called *PC cards*. There are several types of PC cards; they are not all interchangeable.

PC socket

Also called *PC terminal* and *PC connector*. The small socket, shaped like a bulls-eye, that allows users to connect electronic flashes without *hot shoes* or *radio slaves* to a camera. See also **PC cord; hot shoe.**

PCT

A file extension for a file format known as the Macintosh PICT file format. See **Macintosh PICT format.**

PC terminal

See **PC socket.**

PCX

An abbreviation for *PC paintbrush bitmap graphic format*. A file format for images. ZSoft developed the format for use in its PC paintbrush software program. PCX is a compressed file format, but because it uses a simple compression technique, it is not very useful as an image file format. Photoshop, among other programs, can read and convert PCX graphic files.

PDA

An abbreviation for *personal digital assistant*. A PDA is a small, hand-held computer device with the capacity to keep a calendar and a phone directory, make lists, take notes, and store personal information. It often includes telephone, fax, and other wireless-communication functions. Examples of PDAs, a very common tool used by professional photographers, include the Palm Pilot, Blackberry, and PocketPC.

PDD

An abbreviation for *Photo Deluxe Data*. An image file format developed for Adobe Photo Deluxe.

PDF

An abbreviation for *Portable Document Format*. A file format developed by Adobe for electronic documents. Adobe created it as an open-file format so that other companies could use it. Adobe makes available *Adobe Reader*, a free program designed to read electronic documents. Adobe Reader is available for both Macintosh and Windows PC computers. PDF has now become a near-standard format for distributing documents. Adobe Photoshop and many other programs both read and write

documents in PDF format. PDF files typically are smaller than other similar file formats. Digital photographers can use PDF to send contact sheets and images to clients for viewing.

PDL

See *page description language.*

Personal Computer Memory Card International Association

(PCMCIA)

The standards body responsible for *PCMCIA cards*, now often called *PC cards,* used in laptop computers. See *PCMCIA card.*

Photo CD (PCD)

One of the earliest forms of digital image storage on a CD. The system, developed by Kodak, was used to store images that had been digitized from film. The images were stored in five or six different resolutions, depending on whether Photo CD or *Pro Photo CD* was ordered. The sizes were Base/16 (128 pixels x 192 pixels), Base/4 (256 x 384), Base (512 x 768), 4 Base (1024 x 1536), 16 Base (2048 x 3072), and 64 Base (4096 x 6144). The last size was the optional, largest size, available only on the Pro Photo CD. Photo CD was used for a number of years beginning in 1992, but is seldom used today. Kodak has discontinued its Kodak Pro Photo CD system and no longer offers technical support for it.

photodiode

A light-sensitive semiconductor diode. When light hits a photodiode, an electron is excited resulting in a current. Photodiodes are used in the CCD image sensors of digital cameras and scanners. See also *CCD; image sensor; scanner.*

photomicrophotography

More commonly called *photomicroscopy* or *photomicrography*. See *photomicroscopy.*

photomicroscopy

Photography of very small objects using a camera connected to a micro-scope.

Photoshop

A very popular professional photo and graphics manipulation software program developed by Adobe. There are several variations of Photoshop, including *Photoshop CS3, CS2,* and *Photoshop Elements*. Photoshop CS3 (and earlier versions still in use, such as CS2, CS, and 7) has many more features than Photoshop Elements and is correspondingly much more expensive. Most digital photographers use one of the various versions of Photoshop. When the term *Photoshop* is used, it is usually in reference to Photoshop CS3 or an earlier version. The term *Elements,* or *Photoshop Elements,* is used to describe only Photoshop Elements. Photoshop can be used to convert images from one color space to another; to enlarge or

reduce an image; to do detailed image manipulations for creative; artistic, or practical purposes; and to create entire graphic layouts.

Photoshop format

Also known as *Photoshop document format*, or *PSD*. The native image file format used by Photoshop to ensure that all information about an image, including data such as layers, is properly saved. PSD generally is supported only by Photoshop and other Adobe programs.

PIC

A file extension for the *Macintosh PICT file*

PICS

A series of PIC files (PICT bit-maps) used to create movie-like animations in software programs. See also **PIC; Macintosh PICT Format.**

pics

Also spelled *pix*. A slang term for *pictures*.

PICT

A file extension for the *Macintosh PICT file format*. See **Macintosh PICT format.**

picture disk

A format similar to Photo CD developed by Kodak for consumer digital images created by scanning from film. The images are stored in JPEG format on a 3.5-inch floppy disk. Each floppy holds 28 images, and the size of each image is about 900 KB when compressed. See also **Photo CD; JPEG; floppy disk.**

picture element

Better known as a *pixel*. See **pixel.**

pigment

A material that absorbs color selectively and thereby changes the color of the light that it reflects. Pigments are used in paints, pigment inks, and other coloring materials. In digital photography, pigment is mainly used in creating types of inks for inkjet printing See also **pigment ink; pigmented ink.**

pigmented ink

One of four types of inks that are generally used in inkjet printers. The

four types are *dye inks* (also called *dye-based inks*), *archival dye inks*, *pigmented inks*, and *pigment inks*. Pigmented ink consists of a mixture of dye and pigment. Dye inks usually have brighter, more vibrant colors than other types of ink. Pigment is longer lasting in light (*light-fastness*) than dye. Pigmented ink is the result of an attempt to make ink more fade-resistant than dye ink, yet better able to maintain color. It is also more resistant to water and generally more expensive than dye ink. Because pigmented ink contains dye, the dye portion has a tendency to fade over time, leaving its pigment base, but it fades less than does dye ink. See also **pigment ink, light-fastness.**

pigment ink

One of four types of inks generally used in inkjet printers. The four types are *dye inks* (also called *dye-based inks*), *archival dye inks*, *pigmented inks*, and *pigment inks*. Pigment ink, generally used in inkjet printers, has only pigment and no dye, which makes it longer lasting, notably in light (*light-fastness*). Pigment ink is considered the most permanent type of ink currently available for inkjet printers. See also **pigmented ink, light-fastness.**

pigment process

The manner in which some color filters used in image sensors are manufactured, so as to produce stable colors over time. *Color filters* are required to produce the standard red, green, and blue (RGB) sub-pixels needed to make up the color information in a single pixel. Pixels are otherwise capable of only grayscale. See also **pixel; RGB.**

pincushion distortion

An aberration seen in CRT monitors and in some, generally inexpensive, lenses. In this aberration, lines parallel to the edges of the frame are not straight but bent toward the center of the image.

pix

A shortened slang term for *pictures*. The term *pixel* is derived from *pix*. See also **pixel.**

pixel

The smallest digital photographic element. Pixel stands for *picture* (or *pix*) element. Each pixel is made of a red, green, and blue (RGB) component. A number from 0 to 255 represents each of these colored components. Three numbers represent an individual pixel. For example, 0,0,0 represents the amount of RGB colors in a black pixel; white is 255, 255,

255; pure red is 255,0,0. Over 16 million colors can be represented using this type of notation.

pixelated

Another term for *pixelation*. Note the difference in spelling. *Pixelated* should not be confused with *pixilated*. Both words are pronounced the same, but the latter means to act in an unusual manner. *(see figure on page 245)*

pixelation

An undesirable effect of the image breaking down into pixels whose sizes are larger than the detail in the image. Enlarging an image too much usually causes this effect. Not to be confused with *pixilation* or *pixelization*. See also ***pixilation; pixelization.***

pixel density

A measure of resolution usually stated as *pixels per inch* (*ppi*) or *pixels per millimeter*. Pixel density can be used to describe the resolution for a scanner, monitor, or digital camera. It should not be confused with *dots per inch* (*dpi*), which is used for printing resolution. See also ***pixel; ppi.***

pixel dropping

A technique used to reduce the size (in pixels) of an image by simply dropping pixels in a regular pattern, depending on the size of the reduction desired. Pixel dropping is simpler than other techniques, but it doesn't achieve the results of such techniques as *linear interpolation, bicubic interpolation,* or *bilinear interpolation.*

pixelization

The blurring of a portion of a still or video image to hide it. This technique shows the blurred portion at a lower resolution. An example would be hiding the license plate of a vehicle in an image to be displayed on the Web so that it cannot be easily traced. Lowering the resolution of the license plate is one way of accomplishing this effect. The term *pixelization* is used because the hiding action involves enlarged pixels. Not to be confused with *pixelation* or *pixilation*. See also ***pixilation; pixilation.***

pixel modulation

Increasing the size of pixels in order to increase their brightness. Pixel modulation is used primarily in printing processes.

pixels per inch (ppi)

A unit used in measuring the resolution of devices such as a scanners, monitors, and digital cameras. Occasionally, *dots per inch* (*dpi*) is used in error when ppi is meant.

pixel quality

The overall quality of the image sensor in terms of size and noise. Less-expensive image sensors (usually found in less-expensive digital cameras)

pixelated – The figure shows the enlargement of a portion of a photograph. It was enlarged so much that the photograph has broken up into pixels, an effect known as pixelation.

generally have more noise and are smaller, so as to fit onto the smaller image sensor. Given the same number of pixels, those found on a larger sensor typically have less noise and are of a higher quality.

pixel skipping

A method used to reduce image size. Pixel skipping is similar to *pixel dropping* in that the image size is reduced by simply removing some of the pixels. It is not the highest-quality method of reducing image size, so it is not very commonly used. See also *pixel dropping.*

pixilation

An animation technique using live actors photographed in a stop-motion style of movie-making. The technique is similar to that of claymation, using clay figures moved slightly for each frame photographed. Not to be confused with *pixelation*. See also *pixelation.*

pixmap

A colored raster image. See *raster image.*

plasma display

A type of flat-panel display used primarily for newer digital and HDTV television sets. These displays consist of noble gases in plasma cells between two panels. Points on the panels are charged, causing the gas to glow. Plasma displays tend to be more expensive than similar LCD displays and are used in higher-quality television sets. Plasma displays work well for the wide-screen environment and are often brighter, have a wider color spectrum, and offer a wider viewing angle than competing types of displays, although the gap in quality is narrowing.

plug and play (PnP)

The capability of simply plugging a new peripheral into a computer, which recognizes it and then operates it without having to add device drivers or perform special configurations. Plug and play is a feature of many modern operating systems.

plug-in

A program or subprogram used in conjunction with the main program that it plugs into. Photoshop, for example, has many plug-ins available to either perform functions that Photoshop itself doesn't do, or to do existing functions better. *Sharpening* and *noise reduction* are two areas in which many photographers choose to use a plug-in. Plug-ins for reading special image formats, or for using web cams with browsers, among other functions, are also available..

PLUS

An abbreviation for *Picture Licensing Universal System*. A system developed by the PLUS Coalition, a group of industry experts, leading companies, and associations, to facilitate the licensing of photographs and illustrations. The coalition designed a standard vocabulary, called PLUS,

and is now developing other tools for making the licensing process easier and faster for all involved.

PLUS Coalition

A group of companies, associations, and experts involved in designing a standard vocabulary and procedures for licensing images, called the *Picture Licensing Universal System*, better known as *PLUS*. See ***PLUS.***

PMA

(1) An abbreviation for *Photo Marketing Association* (International). The official name has changed to *Worldwide Community of Imaging Associations*. PMA's membership is made up of a number of associations related to the photography industry. (2) An abbreviation for *program memory area*, the part of a recordable compact disc (CD) on which the table of contents is written.

PMOS (or pMOS)

An abbreviation for *positive metal oxide semiconductor*. Also known as *MOS* and *MOSFET*. A type of *field-effect transistor*. One of the most popular MOSs in digital is the *CMOS* or *complementary metal-oxide semiconductor*. *MOS* is the most widely used type of transistor currently used in digital circuits. These transistors are basically miniature switches and are widely used in digital cameras and computers. See ***CMOS: MOSFET: MOS.***

PMT

An abbreviation for *photo multiplier tube*. A device used in higher-quality drum scanners to detect light shining through negatives or transparencies being scanned.

PNG

An abbreviation for *portable network graphics*. A compressed image and graphics format. PNG was designed to be a more versatile format than *GIF* for use on the Web. It uses lossless compression and generally compresses more than GIF. PNG supports 24-bit color, unlike GIF, which only allows 256 colors. PNG also supports transparency and partial transparency within the file. Not all image-processing and web-browser software support the PNG format. See also ***lossless; GIF.***

PNOT

(1) Part of a data format, used by Apple in its Macintosh computers, to store image data such as keywords and descriptions within the *resource fork* of the image file. Use of the resource fork for data storage has declined. (2) PNOT is also a reference to movie-preview data within the QuickTime data format. Extensis Portfolio and earlier versions of Photoshop could read this format.

PnP

See ***plug and play.***

P

port
> See **ports.**

Portable Document Format
> See **PDF.**

portable network graphics
> See **PNG.**

portal
> Also know as *gateway* and *web portal*. A website designed to be an entrance to a number of other websites. For example, a portal could offer e-mail viewing, shopping, news, weather, entertainment, or a search engine. Each click would take the user to another website, or to specific pages on another website, to see a broad spectrum of information and activities.

portrait mode
> An image in a vertical orientation. The opposite of *landscape mode*, which is horizontally oriented. See also **landscape mode.**

ports
> Connections in computers. Ports can be either computer hardware ports for connecting peripherals or other computers, or they can be software ports, allowing computer software programs to connect to each other. Because digital cameras have microprocessors built in, they too can have hardware ports, to connect a cable for downloading image files directly to a computer.

posterization
> An image that has no continuous tones but rather a series of individual tones separated by distinct lines. Posterizing is often used as a creative technique; filters are available in photo-manipulation programs such as Photoshop to facilitate this. Posterization can be caused by over-manipulating a digital image, especially when lower bit-value images such as 8-bit (rather than 16-bit) are heavily manipulated. Unwanted posterization is often called *banding*. See also **banding.**

posterize
> The process of creating an image with *posterization*, either unintentionally or deliberately. See **posterization.**

PostScript (PS)
> A *page description language*, or *PDL*, developed by Adobe for use in electronic desktop publishing. PS precisely describes the layout of the page text and graphics, so a desktop printer can print the page correctly. Not all desktop printers support PostScript. Typically, PostScript is used with laser printers. In many cases, PostScript is being replaced by PDF documents. See **PDF.**

ppi

See *pixels per inch.*

preferences

A set of functions within a software program allowing the user to define many aspects of the program's appearance and operation so as to suit the individual user's tastes and workflow.

prescan

A low-resolution scan of an image done quickly so the operator can set parameters and cropping before doing the longer, high-resolution scan.

preview

(1) A function often found in image-manipulation programs allowing the user to see a small, low-resolution image as it will appear after applying an operation such as a filter. (2) An electronic view of a document before it is sent to the printer such that formatting and layout can be checked without wasting time and printing resources.

preview screen

(1) The displayed preview from a software program. (2) The LCD preview screen found on the back of most digital cameras. In both cases, the purpose is to see a small, low-resolution view of an image or document so as to be able to judge layout and other general information.

printer resolution

Generally measured in *dots per inch* (*dpi*). The larger the number, the higher the printer resolution. A higher resolution means that the printer can print finer detail in images. Printers used for images typically need higher resolution to make those images look "photo realistic." Image resolution is generally smaller than printer resolution. As an example, an image with an image resolution of 240 ppi may be printed on a printer with 1,440 dpi. The dots in this case are the actual ink dots and not just the number of pixels the printer is printing.

printing resolution

The resolution at which an image or document is being printed, generally expressed in dots per inch (dpi). See also *printer resolution.*

process colors

The color inks used in the four-color printing process. Four-color printing uses cyan, magenta, yellow, and black, the CMYK printing technique. The term *process colors* usually refers only to the three colors, and not the black. See also *CMYK.*

programmed image control (PIC)

A function or mode developed by Canon for its cameras. PIC is an advanced program mode that selects various camera functions depending on which shooting condition is selected: portrait, landscape, close-up,

sports, or night scene. Besides aperture and shutter speed, PIC also determines automatic focus and film advance settings. See also ***program mode.***

program mode

An automatic-exposure function on some digital cameras that allows the microprocessor in the digital camera to choose the shutter speed and aperture for a photograph. The user selects only the camera's ISO sensitivity. See also ***ISO; aperture; shutter speed.***

program shifting

A function on some digital cameras allowing the user to leave the camera in program mode and yet quickly vary the combinations of correct exposure by simply turning a single dial. This function facilitates finding a higher or lower shutter speed or a higher or lower aperture (f-stop) setting without leaving the program mode. See also ***program mode.***

progressive CCD

A CCD that produces a *progressive scan output* rather than an *interlaced output*. Progressive CCD is used in digital video cameras. See also ***CCD; progressive scan; interlaced scanning.***

progressive JPEG

A JPEG image that gets increasingly clear as the resolution builds during downloading. This was an important feature for larger images in the days when nearly everyone had a slow, dial-up modem connection. Now that many users have high-speed Internet connections, progressive JPEGs are not necessary. Not all browsers support this format, which further discourages its use.

progressive scan

One of the two types of display techniques used for video monitors and television sets. The other technique is *interlaced scanning*. A progressive scan starts at the top and begins displaying the image, from left to right across the screen, to the bottom. This process is usually repeated sixty times per second. The entire image is displayed; no separate even-odd scan lines are present, as in *interlaced scanning*. This technique generally provides a higher-quality image display. Traditional analog television commonly uses the interlaced scanning technique. See also ***interlaced scanning.***

PROM

An abbreviation for *programmable read-only memory*. A computer memory chip that holds a permanent program in its memory. A *ROM* is similar, except that its programming is hardwired during manufacture. PROMs are programmed after manufacture and then locked; that is the program is burned into the PROM's memory, so reprogramming is not possible. See also ***ROM.***

protocol

Precise instructions regarding exchanging information in computers or other electronic devices. Protocol functions include starting and stopping a message, determining how the message is formatted, error checking, dealing with corrupted messages, and determining how to start and end a connection.

proxy

See ***proxy image.***

proxy image

Also called *proxy*. (1) A low-resolution image holding the place of a higher resolution image. This substitution is done in some cases when posting video to the Web so that the entire video is not contained in the posting. (2) A technique used in some software programs enabling the photographer to operate on a low-resolution proxy image file until the displayed result is satisfactory; the final displayed result can then be applied to the high-resolution image to create a high-resolution version. This is done to increase the operating speed of the software.

PSD

An abbreviation for *Photoshop document format*. The native format for Adobe Photoshop software. See ***Photoshop format.***

public domain

Items that are no longer covered by copyright. These can include creative works, such as photographs, art, writing, computer software, and music. The change of status from copyrighted to public domain can happen because the copyright has expired, such as in the case of Shakespeare's plays. Additionally, the work may not be copyrightable, such as lists of words or work created for the government, or the creator may have abandoned the copyright by expressly placing the work into the public

domain. When a work becomes public domain, others may freely use and reproduce the work without permission of the creator.

QTVR

See *QuickTime VR.*

queue

A line, or series, of tasks waiting to be completed in a computer. Examples include print jobs waiting to print and activities waiting to be processed through the CPU.

quick mask

A function in Photoshop that attempts to create a mask for the user. The mask is displayed as a *color overlay* on top of an object and can be used to separate the object (or objects) form the background. After creating a quick mask, the photographer uses other tools, such as the *paintbrush* or *lasso tool*, to refine the edges of the mask and clean it up. See also *mask.* *(see figure below)*

QuickTime

A compressed digital video file format (.mov) and software developed by Apple. Both the software program and the file format are known as Quicktime. Software to run QuickTime movies is included with every Apple Macintosh computer. Software is also available for use on Windows PC computers. The QuickTime movie digital video format is widely used on the Web.

QuickTime VR (QTVR)

An abbreviation for *QuickTime Virtual Reality*. A plug-in for *QuickTime* allowing the use of panoramic file-formatted images. Often, the panorama will be a 360° wraparound image. See also *QuickTime.*

QVGA

An abbreviation for *quarter video graphics array*. A small video file format that displays images at 320 x 240 pixels. The format is used in PDAs and mobile phones. See *PDA.*

quick mask – A function known as quick mask in Photoshop allows subjects to be isolated from the background. This figure shows the red used by quick mask over the background and how close it gets to the hairs on the caterpillar.

Q

raccoon eyes

Refers to portraits of people with undesirable dark circles around the eyes. Because of improper lighting, the eyes are not fully lit and therefore surrounded by dark circles. The shape of the face and location of the light source affect the degree of darkness. The cure for this problem is fill-lighting, using either a reflector or auxiliary lighting such as a flash. *(see figure on page 255)*

radio slave

A device attached to a camera that is used to trigger electronic flashes by radio signal. This is very useful for photographers to control a number of electronic flashes at a distance from the camera without stringing wires from one position to another. For example, a wedding photographer can set up several flashes at a wedding reception to capture a couple dancing in relative darkness. By using radio slaves rather than optical slaves, the photographers flash units are not triggered when guests take flash photographs.

RAID

An abbreviation for *redundant array of independent disks*. Put simply, a box with a number of disk drives in it. The RAID can be configured for speed by dividing up the saved information between two or more drives (RAID level 0), or it can be configured for safety against data loss by automatically storing the information on another drive, a process called *disk mirroring* (RAID level 1). There are also ways to configure the drives so that the array will continue to operate with one or two failed drives.

rapid rectilinear lens

An *aplanat lens* that has been corrected for *spherical aberration* and *coma.* See ***aplanat lens.***

raster

A display of information consisting of rows or lines. Raster connotes an image made up of rows of pixels. See also ***raster image.***

raster element

A single pixel in a *raster image* or *bitmap image*. A group of raster elements constitutes a raster image. See also ***raster image.***

raster image

Also known as *bitmap image* and *raster graphics image*. An image made

raccoon eyes – The dark shadows around a persons eyes are known as raccoon eyes and are caused by the main light being overhead and the absence of any fill light.

up of rows of pixels. A raster image can be shown on a monitor or printed on paper or other material. See also *bit mapped image.*

raster image file format (RIFF)

A graphics file format used by some scanners. RIFF is an expanded form of the *TIFF format*. See also *TIFF.*

raster image processor (RIP)

A processor that performs rasterization on an image or document in preparation for printing. The output from a RIP can be a file, such as a *PDF file* or *PostScript file*, or a file in another *page-description language*. There are hardware- and software-based RIPs. A RIP will interpolate the document and make it larger or smaller in resolution as is necessary for the printer. See also *PDF; PostScript; page description language.*

rasterization

The conversion of an image or document to a *raster image* (*bitmap*), usually for printing purposes. The device or software that performs the rasterization is known as a *raster image processor* or *RIP*. See also *raster image processor.*

raster scan

The display technique used in televisions and computer monitors. The scan goes from left to right and from top to bottom to display the entire image. The image is a raster because it is made up of pixels in straight scan lines. Sometimes the image is displayed in two separate fields with one field made up of the even scan lines and the second field made up of the odd scan lines. Thus it takes two complete fields to show the entire image. This is the technique used in analog television sets.

raw

Also called RAW, *raw format,* and *raw image* format. An image-storage format that stores the unprocessed electrical signals from the sensor in a unique format. Raw is often thought of as a digital equivalent of a negative and is usually different for each camera and manufacturer. The advantage of the raw format is that many decisions, such as on white balance or color temperature, can be made by the photographer later during processing and processed in the computer rather than in the camera. The photographer can try a number of options until the image is exactly the way he or she likes it. Some of the disadvantages of the raw format are that it takes up more storage space on the digital memory card, the camera often works more slowly while photographing, and more post-production time is required at the computer. Some photographers always shoot in raw format, others choose difficult lighting situations to use raw. Because raw is a special, proprietary format, it requires special software to decode, usually provided by the camera manufacturer as well as third

parties. The raw image is processed into the desired image and then save it to a standard format such as TIFF or JPEG. The raw formats each have their own name, such as *NEF*. Photoshop and other third party software programs have the ability to process many different types of raw images and offer another way to process the images. Each processing software method produces files with a different look. In some cases, the software provided by the camera manufacturer produces a better looking image, but at the price of not being as easy to use as one of the more versatile software programs such as Photoshop. There is one standard raw format developed by Adobe, called *DNG* (*Digital Negative*) that is offered to all camera manufacturers. DNG is still new, however, and no camera-maker has yet adopted DNG for its cameras. Some photographers are converting their proprietary raw formats to DNG because they feel that it is more likely to be used in the future, considering the current rapid development cycle of digital photography. Note that it is called a *raw*, not *RAW*, format because it is not an acronym. See **DNG.**

raw data

The data from a *raw image* that has yet to be processed. See also **raw.**

raw format

See **raw.**

raw image format

See **raw.**

Rayleigh scattering

The scattering of light by small particles. This scattering of light is strongly dependent on the wavelength of the light. The sky is perceived as blue as a result of Rayleigh scattering because blue light is scattered more intensely than red light is. The particles are smaller than the wavelength of the light being scattered. See also **Mie scattering.**

ray tracing program

A computer program that uses computed light-ray interactions to draw a three-dimensional image. The values and locations of the rays are computed by the software, based on user definitions of the scene. The light source and objects in the scene are described and the light rays from the light source are traced to the viewing location. This renders the objects in the scene in three dimensions.

RDF schema

An abbreviation for *resource description framework schema*. A *metadata schema*, or set of specifications, used with *XML*. See also **metadata; XML.**

read-out register

A part of a CCD in which the charges from the photosites are accumulated row by row. The read-out register reads an entire row at a time on

the CCD. The value from the read-out register is then sent to an *output amplifier* and an *analog-to-digital converter* before being output. See also **CCD; analog-to-digital converter.**

ready light

A light on the back of a flash or other electronic device that signifies when the device is ready to use. A ready light attached to a flash is important because the capacitors take time to recharge before the flash can fire. In a battery-operated flash, as the batteries get weaker the recharging time can grow from a few seconds to many seconds. The ready light allows the photographer to wait until there is enough energy to fire the flash properly. *(see figure on page 259)*

real-time image processing

A combination of computer hardware and software that can process images as fast as they are generated. This process is needed in certain industrial-inspection and robotic-vision operations, for example. Depending on the processing needed, it can require extremely fast computer hardware.

reboot

The process of restarting a computer system or peripheral so that the software will be reloaded and the settings reset to their initial startup values.

recorded pixels

The pixels from an image sensor that are actually recorded. Not all pixels from an image sensor are necessarily recorded. In some cases, the image is cropped slightly so that the number of pixels recorded is smaller than the total number of available pixels. See also **effective pixels.**

rectangular pixels

Pixels that are rectangular in shape, rather than square. Typically these are found in digital television and occasionally in computer monitors, rather than in digital camera sensors. Rectangular pixels are not usually desirable in camera sensors.

recycle time

The amount of time needed for the capacitors on an electronic flash to recharge so that the flash is ready to be used again.

recycling time

The period of time needed for an electronic flash to refire. On a battery-powered flash, this period usually increases as the batteries get weaker.

red

One of the three primary colors used in digital photography. The others are blue and green. The three make up the RGB colors used in the *RGB color model* and in most digital-camera color spaces.

ready light - The red light glowing above is the ready light on an electronic flash to tell the photographer the flash is ready to fire.

red eye

The condition of a subject's eyes appearing to be red. The irises of the eyes appear red instead of black because light from the flash is reflected back from the inside of the retina of the eye directly to the camera. This problem can be avoided by moving the flash head away from the center of the lens, either to one side or higher on an arm. This action is difficult to perform when hot shoe flashes don't have special adapters or cables. *(see figure on page 261)*

red-eye reduction

A function in some digital cameras that attempts to reduce the visibility of *red eye* by firing a small pre-flash from the camera's built-in electronic flash. The pre-flash causes the irises of the subject's eyes to constrict, which reduces the amount of light reflected back as red eye. See also ***red eye.***

red-eye reduction mode

A mode in some digital cameras that attempts to use a *red-eye reduction* feature to reduce *red eye*. See also ***red eye; red-eye reduction.***

redo

When an error is made, there are often two commands that can help. The first is *undo*, which allows the user to specify that the software restore the file to its previous state before the last action. This command is helpful to see what action was actually done. The second command is *redo*, which tells the software to restore the file to the state before the undo command was issued. This is useful when, after using the undo command, the user determines that the last action was, in fact, correct after all. See also ***undo.***

red (R) green (G) blue (B)

The three colors used in an RGB color space. See ***RGB.***

reforming

The process of resetting the capacitors on an electronic flash so they can be fully charged. If a flash is not used for a long period of time, recycling during operation can take a long time and the resulting flash output is lowered. Reforming the capacitors can help. Reforming is done by inserting freshly charged batteries, letting the flash charge, firing it off at full power, letting the flash charge again, and firing the flash at full power again. Continue this process for a number of cycles. It is often necessary to let it cool down for a few minutes every five to ten flashes.

refraction of light

The bending of light rays when the light changes speed, usually as it passes through one medium into another. An example would be when a light ray enters a lens. Refraction of light is part of the concept that led to the development of lenses, which are designed to bend light rays and

red eye – The red glow in the eye is caused by a reflection from the retina of a flash and is known as red eye.

focus them at a point behind the lens. Snell's Law is used to calculate refraction that occurs. See also ***angle of refraction; Snell's Law.***

refresh rate

The number of times that an electronic image is redrawn on a CRT or LCD monitor. This rate is usually expressed in *hertz* (number of times per second). Typical numbers are in the range of 60 to 100 hertz.

relative colorimetric

One of several possible *rendering intents* that define the method used to change the colors in one color space to another color space. Relative colorimetric starts with the white point of the first color space and maps it to the white point of the second color space. Then it maps the other colors in relation to that white point, scaling them as necessary. Any out-of-gamut colors are mapped to the closest in-gamut color. Other rendering intents include *absolute colorimetric* and *perceptual colorimetric*. Perceptual colorimetric is probably the most popular rendering intent for photographs; relative colorimetric is the second most popular. See also ***perceptual colorimetric; absolute colorimetric.***

remote sensor

A sensor that can be used to fire an electronic flash that is not attached to the camera by a wire. The sensor can use radio signals, infrared signals, or the visible light from another flash firing to operate the electronic flash attached to the sensor. Some flashes have a built-in remote sensor. These are two-part devices; they have a sender unit attached to the camera and a receiver unit attached to the flash so that the flash can be fired remotely.

removable media

Any type of optical or magnetic media that can be removed from the recording device. CDs, DVDs, and CompactFlash cards are a few examples of removable media. An internal hard drive is an example of media that is not removable.

render

To convert from one form to another. An image can have its pixels rendered from the raw data. An image can also be rendered from one color space to another using a rendering intent. See also ***rendering intent.***

rendering intent

The method used to convert an image from one color space to another. There are several common rendering intents. The most common is *perceptual colorimetric,* probably followed by *relative colorimetric. Absolute colorimetric* is also commonly used. See also ***absolute colorimetric; perceptual colorimetric; relative colorimetric.***

resample

Another term for *interpolation*. Resampling means to remove or add pixels to reduce or increase the size of a digital image or to change its resolution. This is done for printing digital images and for using them on web pages or in slide shows.

resampling

The process of removing or adding pixels to an image.

resize

To change the size of an image. This is usually done by *interpolation* or *resampling* to add or subtract pixels. See also ***interpolation; resampling.***

resolution

Refers to the total number of pixels in an image, generally expressed as pixels per linear distance, such as *pixels per inch* or *pixels per millimeter*. See also ***image resolution.***

resolution, interpolated

(1) The resolution of an image that has been increased with the use of software. (2) Images scanned at a size larger than the optical limit of the scanner. The additional pixels needed are computed based on various techniques but are not real data. See also ***interpolation; image resolution; resampling.***

resolution, optical

The resolution of a device, often a scanner, which is measured in real pixels and not ones created with software. Some scanners have an *optical resolution* and an *interpolated resolution*. The optical resolution usually is smaller than the interpolated one. See ***interpolation; image resolution; resolution interpolated; resampling.***

resolution, output

The resolution of an image as it is displayed or otherwise output from a device. The resolution is usually stated in terms of *pixels per inch* or *pixels per millimeter*.

resolving power

A measurement of the ability to see fine detail. Resolving power is used to compare lenses to find the smallest distance between two points that can be determined with a particular optical device. Normally the resolving power is stated in terms of the number of lines per millimeter.

resource description framework

See ***RDF schema.***

resource fork

A feature of Macintosh data files and applications. An area within a file where information about that file is stored.

retouching

Enhancing a digital image. Any kind of image can be retouched, but portraits probably undergo this process more often than other types of images. Popular types of retouching include removing blemishes, softening lines around the eyes (sometimes called *crows feet*) and on the neck, removing or minimizing dark circles under the eyes, slimming the face and figure, removing wrinkles in clothing, opening up a closed eye (a *blink*), and removing straps and other parts of clothing that should not be showing. Retouching is done with image-manipulation software such as Photoshop.

retouching – after – The figure above shows a portrait that has been retouched with the clone tool and healing brush tool. Compare it to the before photograph.

retouching – before – The portrait on the previous page has not been re-touched. Compare it to the after version to see what retouching has been done.

R

RF

See **royalty-free.**

RGB

An abbreviation for red (R), green (G), and blue (B), the three primary colors of visible light. RGB is the most common type of *color space* used in digital photography. Four-color printing uses CMYK (cyan, magenta, yellow, and black).

RGB filtering

Red, green, and blue filters applied to *grayscale* (sometimes called black-and-white) pixels. This application changes the image in a CCD image sensor from grayscale to color.

RIFF

See **raster image file format.**

rights-managed

A type of *stock license* (sometimes called *RM licensing*) in which the licensing fee varies depending on usage. Large use and large distribution require larger fees than smaller use and smaller distribution. The other popular type of stock licensing method is called *royalty free* (*RF*). See **royalty free.**

rights-protected license

Also called *RP license*. A type of rights-managed stock license. Some stock distributors use the term to describe images they distribute exclusively. Since the images are not available from any other distributor, the licensing history of the image is known completely and the license can be written to protect the licensee so that no competitors will be able to use the image during the term of the license.

ring flash

A flash unit in the shape of a ring or donut. The ring flash fits around the lens to make the subject appear evening-lit from the front in all directions. The batteries and power unit are usually stored in a separate box attached to the camera's hot shoe. The ring flash was originally designed for use in close-up photography, but it has been used by creative photographers to make innovative portraits with very few shadows.

ring pixel

A pixel on a digital camera image sensor located outside the image area but used as part of the image-capture process for filtering purposes. A group of these pixels forms a ring around the image area, hence the name.

RIP

See **raster image processor.**

RISC

An abbreviation for *reduced instruction set computer*. Because the computer or microprocessor has a reduced instruction set, a RISC will generally operate faster than a standard computer. The philosophy of this design originated because traditional chip designs incorporated many seldom used features that consumed performance capability. Designers chose to create a chip with a reduced instruction set and increased performance. A RISC computer chip is also less expensive to make because of its simpler design.

RLE

See **run length encoding.**

RM

See **rights-managed.**

rotate-canvas command

A function in Photoshop allowing the user to rotate the image or canvas by set amounts in either direction. This function can be used to change a *horizontal* (*landscape mode*) image to a *vertical* (*portrait mode*) orientation.

royalty

The fee a copyright holder (the photographer) earns when his or her image is licensed. Depending on the licensing model used, the royalty could be earned for each use of an image, or it could be a single payment. See also **rights managed; rights protected license; royalty free.**

royalty-free

A stock-licensing model in which the person or company licensing the image pays only one fee, which is usually dependent on the downloaded size of the image rather than the individual uses. Each stock distributor

has different restrictions on what can be done with the image under a royalty-free license. For example, the user is usually not permitted to resell or relicense the image. Sometimes users are not allowed to sell the image without a special license if it is the primary item being sold (such as a print or calendar). Occasionally the license is limited to a single user. In that case, a designer can only use it for one client. *Royalty-free* is not really royalty "free"; the royalty is typically limited to a single payment no matter how many times the image is used. See also ***rights-managed; right- protected license.***

RPM

An abbreviation for *revolutions per minute*. In digital photography, *RPM* is used to describe the speed of the turning disk in a hard drive. The faster the disk turns, the faster the access of data on the drive. Typical speeds are in the range of 4,000 to 7,200 rpm. See also ***hard drive.***

RS232C

A standard for the communication of data between a computer and a modem or computer serial port. The standard was developed by the Electronic Industries Alliance and is now maintained by the Telecommunications Industry Association. USB is now replacing much of the RS232C interface uses in personal desktop computers. See also ***USB.***

RS422

Currently known as *EIA-422*. A technical standard, similar to *RS232C,* for computers to communicate with other devices. RS422 / EIA-422 protects against noise interference better than RS232C. The distance limit of RS232C, 50 feet, has been extended to 3,000 meters with RS422 / EIA-422. See also ***RS232C.***

rubber stamp

Also known as the *clone tool* or *clone stamp tool*. A tool in Photoshop allowing the user to copy parts of an image from one location to another. The rubber stamp tool can be used to remove distracting elements in an image or for retouching purposes. See also ***clone stamp tool.***

rule of thirds

A compositional tool used in photography. The image or scene is divided into three vertical sections and three horizontal sections using two vertical lines and two horizontal lines. The four points where these lines cross are usually good spots to have the main subject of a photograph appear, for both compositional reasons and pleasing proportions. The crossing points are sometimes called *power points* or *focus points*.

rule of thirds – An image can be divided into thirds in both the horizontal and vertical directions for the purpose of creating a composition. When the subject is placed at the intersection of those lines, it is known as the rule of thirds.

R

rules of sharpness

Refers to the perception of sharpness by the viewer, which involves the viewing distance, size of the image, compression of the image, contrast, and other factors. The rules illustrate that scanning an image at a higher resolution will produce a better-quality (and sharper) image than scanning it at a lower resolution. Also, scanning an image at a higher resolution will generally produce a better-quality image than scanning at a lower resolution and then interpolating it up to the size of the higher-resolution image. Finally, users need to be aware of the amount and type of compression applied to images after scanning, as that will affect the perception of sharpness as well.

run length encoding (RLE)

> A non-lossy compression algorithm. RLE is used in *BMP* and *GIF* files, among others. It is also used to compress animation stills. See also ***non-lossy; GIF; BMP.***

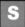

Sabbatier effect

> Commonly, but improperly, called *solarization*. A photographic effect produced in analog photography by flashing the image with light while it is still in the development phase. The image takes on a surreal look because some areas are negative and some positive. Photoshop now offers filters that can digitally produce a similar effect. Manipulation of curves in Photoshop can also produce a similar look. *(see figure below)*

Sabbatier effect – This figure shows a technique known as the Sabbatier effect.

sampling error

The developing of conclusions based on a small amount of data and using those conclusions to apply to the entire population. The difference in the conclusions made with the two sets of data is called the *sampling error*. In digital photography, there is very little light in the darkest shadow areas. Thus the image data collected from those locations tend to generate more noise than in the highlight areas. Part of that noise is due to sampling errors of the few photons available in the dark areas.

SATA

An abbreviation for *serial advanced technology attachment* (or *serial ATA*). A type of interface for connecting hard drives to a computer using fewer wires than the IDE (Integrated Drive Electronics) interface. Having fewer wires enables the interface cable to be run a longer distance.

saturation

One of the attributes of color, related to the *intensity* of a specific *hue*. When a color is less saturated, it generally has more gray or white in it. If it is completely unsaturated (saturation = 0), then the color is gray. Colors with low saturation usually look washed out or faint in color. Intensity also relates to the purity of a color.

saturation level

When an image sensor such as a CCD has received the maximum amount of detectable light, it is said to be saturated. Any additional light intensity will exceeded the CCD's saturation level. See also ***CCD.***

save-energy mode

(1) A function that powers down parts of an electronic device to save energy. This function is especially important in battery-powered devices. (2) The name of a specific mode on Canon Speedlite electronic flashes in which battery drain is reduced by not keeping the capacitors charged. On some Canon flashes, the timing of this function is adjustable, while for others, the time period is set.

save-for-Web command

A function in Photoshop's Image Ready and similar image-manipulation programs that saves images in their smallest possible size. One way to achieve this minimum size is to remove all metadata. Digital photographers should be very careful about using this function because, without the metadata present, their images could be left unidentified. Orphan works legislation has been proposed in the United States that would allow anyone to use unidentified images without fear of copyright violation. Other methods available to reduce image size include the quality level of the JPEG and number of colors on a GIF format. See also ***metadata; JPEG; GIF.***

S

scale

To change the size of an image upward or downward. For example, a thumbnail is a small-scale version of the original. See also *interpolate; thumbnail.*

scan back

See *scanning back.*

scanned image

A digital image produced by using a scanner to convert a negative, transparency, or a print. Usually, scanned images cannot be interpolated upward as much as a digital image produced from a digital camera.

scanner

An electronic device used for converting an analog image—in the form of a negative, transparency, or print—into a digital image. There are several types of scanners, including a flat-bed scanner, drum scanner, and transparency scanner. The drum scanner is generally the most expensive and produces the highest quality. The transparency scanner, which scans images such as negatives and transparencies, generally produces a higher-quality digital-image scan than a flat-bed scanner.

scanning back

Also called a *digital scan back.* A digital-imaging device attached to the back of medium-format or large-format cameras. A high-quality and, therefore, expensive device, the scanning back generally has *CCD* or *CMOS* image sensors. Exposure times are generally long, which often limits the scanning back's use to still-life subjects. File sizes are very large, so the scanning back is usually attached to a computer during use. See also *CCD; CMOS.*

scan head

The portion of a scanner that contains the image sensor. The scan head is often a linear array of sensors that is moved across the image to digitize it. See *scanner; linear array.*

scan size

The size of a digital image produced by scanning. The scan size can be stated in megabytes, in pixels, or in inches (or millimeters); resolution is stated in pixels per inch (ppi) or pixels per millimeter (ppm). See also *scanned image.*

scan time

The period of time taken to create a digital image from an analog image using of a scanner. The analog image is in the form of a negative, transparency, or a print. The time can vary from seconds to a number of minutes, depending on the resolution chosen to scan at, the speed of the scanner, and the size of the original. See also *resolution.*

scattering

> The process of light rays deflecting in random directions as they strike particles in the air or move through a transparent medium, causing them to diffuse, and even change frequency, which alters the color. Scattering results in color changes such as the blues of the sky and the reds of the sunrise and sunset.

screen shot

> A digital image of the image (or portion thereof) displayed on the monitor screen. A screen shot is usually created with a special software program and can be used to illustrate what a program is doing, copy an error message, or capture important information. It is created with a few keystrokes and then saved as a digital image, if desired. The image can be saved as a TIFF or JPEG file, among others, depending on the software. *(see figure below)*

screen shot – When an image is captured of the current contents of a computer monitor or screen, it is known as a screen shot. This is often done by using a special software program and not a camera and is shown in this figure showing the Photoshop File Browser.

SD memory card

An abbreviation for *secure digital memory card*. See ***secure digital memory.***

SDRAM

An abbreviation for *synchronous dynamic random access memory*. A type of memory used in digital cameras and higher-speed desktop computers. SDRAM runs at a higher speed than other types of memory. The *synchronous* in the name indicates that the memory is synchronized with the computer's processor, which is one reason for the SDRAM's higher speed.

secure digital memory

Also known as an *SD memory card*. A popular flash-memory card used to store images in digital cameras and other digital devices, such as PDAs and hand-held computers.

sensitivity

Refers to the quality of sensing how much light is required to create an image that is properly exposed. The overall sensitivity of a digital camera system involves the image sensor in the camera body, the exposure settings on the camera, and the f-stops available on the lens. The greater the sensitivity of an image sensor, the less light required to make an acceptable image.

sensor

A device that converts analog information, such as light, to digital information for further processing. The sensor used on a digital camera to create images is called an *image sensor*. Light falling on the sensor causes it to generate electrical currents that are converted to pixels, which can be displayed to form an image. There are many other types of sensors used for other purposes. Some of these include digital thermometers, digital multimeters, digital devices of all kinds in automobiles, and so on. See also ***image sensor.***

sharpen

A function in photo-manipulation software such as Photoshop that makes a digital image appear sharper. See also ***sharpening.***

sharpen edges

A technique used in image-manipulation programs to increase the apparent sharpness of an image. The boundaries between tones in an image are darkened in a way that appears to make the edge, and thus the image, sharper. *(see figures on page 275)*

sharpening

The process of using a software technique on digital images to make an image appear sharper. In sharpening, the software increases edge sharp-

sharpen edges – before – This is the original detail of an eye before it has been sharpened. See the other figure to see what it looks like after the edges are sharpened.

sharpen edges – after – This figure shows the eye from a portrait after the sharpen edges command has been used. Notice the detail on the small eyelashes.

ness and contrast to bring out fine detail, thus making the overall image appear to be sharper than it actually is.

shutter lag

The period of time from when the shutter release is pressed to when the actual exposure occurs. With some digital cameras, this period is long enough to interfere with capturing moving objects or subjects, such as those seen at sporting events. Shutter lag should definitely be considered when purchasing a digital camera.

side car file

An additional file, created by the computer, to store *metadata* for the original (usually raw) file. The suffix on the file is *.xmp*. This system is used to keep from altering the original *raw file*, since it often contains proprietary and undocumented data. Keeping raw files together with sidecar files prevents the loss of metadata. Some software automatically keeps them together, but any manual moving of files, outside of the software, must be done carefully. See also *raw file.*

SI system

See *Système International d'Unités.*

slave flash

See *flash, slave.*

slide

Transparencies fixed in individual mounts. The most common type of slide is a 35mm image mounted in a two-inch square cardboard, plastic, or metal mount. These slides are used for projection through a projector. Before the advent of digital imaging, slides were the most common type of image original used for reproduction. Today, slides can be easily and inexpensively made from digital images that may be needed for projection in a facility that does not have a digital projector. *(see figure on page 277)*

slide scanner

Also called a *transparency scanner*. A scanner that converts slides, generally 35mm transparencies, to digital images. An image is created by a moving sensor that detects light shone through a slide or negative. See also *scanner.*

SLR

An abbreviation for *single lens reflex*. A type of camera that uses the same lens to view and photograph the subject. A second type of camera, called a *rangefinder*, uses one lens to view the subject and a second lens to photograph the it. An SLR commonly uses a mirror to direct the light from the subject to the optical viewfinder. This mirror moves out of the way when the shutter button is pressed so that the light can go directly to the image sensor instead of to the optical viewfinder. Most SLR cameras

Slide Number C-895-30
Catalina Island

Model Release #

Copyright John G. Blair Photography

slide – This is a 35mm mounted transparency known as a slide.

have interchangeable lenses. The photographer can choose, for example, an ultra-wide-angle, wide-angle, normal, telephoto, or macro lens. SLRs are one of the most popular types of digital cameras for both professional and advanced amateur photographers.

SmartMedia

A type of memory card that uses flash memory. The SmartMedia card is used to store data such as digital images. It was originally called a *solid state floppy disk card*, or *SSFDC*, since it was designed as a replacement for floppy disks. It has been used in a number of digital cameras for image storage, but its popularity has waned.. With the increasing demand for larger memory cards, SmartMedia cards, stuck at 128 MB, struggle to compete, although they continue to be manufactured.

SmartMedia memory

A type of memory card that uses flash memory. See **SmartMedia.**

SMC

An abbreviation for SmartMedia Card. See **SmartMedia.**

smoothing

A technique designed to reduce digital artifacts, such as jagged edges or stair-stepping, found in digital images. Smoothing is done by averaging pixels with surrounding pixels. *Anti-aliasing* is a type of smoothing. See also ***anti-aliasing.***

Snell's Law

Also known as the *law of refraction*. A formula describing the behavior of light rays passing through a media boundary between two different media. The formula relates the velocity of the light with the angles of incidence and refraction and depends upon the refractive index of each of the two media.

solarization

More properly known as the *Sabbatier effect*. A partial reversal of the image such that it contains both positive and negative parts relative to the original subject matter. See ***Sabbatier effect.***

solid state floppy disk card (SSFDC)

Better known as *SmartMedia card*. A type of memory card originally designed to replace floppy disks. It was solid-state with no moving parts and much smaller than floppies. See also ***SmartMedia.***

spatial resolution

(1) The resolution, in pixels, of a digital image. The measurement of the total number of pixels is usually expressed as the horizontal measurement by the vertical measurement. An example would be an image that is 1,280 x 960 pixels. (2) The size of the smallest subject that a digital camera and lens can resolve. See also ***resolution.***

spectrophotometer

A device that measures the intensity of a light as a function of its color, or wavelength. It is used as a color-measurement tool. Incoming light is divided into different *spectra*, or *frequencies*, that are then measured with light sensors. There are also spectrophotometers that measure ultraviolet (UV) and infrared (IR) light. See also ***spectrophotometry.***

spectrophotometry

The study of the color, or wavelength, of light by the use of a *spectrophotometer*. The spectrophotometer measures the intensity of the light at different colors or frequencies. See ***spectrophotometer***

specular highlight

A bright reflection off of a subject, usually with no detail. A specular highlight is also the brightest spot in the image. It provides the viewer of an image a better sense of the shape of an object. Regular highlights are bright but usually have more detail than do specular highlights. A catch-light in the eye is an example of a specular highlight.

specular light

Light that reflects directly off of an object in such a way that the *angle of reflectance* is the same as the *angle of incidence.* Shiny subjects typically produce specular highlights rather than diffuse highlights. See also *specular highlight.*

specular reflection

Specular light reflecting off of a surface. A mirror is a good example of a source of a specular reflection that allows the viewer to see the source of the light. See *specular light.*

spherical aberration

A defect in a lens such that light coming from different parts of a lens focuses in different locations rather than at a single point. The result is an image that is not sharply in focus at all points. Most lens designs today avoid spherical aberrations; only very inexpensive lenses suffer from this aberration.

S-RAM

See *static random access memory.*

sRGB

Also known as *standard RGB.* A somewhat small *color space* designed for use on monitors and the Internet. Many photo labs also use this color space for printing images. Some digital cameras use sRGB for their JPEG images. In general, it is better to use a larger color space, such as Adobe RGB (1998) or ProPhoto RGB, rather than sRGB if any of the images will have any commercial applications. sRGB is not a large enough color space to provide all of the colors that standard four-color printing (CMYK) can reproduce. Most stock agencies prefer to receive images in a larger color space, for example. See *color space; CMYK; Adobe RGB.*

SSFDC

See *solid state floppy disk card.*

staircasing

Another term for the *jaggies* or *aliasing,* which are undesirable artifacts produced in digital images. See *jaggies.*

static RAM

See *static random access memory.*

static random access memory (S-RAM or static RAM)

Memory that does not need to be refreshed to maintain its content. The information stored is static, but power must be applied continuously to maintain it. S-RAM is a semiconductor memory. Other types of memory include *SDRAM* and *DRAM.* See also *SDRAM; DRAM; RAM.*

stitching

The process of putting together a number of digital images to create a

larger digital image. This can be done manually with the aid of an image-manipulation program such as Photoshop, or automatically with specialized software and hardware. Stitching can be used, for example, to create an ultrawide, panoramic image; a wide-angle image of a subject when space is limited; or a higher-resolution image.

storage

A device used to save data such as digital images. If the data or image is not saved from the computer's memory, it will be lost when the computer is turned off. Storage can take the form of *optical storage*, such as DVDs and CDs; *electronic storage*, such as flash memory cards; or *magnetic storage*, such as hard drives. See also **CD; DVD; flash memory; memory card; hard drive.**

storage cards

Used to store data such as digital images. Storage cards are usually flash memory cards. See also **memory card; flash memory.**

streaking

See **streak noise.**

streak noise

Also known as *streaking* and *vertical correlated noise*. Noise in an image that takes the form of streaks. This type of noise is found most often in scans. It can be caused by a transmission error. See also **vertical correlated noise.**

stuck pixel

See **hot pixel.**

sub pixel

Pixels that represent only one color. Typical digital camera sensors and LCD screens have three sub pixels for each pixel. There is a red, a green, and a blue (RGB) sub pixel, which, together, make up one pixel. Some systems treat the three sub pixels as one pixel; some systems treat each one separately, doing separate calculations for each sub pixel. See also **pixel.**

subtractive color system

A system that produces color by subtracting colors from a reference color. An example of a subtractive color system is one that uses pigments such as cyan, magenta, and yellow (the CMY portion of the CMYK four-color printing process). When those three colors are mixed, black is produced because each color subtracts all but their own color from white, which leaves black. In an *additive color system* (such as one that emits light rather than reflecting it), combining the three primary colors produces white rather than black. See also **additive color system; CMYK.**

sunny-16 rule

A rule of thumb used in photography to estimate the proper exposure

under sunny conditions when there is no light meter available. The rule is that under midday direct sun, the camera aperture should be set at $f/16$ and the shutter speed should be set at 1/(ISO speed). So, for example, if the camera were set at ISO 100, the shutter speed would be set at the closest shutter speed to 1/100, which is probably 1/125th of a second.

super extended graphics array (SXGA)

Refers to a computer monitor with a resolution of 1280 x 1024 pixels. The SXGA is a relatively common resolution monitor by today's standards.

super pixel

A pixel made up of multiple pixels. See also *binning.*

super video graphics array (SVGA)

Refers to a computer monitor with a resolution of 800 x 600 pixels. The SVGA is a relatively low-resolution monitor by today's standards.

Super XGA

See *super extended graphics array.*

SVGA

See *super video graphics array.*

SWF format

A vector-graphics file format created by FutureWave, which was acquired by Macromedia and now belongs to Adobe. Flash software produces animations that are stored as SWF formatted files. SWF is a compressed file format created for use on the Web. Since it was developed, it has been extended to allow audio and video storage as well. Adobe's Flash Player will play the files.

SXGA

See *super extended graphics array.*

synchronous dynamic random access memory

See *SDRAM.*

sync speed

The shutter speed a camera uses when connected or "synced" to an electronic flash. Typically the sync speed refers to the maximum speed that can be used. Older SLR film cameras with focal plane shutters were often limited to 1/60th of a second. Modern digital SLR cameras typically have sync speeds of 1/90 to 1/125 of a second. Sometimes the maximum sync speed is dependent upon which flash unit is used.

Système International d'Unités

Also known as *SI system*. An international measuring system based on the original metric system. The SI system has seven base units: length (meter), mass (kilogram), time (second), electrical current (ampere), temperature (kelvin), amount of substance (mole), and luminous intensity (candela). Prefixes are added to define a smaller or larger amount of the

original unit; these include *kilo*, *mega*, and *giga* for larger, and *centi*, *milli*, and *micro* for smaller.

tagged

Marking in a digital image file to indicate that a color space profile is embedded. Software, such as Photoshop, searches for these tags and either uses that color space, converts the image to the current color space, or stops and asks what the user wants to do, depending on how the software preferences are set.

Tagged Image File Format

See *TIFF.*

TARGA format

Also called *Truevision TGA file format* or *TGA.* An image file format. The file extension is either *.tga* for most computer systems or *.tpic* on older Macintosh computers. Since TARGA was originally designed for video editing, the resolutions are often similar to those of the two television standards: the *NTSC* and *PAL* formats. TARGA supports the 32-bit truecolor format. See also ***NTSC; PAL; truecolor.***

taxonomy

A hierarchical *controlled vocabulary* used for classifying objects into categories. Because it is hierarchical, each descending level classifies objects into increasingly finer categories. A taxonomy is used when keywording images to ensure that images are easy to find with a text-based search. See also ***controlled vocabulary; keywording.***

technology without an interesting name

See *TWAIN.*

terabyte

A unit of measure equal to one trillion bytes, which is the same as one million megabytes or one thousand gigabytes. This scale of measure is used for measuring the amount of storage available on a hard drive or the size of a really large image. See also ***byte; megabyte; gigabyte.***

test chart

A chart used for testing lenses. It has pairs of lines printed increasingly closer together. To check the resolving power of the lens, the test chart is photographed. The test chart can be used to check the resolution of the camera and lens. A specific chart, called the *I3A/ISO Camera Resolution Chart*, is used for digital cameras. The resolution is measured in line pairs per millimeter or lines per picture height. Other test charts are designed to

measure optical aberrations; there are also special charts for microphotography, scanners, projectors, and digital video cameras.

TFT

See *thin film transistor.*

TGA

See *TARGA format.*

thermal dye sublimation printer

Also called *dye sublimation printer*. A digital printer that heats solid, transparent dyes to transfer them to a medium such as paper. Thermal dye sublimation printers usually use cyan, magenta, and yellow solid dyes in the form of a ribbon. When heated, the dye goes directly from the solid (ribbon) to a gas form, a process called *sublimation*. Because the dyes are transparent, they can be laid on top of each other to form different colors. Different shades of color are created by using varying amounts of heat. Dye sublimation printers are cleaner than inkjet printers because there are no liquid inks involved. See also *dye sublimation.*

thermal dye transfer

Another name for *thermal dye sublimation printing*. See *thermal dye sublimation printer.*

thermal imaging

A type of imaging that uses infrared radiation instead of visible light. Thermal-imaging cameras are sensitive to heat energy and can often display this information in grayscale (black and white) or color. The color image uses various colors to represent different temperatures. For example, red is used for the hottest areas, then orange, then yellow, and so on. Thermal-imaging systems have widespread use in fire, police, military, and civilian applications. Some of these applications include sensing body heat to find people hidden from view, especially at night; finding fire areas hidden in walls or victims hidden in smoke; and checking for heat loss in houses. Thermal imaging is different from infrared photography. See also *infrared photography.*

thermal printer

A printer that uses heat to print on special paper. The paper changes color when a heated print head is placed against it. Thermal printers tend to be quiet, fast, and inexpensive. They are commonly used to print receipts in businesses.

thermal wax transfer printer

Also called *thermal transfer printer*. A printer that works by melting a wax ribbon with a heated print head to transfer the wax to paper. Although color thermal wax transfer is possible, color printers are not as common as black and white in this type of printing. Thermal wax transfer printers are often used to print merchandise tags and barcodes because the

T

paper lasts longer than when used in thermal printers. See also ***thermal printer.***

thin-film-transistor

Part of a type of display used in digital cameras and computers. This transistor is actually just one component in the *active matrix display* or *liquid crystal display*, two terms that are now often used interchangeably. See also ***active-matrix display.***

thousands of colors

See ***16-Bit color.***

thumbnail

A small digital image representation of a larger digital image. Thumbnails are used because they can be quickly scanned, they take less storage space, they take less time to download from a website, and they can be printed on much less paper if a hard copy is desired. Thumbnails are usually low-resolution images.

thumbnail index

A group of thumbnail images. A thumbnail index can be a printed sheet or a small grouping of images on a digital camera's LCD screen. Because it looks similar to a contact sheet made from negatives, a printed thumbnail index sheet is often called a *contact sheet*, even though it is made from digital images. See also ***thumbnail.***

thyristor

A semiconductor switch or gate often used in electronic flash units to control the amount of light generated. The thyrsistor controls the light by allowing the energy from the capacitors to be sent to the flash tube to illuminate it when a control signal is received. Once the control signal stops, the thyristor gate is closed, stopping the energy from reaching the flash tube. This stops the flash from firing until the control signal returns.

tif

The file format extension for a TIFF file. See ***TIFF.***

TIFF

An abbreviation for Tagged Image File Format. TIFF is a common file format used for storing images, especially those being worked on. TIFF images can be opened and resaved without creating artifacts because the

TIFF image file is usually an uncompressed file. Even when the file is compressed, the compressed version, known as *TIFF-LZW*, uses a lossless compression method. TIFF is a good file format for digital photographers to store their final retouched master images. See also ***LZW.***

tint

A color created by adding white or more light to another color. See also ***hue; color theory.***

tolerance

A value used in some Photoshop tools to describe the range over which the tool should be applied. For example, when using the magic wand tool, the tolerance value selected by the user tells Photoshop how close to the chosen value that the pixels it selects needs to be so that they are included in the selection.

tonality

(1) The overall or dominant *hue* in a *color image.* (2) The *brightness* of a *grayscale image.*

tonal range

See ***gamut.***

tonal-range compression

See ***gamut compression.***

tone

Also known as *value.* (1) The color difference from neutral. (2) The *brightness* of an image.

tone compression

The compression or reduction of tones in an image. Tone compression often occurs when moving from a digital image to a four-color printed image. See also ***tone.***

tone curves

Called *curves* in Photoshop. A graphical representation of tones available in some image-manipulation software. Once the curve is shown, it can be manipulated by the use of the mouse to change the tonal relationships.

tone mapping

A process of adjusting individual tone values in an image to allow them to

be reproduced in a device (such as a monitor or printer) that has a smaller tonal range than that of the original image. Tone mapping is especially useful for printing *high dynamic range images* (*HDRI*), created by combining other images. Without tone mapping, the tonal range of the HDRI will exceed the ability to print it. Tone mapping reveals both highlight and shadow detail by compressing all of the tones in the middle. Specialized software is required.

tones

(1) The grays, or colors that are close to one another in lightness or darkness. (2) The colors created by adding gray to a primary color. See also ***tone.***

tone separation

The difference in individual *tone values*. If the tone separation grows, it appears as *posterization*, with distinct bands of tones. Posterization is seldom a desirable condition. See also ***posterization.***

tone values

The various tones available between the highlights and shadows. Tone values are contingent on the number of bits available. In an 8-bit grayscale image, for example, there are a total 256 tones from black to white.

toning

Changing the overall color of an image by changing its tones. An example would be creating a sepia tone image from a grayscale image. Toning can be done on digital images using image-manipulation software such as Photoshop. *(see figure on page 287)*

transfer function

(1) The relationship in a system's input and output that is represented mathematically. It is used in digital photography as a function imbedded in an image file that adjusts an image at the time of printing to allow for factors such as *dot gain*. (2) A shortened form for *modulation transfer function* (*MTF*). See also ***modulation transfer function; dot gain.***

transfer rate

A measure of how fast information such as digital images can be either transferred within a computer system, from one computer system to another computer system within a local network or uploaded through an online network. This transfer rate is often expressed in *bytes per second, bits per second, kilobytes per second, kilobits per second*, or even *megabytes per second*. See also ***bit; byte.***

toning – This black and white image has been changed to a sepia image by toning.

transform

(1) To change an image from one color space to another. (2) To change the scale of an image. (3) Also a function in Photoshop that allows the user to alter the image by skewing, distorting, or changing the image's perspective.

translucent

The property of letting some light through an object without the object being totally transparent. The light that passes through a translucent object is diffuse rather than defined. No detail can be seen through a translucent object. See also **transparent.** *(see figure below)*

translucent – A photograph taken through obscure glass, which is known as translucent because no detail is transmitted.

transmissive light

Light that has passed through an object rather than being reflected by it. The most obvious example in photography is the use of transmissive light to view a slide, negative, or digital image on a monitor. *Reflective light* is used to view a print.

transmittance

The amount of light that passes through a *translucent* object. See also **translucent.**

transparency

(1) An object that allows light to pass through it. The object is thus clear and not merely *translucent*. (2) In analog photography, a piece of transparent film that shows a positive version of an image. The most common transparency is a *color positive*, which can range in size from a 35mm transparency (also called a *slide*) up to an 8 x 10 inch positive image. See also *translucent.*

transparency scanner

See *slide scanner.*

transparent

The property of an object that allows light to pass through it. The object is thus clear and not merely *translucent*. Unlike *translucent*, detail can be seen if an object is transparent. See also *transparency; translucent.* *(see figure below)*

transparent – A glass window that allows the subject to be seen clearly is known as transparent.

transverse chromatic aberration

A form of *chromatic aberration* in which the light focuses at different locations on the image plane depending on the wavelength of the light. See also ***chromatic aberration.***

trichromatic

Three colors. Usually refers to the standard color representation of red, green, and blue (RGB). These three colors can represent all colors. See also ***RGB.***

trigger

A device or function that begins the operation of the unit. Cameras and flash units can be triggered either electronically or mechanically.

tri-linear array

Three linear arrays. Typically, each array has a different color filter on it: one for red, green, and blue. Tri-linear arrays are used in scanners to produce a full-color image on a single pass of the scan head. See also ***tri-linear scanner.***

tri-linear scanner

A scanner that uses a tri-linear array as the scan head, allowing the scanner to produce a full-color image scan in a single pass. See also ***tri-linear array.***

tritone

An image reproduced by using three different colors or tones.

True Color

See ***24-bit color; 32-bit color.***

TS

An abbreviation for *tilt and shift*, which are functions typically found on view cameras to control *depth of field* and *perspective control*. There are a few, specialized TS lenses available for 35mm cameras that can be used with some digital cameras. These lenses are more commonly known as *perspective control lenses*.

T-stop

Refers to *transmitted light*. It is also called a T/stop. Related to *f-stop*,

the T-stop does not give the same result. The T-stop is dependent upon the light passing ability of the glass as well as the optical system. The T-stop aperture indicates the actual amount of light going through the lens's aperture. F-stops show the size of the aperture opening compared to the focal length of the lens. Many lenses with T-stops mark the T-stops in red, with the f-stops marked in white on the same lens barrel. Since zoom lenses often have light loss in different parts of the zoom range, using T-stops on them will help get the best exposure. Typically, T-stops are used on motion picture camera lenses because they want more precision in their settings. See also **aperture; f-stop.**

TTL

An abbreviation for *through the lens*. Indicates that the meter reads the light after it passes through the lens. The TTL meter light sensor is usually located right in front of the image sensor plane and flips out of the way during the actual exposure.

TTL flash

An electronic flash connected to a special sensor inside the camera. The sensor measures the amount of light from the flash that is returned to the camera from the subject. The sensor reads this returned light being reflected off of the image sensor during the exposure. When the proper amount of light has been received, the flash circuit shuts off the firing of the flash in mid-flash.

TTL meter

A light meter that measures the amount of light after it passes through the camera lens. See also **TTL.**

tungsten light

More commonly known as *incandescent light*. Light that is produced by standard household incandescent light bulbs. In point of fact, tungsten light is produced by an incandescent light bulb with a tungsten filament, but the terms have come to be used interchangeably. The first incandescent light bulbs used carbon powder and platinum filaments. There were also incandescent lights made with carbon rods. A tungsten light bulb works by heating a tungsten filament wire inside a clear or frosted bulb by passing a current through the filament. The inside of the bulb is filled with an inert gas,

such as nitrogen, so the tungsten filament glows white hot at temperatures of 2,000 K to 3,000 K or more. Since oxygen is not an inert gas, it is not is present, so the filament glows but does not burn. The white-hot filament produces both light and heat. When photographing with tungsten light, the warmer color of the light must be taken into account. Many digital cameras have a tungsten white balance setting; alternatively, the images can be adjusted after-the-fact using image-manipulation software.

tv

An abbreviation for *time value*. A term used to mean *shutter-priority auto-exposure*. Shutter-priority auto-exposure is when the photographer sets the shutter that is desired and the camera's auto-exposure system sets the aperture. Some camera manufacturers, such as Canon, Pentax, and Contax, use this term. See also ***auto-exposure.***

TWAIN

An abbreviation for *technology without an interesting name*. There are other slight variations on the name, but this version appears to be the most popular. TWAIN is a data communication standard used to allow scanners, digital cameras, and similar devices to communicate with and output data to computers. Typically the devices that use this standard come with a TWAIN software driver that is added to the computer's software. This driver allows the computer software to control the device.

tweening

Short for *inbetweening*. A process of producing animation drawings in between two others to make one flow smoothly into another. Tweening is widely used for moving graphics in Flash and in animated GIFs. Some of this work can be done automatically with software. See also ***flash; GIF.***

UGA

See ***ultra graphics array.***

UI
> See ***user interface***

ultra extended graphics array (UXGA)
> Also called *ultra graphics array*. A monitor resolution of 1600 by 1200 pixels. A widescreen version, known as WUXGA, is also available.

ultra graphics array
> See ***UXGA.***

uniform resource identifier (URI)
> Often erroneously called *URL* (*uniform resource locator*). URI is the identifier of a resource on the World Wide Web. URL not only identifies a resource, it also locates it. See also ***uniform resource locator.***

uniform resource locator (URL)
> Also referred to as *web address*. Identifies and locates resources on the World Wide Web. It is sometimes used generally to refer to both *URL* and *URI* (*uniform resource identifier*). See also ***uniform resource identifier.***

Universal Photographic Digital Imaging Guidelines
> See ***UPDIG.***

universal serial bus (USB)
> A hardware standard for connecting peripheral devices to computers. USB allows up to 127 devices to be connected to a single USB host controller. USB hubs can be installed so that multiple devices can be connected to one USB port. A higher-speed version of USB, called USB 2.0 (USB2), has also been created. A USB2 port can have either a USB or USB2 device plugged into it. Many digital media card readers use either a USB or USB2 port to make their connections. USB connects at a speed of up to 12 Mb/sec, and USB 2.0 connects at speeds up to 480 Mb/sec. Most devices do not reach the maximum speed. When a number of devices are connected through a *hub*, or a single connection, they must share the available bandwidth. When selecting a USB or USB 2.0 hub, be sure that it is suitable for the desired application and will not slow down data transfer. For example, a USB hub will operate at USB speeds rather than USB 2.0 speeds no matter which type of device is plugged into it.

U

unsharp masking (USM)

A confusing name for a popular sharpening technique used on digital images to make them appear sharper when viewed. This apparent sharpness can be adjusted by the user to keep the image from looking over-sharpened. Unsharp masking software works by blurring a copy of the original and then comparing it to the original. The images are combined so that edges between elements in an image become more defined and have more contrast. This enhanced edge fools the eye into believing that the image is sharper than it is. A threshold value can be set so that small image details are not damaged or destroyed by the software. The amount of the sharpening can also be controlled, along with sizes of edges to be affected (called *radius* in the software). *(see figures on pages 294 and 295)*

unsharp masking – before – The photograph before any sharpening is done. See the other figure for the after view.

unsharp masking – after – This image has been sharpened with a technique known as unsharp masking. Compare it to the figure before the unsharp masking.

untagged

Refers to an image file that does not have an *ICC color profile* attached. Because there is no profile tag, image-manipulation software does not know which color space to use with the image. It is important for the user to determine which color space gives the best color and then resave the image with the color space profile information embedded. This converts the image to a tagged file and allows other software to utilize the image properly. See also *color space.*

UPDIG

An abbreviation for *Universal Photographic Digital Imaging Guidelines.* A series of documents prepared by the UPDIG Working Group to establish digital imaging standards, standard terminology, and suggested

U

workflows. UPDIG is made up of a number of leading nonprofit associations, trade groups, and manufacturers in the photography industry.

upgrade

To replace computer hardware, software, or digital photographic devices with a more recent and usually more powerful version. Upgrading can also refer to adding features, such as a second hard drive, or more of the same capability, such as additional RAM, to a computer. In the case of digital cameras, the internal firmware may need to be upgraded from time to time to correct problems that are discovered or to improve performance.

upload

To send data to another computer. More specifically, to send data to a remote computer system, a website, or an FTP server.

upresing

Also called *uprezing*. The process of interpolating an image to a larger size. The term refers to "upping" the resolution of an image.

uprezing

See ***upresing.***

URI

See ***uniform resource identifier.***

URL

See ***uniform resource locator.***

USAF 1951 resolution test

A test chart developed by the US Air Force in 1951 to measure the resolution of cameras and microscopes. The 1951 chart has been supplanted by more current versions that are easier to use and that allow software to automatically determine resolution values. Modern versions also make it easier to determine lens aberrations located in corners and to check the resolution of scanners. See also ***test chart; resolution.***

USB

See ***universal serial bus.***

USB2

See ***USB 2.0.***

USB 2.0

Also called *USB2*. A higher-speed version of the *universal serial bus* connection standard. See ***universal serial bus.***

USB hub

A connecting device that allows multiple USB devices to be plugged into a single line or port. See ***universal serial bus.*** *(see figure on page 297)*

USB hub – This is an image of an USB hub with one input port and four output ports.

USB port

A location on a computer, a USB hub, or other device to which USB devices can be connected. See *universal serial bus.*

USEPLUS

The organization that developed *PLUS* (*Picture Licensing Universal System*). See *PLUS.*

user interface

The manner in which a user interacts, controls, and deals with a software program or electronic device such as a digital camera. When the UI takes the form of icons and similar features, it is called a *graphical user*

interface, or *GUI* (pronounced "gooey"). See also ***graphical user interface.***

USM

See ***unsharp masking.***

UXGA

See ***ultra extended graphics array.***

value

The brightness or lightness of an image or color. Value is a measure of where the color lies along a line between light (white) and dark (black).

vector

A line that is mathematically defined as relative to its direction and length. This mathematical definition takes the form of an equation or formula that makes it useful for an image format. Vectors are used to create *vector graphics* and *vector images.* See also ***vector graphic.***

vector graphic

Also called a *vector image.* A graphic image made up of vectors, which are called *paths.* These paths form various geometric shapes such as squares, circles, and polygons. Each of these paths is mathematically defined so it can be scaled upward without developing artifacts. Since the shapes are vectors, and not pixels, there is no pixelation when the resolution is increased. See also ***vector.***

vector image

See ***vector graphic.***

vector path

Also known simply as *path.* A vector image is made up of vectors, which are also called paths within the image. See also ***vector graphic.***

vertical correlated noise

Also known as *streak noise* and *periodic noise.* A defect inherent to CCD technology and found more often in scanners. See also ***streak noise.***

vertical refresh rate

Also known as *refresh rate* and *vertical scan rate*. The rate at which a monitor or television set refreshes its picture or screen. See also ***refresh rate.***

vertical scan rate

See ***refresh rate; vertical refresh rate.***

VESA

See ***Video Electronics Standards Association.***

VGA

See ***video graphics array.***

video card

Also called *video display board*. A circuit board or interface card that is added to a computer so that the computer can control the video processing for a monitor. Faster video cards with additional memory are required for the most demanding applications, including digital-imaging software, such as Apple's Aperture, and many three-dimensional games.

video display board

See ***video card.***

Video Electronics Standards Association (VESA)

An association founded by a group of manufacturers to develop international standards for video displays. These standards include connector standards, display-resolution standards, and various other technical standards.

video graphics array (VGA)

Refers to a computer monitor with a resolution of 640 x 480 pixels. The VGA is a very low-resolution monitor by today's standards.

video out

A connector or port on many digital cameras and other electronic devices that allows a video signal to be obtained for display on a monitor or for recording. Since the signal is a video signal, it can be displayed on a regular television set.

viewing screen

The translucent screen on a camera that shows the subject. The term is

occasionally used in the digital world to describe the LCD screen that serves the same purpose on a digital camera. See also *LCD screen.*

vignette

A darkening or lightening around the edges of an image. A vignette can be a creative technique or an error. See also *vignetting.*

vignetting

The process of putting a vignette around a subject. Vignetting can be done purposefully, as an aesthetic technique in portraits, for example. Or it can be done in error, as when a lens doesn't fully cover the image sensor or when an added device, say a lens shade, cuts into the image. See also *vignette.* *(see figure on page 301)*

visible light

The light in the spectrum that the human eye can see. See also *visible spectrum.*

visible spectrum

The portion of the *electromagnetic spectrum* that can be seen. The human eye can see a range of *visible light* with wavelengths at the lower end of about 380 to 400 nanometers and at the upper end of about 700 to 780 nanometers, depending on the individual. The visible spectrum thus has only an approximate range since it varies from person to person. See also *electromagnetic spectrum.*

VIVO

An abbreviation for *video in video out.* A feature on higher-end *video cards* that allows video signals to go in as well as out. See also *video card.*

V-Number

See *Abbe number.*

volatile memory

Memory that must have power applied to it to maintain information. Typical RAM memory is volatile memory, while digital memory cards used in digital cameras are made up of non-volatile memory. See also *RAM; non-volatile memory.*

watt

The standard unit of power. One watt is equal to one joule per second. When working with electrical devices, it is calculated by multiplying volts by amps. The watt gets its name from James Watt (1736–1819), a Scottish inventor and engineer.

vignetting – This image has had the edges lightened in an effect known as vignetting.

W

watt-second

A unit of measure used to rate electronic flash units. Since it is a measure of energy, different electronic flash units with the same watt-second rating can have very different light outputs based on their efficiencies, so this measure should be used carefully. One watt-second is equal to one joule.

watts per second

A unit used in measuring *energy*, which is power performed for a period of time. A watt is a joule per second, so watts per second are joules per second per second. A candle produces about one watt, so watts per second is the amount of power produced by a candle for a second.

wavelength

The length between two waves. Wavelength can be measured between any two similar points on a series of waves, but is usually measured between two peaks. Since light is a waveform, different colors of light can be specified by their wavelength.. Digital photographers concern themselves mainly with the *visible light spectrum*, which has a wavelength of about 400 to 700 nanometers. See also ***visible light spectrum.***

wavelet compression

A type of data compression used with some types of image formats. It can be either a lossy or lossless compression type. JPEG 2000 is an example of a still-image format that uses wavelet compression for its compression algorithm. See also ***lossy; lossless; JPEG 2000.***

WB

See ***white balance.***

wdp

The file extension for Windows Media Photo. See ***Windows Media Photo.***

Web

See ***World Wide Web.***

web address

See ***universal resource locator.***

web colors

See ***web-safe colors.***

web optimization

A process that prepares images before uploading them for display on the World Wide Web. The process involves (1) reducing the size and resolution of an image and increasing the compression to speed up download times; (2) converting the image's color space to sRGB so that it will display better on a wider variety of web browsers; or (3) removing metadata to reduce the size of the image file. This last function is not recommended for digital photographers because images without metadata

can become *orphans,* with reduced or eliminated copyright protection.

web page

A single document on a *website* presented on the *World Wide Web.* A web page is usually written in *HTML.* A number of web pages are usually gathered together in a website. See also *website: HTML; World Wide Web.*

web photo gallery

A group of digital images gathered together and presented on a website for clients, potential clients, or others to view. These are often set up in a digital slideshow format or as a group of thumbnails that can be clicked on to see a larger version of an image.

web-safe colors

Also called *web colors.* A group of 216 colors that will display uniformly in most computers and web browsers. In addition to the 216 colors, there are forty additional colors that are unique and reserved for the use of various operating systems. At one time computers could only display 256 colors, so the web-safe colors were configured so they would work on these earlier computers. Many monitors and computers can display more colors because they have moved from 8-bit to 16- and 24-bit displays. This has caused the use of web-safe colors to decline.

website

One or more web pages gathered together on the World Wide Web under a single domain or subdomain. These web pages are usually interconnected and maintained by one organization. Each website is accessed by use of a *web address*, or *universal resource locator* (*URL*). *Website* is sometimes written as two words: web site. See also *universal resource locator; web page.*

white

(1) The mixing of all colors of visible light in an *additive color system.*
(2) The absence of all color (pigments) in a *subtractive color system.* See *visible light spectrum; additive color system; subtractive color system.*

white balance (WB)

A function on most digital cameras used to adjust or correct for various lighting conditions. The color of the subject is dependent upon the lighting conditions under which it is viewed. White balance corrects the colors in an image so that a white object will appear white in the final image. Different lighting conditions produce different color temperatures, and those color temperatures occasionally need to be adjusted. The overall purpose is to produce an image without a noticeable colorcast that looks natural. See also *color temperature.*

W

white light
> (1) Light made up of equal amounts of the three primary colors of red, green, and blue (RGB). (2) The result of mixing all of the colors of the visible color spectrum. See also **visible color spectrum.** *(see figure below)*

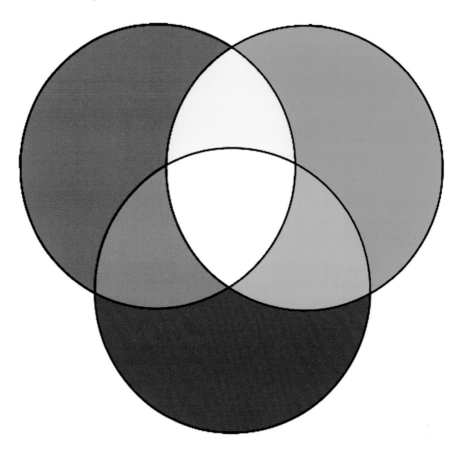

white light – When red, green, and blue (RGB) colors are combined in an additive color system, the intersection of all three colors makes white light, as shown in the figure.

white point
> (1) The color of a white pixel on a computer monitor. This color is stated as a color temperature in kelvins. A typical white point is 6500 K, also

called *D65*. (2) The mixing of the three primary colors of red, green, and blue (RGB). See also ***D65.***

white point adjustment

The adjustment of the *white point* on a monitor. Most monitors have adjustable white points, with several choices available. Many photographers are standardizing on *D65* (6500 K), which matches the white point standard of the sRGB color space. See also ***D65; white point; sRGB.***

wide open

The point at which the aperture is as large as possible for a given lens. Achieving this is usually done by using the smallest number (f-number) on the lens barrel.

widescreen ultra extended graphics array

See ***WUXGA.***

Wi-Fi

An abbreviation for *wireless fidelity* or *wireless local area network* (*WLAN*). A technology designed to connect digital electronic devices without wires. Wi-Fi is commonly used to connect computers and even cell phones to the Internet, but it is also being used to connect digital cameras to laptop computers so that photographers can automatically download their images to their computers as they work.

Windows Media Photo

A file format and file compression technique for digital images. It uses the file extension *.wdp*. It was developed for Windows by Microsoft but is not widely supported outside of that environment. It has been renamed *HD Photo* and now uses the file extension *.hdp*.

wireless local area network

See ***Wi-Fi.***

WLAN

See ***Wi-Fi.***

workflow

All of the steps involved in making a photograph, from the creation of the original image to its final form as a digital file or printed image. The goal is to reduce as many steps in a workflow as possible to speed up processing and reduce errors.

work for hire

An abbreviated term for *work made for hire*. A contract for creating a work subject to copyright where the contractor is the copyright holder; the creator (photographer in this case) is simply paid for his or her work and holds no part of the copyright. It is a legal definition under US copyright law. This law defines when work for hire is allowed so that someone besides the creator can claim ownership of the copyright. Employment by a company is an example of a situation in which the copyright is

owned by the company and not the creator, Except for a few exceptions defined by law, the creator is assumed to be the copyright holder. Most professional photography organizations discourage photographers from participating in work for hire without an employee relationship because the photographers have to give up any future rights and earnings from their work, a situation comparable to being an employee without receiving benefits. According to these same professional organizations, the creation of photographs is not one of the exceptions allowed under US copyright law for a work to be a work made for hire if the photographer is not an actual employee of the contracting party.

World Wide Web (WWW)

Also called the *Web*. The grouping of all websites and web pages currently accessible to the public. More than 100 million websites currently exist. The World Wide Web came about in 1991. Tim Berners-Lee first proposed the idea for the Web in 1989 as an information-sharing resource for researchers.

WORM

See *write once read many.*

write once read many

Better known by its abbreviation *WORM*. A technology used with optical media such as CDs and DVDs that can be written only once and not changed but can be read many times.

wrong reading image

An image printed backwards, either accidentally or purposefully. The image is a mirror image of itself. This is a feature of some image software because it enables a photographer to display an image to clients in a way that looks more familiar to them. Most people are used to seeing themselves only in a mirror, so a photograph can look "backward" to them. By displaying the image in a mirror-image form, people see themselves as if they were looking in a mirror. *(see figure on page 307)*

WUXGA

See *ultra extended graphics array.*

WWW

See *World Wide Web.*

WYSIWYG

An abbreviation for *what you see is what you get*. A phrase meaning that whatever is shown on the computer monitor is what will appear in the document.

wrong reading image – This figure shows an image that reads backward as seen in the sign. It is called a wrong reading image.

XCF

The file extension used by the GNU Image Manipulation Program

(GIMP). The initials came from *eXperimental Computing Facility*, a club that GIMP's creators, Spencer Kimball and Petter Mattis, belonged to at University of California at Berkeley. See also **GNU Image Manipulation Program.**

XD card

See **xD-picture card.**

xD-picture card

Also called an *XD card*. A flash memory card typically used in consumer-level digital cameras. The extremely small size of the xD card makes it attractive for use in very small digital cameras. xD cards currently come in sizes from 16 MB to 2 GB. See also **flash memory; memory cards.** *(see figure below)*

xD-Picture card – The tiny memory card that is the size of a penny is known as a xD-Picture card.

X

XGA

See **extended graphics array.**

XML

See **extensible markup language.**

XMP

See **Extensible Metadata Platform.**

YCC color model

A color model developed by Kodak for its Photo CD system. In this color model, the RGB is translated into three components: *luminance* (*Y*), *chrominance* (*C*), and *hue* (*C*). See also **Photo CD.**

yellow

One of the four primary color inks used in four-color printing. The others are cyan (C), magenta (M), and black (K), which together make up *CMYK*. Yellow (Y) is a primary color in a *subtractive color system* and a secondary color in the additive RGB color space. See also **CMYK; four-color printing.**

Young-Helmholtz

A color theory based on the three colors of red, green, and blue. Thomas Young and Hermann von Helmholtz developed this theory during the 19th century based on their on their idea of how the *photoreceptors*, or *cones*, in the human eye work. Young and Helmholtz believed that the human eye is sensitive to the three colors, that there are three types of cones in the human eye, and that each type is sensitive to one of the colors. It took more than one hundred years for their theory to be proven.

Z-buffer

The video memory area that stores the depth information, or *z-axis*, of each pixel for three-dimensional images. See also **hyper Z; hierarchical Z.**

zip

The process of compressing data and storing it in a *zip file format* file. *Zip*, preceded by a dot, is also the file extension for that file format. The zip file can contain one or more documents or files. It is sometimes used to combine a group of images for electronic transport. When doing this, the images are not compressed (they are usually compressed JPEG images anyway) but are *zipped* to protect them from corruption during the electronic shipping. Most recent computer systems have built-in support for zip. See also **zip file format.**

zip disk

A small magnetic disk used to store data. The zip disk, designed to replace *floppy disks*, has a thicker, hard plastic shell around it to offer more protection to the magnetic disk inside. The floppy disk holds only 1.44 MB; the first zip disks held up to 100 MB of data, and later versions could hold up to 250 MB or 750 MB. The later versions never became as popular as the first one. The earlier zip drives could not read the larger disks. *(see figure below and on page 311)*

zip disk – This zip disk can hold up to 100 MB of data.

Z

zip disk versus diskette – The zip disk seen here is about the same size as a diskette but holds 75 times as much data.

zip drive
> A device designed to read and write on small magnetic *zip disks*. See **zip disks.**

zip file format
> The file format used to store files or images that have been *zipped*. Most recent computer systems have built-in support for zip. See also **zip; zipped.**

zipped
> A file (or group of files) that has been saved in a *zip file format*. See also **zip; zip file format.**

Z